Art and Postcapitalism

Art and Postcapitalism

Aesthetic Labour, Automation and Value Production

Dave Beech

PLUTO PRESS

First published 2019 by Pluto Press
345 Archway Road, London N6 5AA

www.plutobooks.com

British Library Cataloguing in Publication Data
A catalogue record for this book is available from the British Library

ISBN	978 0 7453 3925 2	Hardback
ISBN	978 0 7453 3924 5	Paperback
ISBN	978 1 7868 0508 9	PDF eBook
ISBN	978 1 7868 0510 2	Kindle eBook
ISBN	978 1 7868 0509 6	EPUB eBook

This book is printed on paper suitable for recycling and made from fully managed
and sustained forest sources. Logging, pulping and manufacturing processes are
expected to conform to the environmental standards of the country of origin.

Typeset by Stanford DTP Services, Northampton, England

To my art teachers

In memory of Stroud Cornock,
artist and teacher
1938–2019

Contents

Acknowledgements

This book was written while I was a Professor of Art at Valand Academy, University of Gothenburg, and a Senior Lecturer in Fine Art at Chelsea College of Arts, London. I want to thank colleagues at both institutions for their continued support and critical interrogation of the ideas that I set out in this book. I also want to thank comrades in the 'Marxism in Culture' lecture series based at University College London.

An early version of my analysis of the forms of activity – and types of subjectivity – included in contemporary postcapitalist theory was delivered in October 2017 at AltMFA, an alternative educational organisation established by artists for artists in London. Also, in October 2017, I gave a presentation on the concept of postcapitalism for the Collection Collective seminar 'In the Future All Our Homes Will Be Museums' at the Kunsthalle Bratislava. Since both presentations were shaped, in large part, by an email conversation that I had with Peter Hudis about the transformation of work and life in postcapitalism, I want to thank Peter for his generosity in explaining some key principles for thinking about postcapitalism.

An earlier version of my argument about postcapitalism in relation to questions of work rather than art was developed as an article for *Parse* journal. As part of the open peer review process I am grateful to have received excellent feedback from Sarah Brouillette and Jasper Bernes. I also want to thank Marina Vishmidt for making this possible. I gave the first presentation of my rereading of theories of nonalienated labour at the University of British Columbia, Vancouver, in 2017, at the invitation of Gareth James. I am indebted to the audience for raising serious questions about my methodology and conclusions. I hope that the arguments in this book have been improved as a result, but I also hope that if problems persist then I will hear about it.

My investigation of nonalienated labour was significantly extended and improved by an email exchange with the great generosity of the Marxist art historian Andrew Hemingway, for which I am deeply thankful. I have also benefitted from exchanges with Jason Bowman, Andrea Phillips, Mick Wilson, Tom Cubbin, Josefine Wikström, Bruno Gulli, Alberto Toscano and Charles Esche. My thanks to Kim Charnley for comments on an early draft and to Bryan Parkhurst for commenting in such detail on the first full draft of the manuscript.

Thanks also to Jakob Horstmann for making this book possible and for making it better.

I would like to thank the CCW Graduate School for awarding me research time to complete this book.

Introduction:
Postcapitalism, Critique and Art

This book contributes to the political theory of art. Prompted by an observation that current debates on postcapitalism differ from their nineteenth- and twentieth-century counterparts (socialism, communism and anarchism) by omitting art from descriptions of universal emancipation, this book sets out to reconstruct the politics of art through the lens of the supersession of the capitalist mode of production. In doing so, however, I confront the political imaginary of contemporary art. Today, evidently, art is replete with critical practices but typically lacks a clear understanding of the difference between resisting the existing social system and superseding it.[1] In order to assess the various theories of art's hostility to and complicity with capitalism, I will draw on contemporary value theory to focus the analysis on the contradiction between *value production* and the production of *material wealth* that characterises both (1) what is distinctive about work in the capitalist mode of production and (2) what is decisive in the transition from capitalism to postcapitalism.

Value theory is a relatively recent tendency within Marxism and post-Marxism that arose in the wake of the collapse of the Soviet Union, the rise of the global justice movement in the 1990s and the financial crisis of 2007–8.

This diverse movement indicates that despite the notion, which became widely voiced after 1989, that 'there is no alternative' to capitalism, increasing numbers of people around the world are searching for such an alternative. However, there appears to be little or no consensus within the global-justice movement as to what such an alternative might consist of.[2]

Value theorists respond to this issue specifically by arguing that the principal advocates of the so-called 'traditional left' made grave errors in their definitions of capitalism and therefore misconceived the nature of postcapitalism. Value theory declares that postcapitalism is not achieved with the workers' state, the redistribution of wealth, decommodification, the abolition of money or the collective ownership of the means of production but only with the supersession of value production. I will adhere to this principle without endorsing the political abandonment of the

workers' movement or the emphasis on the commodity and commodity form, as some of its leading exponents have concluded.

Postcapitalism today is not another word for communism but the name of a political project that deliberately distances itself, to a greater or lesser extent, from the Marxist and socialist tradition. Contemporary postcapitalism binds itself uneasily to historical postcapitalism through repeated acts of revision, rejection and critique. Prominent authors of postcapitalist theory such as Paul Mason, Nick Srnicek and Alex Williams, Katherine Gibson and Julie Graham, Kathi Weeks, Miya Tokumitsu, Moishe Postone, Michael Heinrich and John Holloway, share an exasperated discomfort with the history of the anticapitalist struggle, despite the diversity of their political and theoretical projects. Contemporary postcapitalism, it could be said, is the intellectual programme, variously conceived, to extend the radical emancipatory politics of the left by leveraging it away from the ostensibly narrow concerns of the workers' movement.

What has happened, among other things, is that the micropolitics of work not only brackets itself off from the workers' movement but preserves and conceals a hostility to the working class and the workers' movement in its dream of worklessness. When political theorists after 1968 refer to the traditional left as a narrowly-conceived class politics that suppresses all other political discourses and movements, the term traditional left is deployed to identify only those specific elements of the socialist and Marxist traditions to be jettisoned by the new politics and therefore is necessarily a distortion because it represents the breadth of socialist and communist traditions from the perspective of what they lack. When the workers' movement aligned itself with anticolonial, feminist, ecological and peace movements, for instance – which it did from the start and regularly throughout – these instances are extracted from the traditional left as if they did not belong there.

As well as marginalising the workers' movement from the politics of work, contemporary postcapitalism – including the value theory strain – typically rejects the principal modes of organisation of workers (trade unions, socialist political parties and vanguard revolutionary parties) and discards the political process of revolution. Indeed, it is within an epoch for which revolution has dimmed that 'postcapitalism' has become one of the buzzwords of political discourse. Gerald Raunig was an early critic of 'the simplistic recipe behind the most diverse Marxist–Leninist discourses of the 20th century: the core of revolution overshadowing all else is to take over the state to create a new society *afterward*.'[3] Raunig proposes an opposition between a linear sequence of revolutionary rupture and a Deleuzean politics of 'transversal activism' which 'does not go from one point to another, from one realm to the next, or from the here and now of

capitalism to the hereafter of socialism'[4] but, following Hardt and Negri, aims 'to attack power from every place, from every local context'.[5] Contemporary postcapitalism runs parallel with the rise of a 'prefigurative politics' which demands the activist to 'be the change you want to see' or 'to create in the here and now the world they would like to see',[6] rather than engage in vanguardist means towards a collective end.

I will be critical of contemporary postcapitalism and its evacuation of class struggle, but my goal is not to reinstate class as the overriding political issue against the grain of a political *milieu* articulated around questions of race, gender, indigeneity, sexuality and so on. What's more, I do not intend to redirect all activities towards a single goal but rather to fill a gap. I will not make the mistake of identifying a certain kind of political activity (or a certain kind of art) necessary for structural transformation and dismiss all other political projects. And yet, I am not arguing that the privileging of class in Marxism has to be replaced with the recognition of a marketplace of rival political discourses in which no specific politics (based on class, race, gender, sexuality, indigeneity, etc.) has any rational political justification for priority over any others, as Chantal Mouffe does.

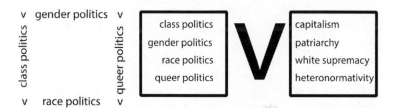

Figure 1 Mouffe's Model of political rivalry *Figure 2* Multi-dimensional model of political rivalry

Instead of thinking of Marxism as a rival for feminism, and feminism as a rival for postcolonialism or queer politics, I want to insist that the rival of Marxism is capitalism (and its apologists), the rival of feminism is patriarchy (and its apologists), the rival of postcolonialism is colonialism (and its apologists), and the rival of queer politics is heteronormativity (and its apologists).

So, while it goes without saying that the abolition of the capitalist mode of production does not, in and of itself, bring about the emancipation of women, people of colour, indigenous peoples and so forth, I want to argue for the necessity of alliances between Marxism and other political movements, because the capitalist world system dovetails with and perpetuates the exploitation and oppression of women, people of colour, the indigenous, LGBTQ+ communities and so on. Rather than choose between

one political project and another, I conceive of radical social transformation as necessarily taking place across multiple connected dimensions of social reality. Hence, my argument is intended to add to the breadth of political projects for contemporary art within a multi-dimensional and multi-layered network of critique, resistance, rebellion, reform and revolution. Each political project, I want to argue, corresponds to a part of the social totality and is connected by the real shared conditions of that social totality.

Similarly, the politics of art might appear to be characterised by rival projects of social and cultural transformation, as if it is necessary to choose between the critique of art's institutions and the critical contestation of the visual field, as if one conception of the politics of art or one set of techniques for politicising art is correct and all others are deluded, complicit, self-defeating and so on. Arguably, the distinction between realism and naturalism in the nineteenth century set the pattern for dividing art politically according to the categories of socialist realism and modernism, Brechtian Epic Theatre and the Aristotelian tradition of drama, avant-garde and kitsch, affirmation and disaffirmation, making political art and making art politically, and, more recently, interactive and participatory art, or conviviality and antagonism. Art is a battleground of political positions but in this book I will always assume a spectrum of resistances, rebellions, critiques and revolutionary projects that pursue the transformation of one or some (but never all) dimensions of oppression and exploitation within the existing condition.

By focusing on the intersection of art and postcapitalism, I want to stretch the scale of art's political ambition beyond the narrow concept of critique, typified by Jacques Rancière's theory of dissensus[7] and Chantal Mouffe's concept of agonism,[8] which is cancelled out by its success,[9] in order to recognise the breadth of critique, including critical methodologies of self-reflexivity, suspicion and enquiry.[10] At one end of the spectrum, artists appear to be content to provoke members of the public 'to pause, think, learn, and act'[11] and at the other end, artists measure the criticality of their work through the actual social changes brought about by it. Art is critical when it contains critical ideas in its content, form or use. Art is also critical when it reveals the limits or assumptions of dominant practices, particularly in the economic, political, domestic and cultural spheres.[12]

Anthony Gardner's political assessment of the postsocialist practices of Ilya Kabakov, Alexander Brener, NSK, Thomas Hirschhorn, Dan Perjovschi and others builds on this model, insofar as their 'noncomformist practices'[13] correspond to a 'withdrawal from the overdetermined categories through which contemporary art's politics are generally presumed'.[14]

Central to such arguments is the parallel critique of social structures and the artistic techniques that have been established to call them into question. As such, existing counter-tendencies are identified almost exclusively with dominant tendencies. I want to knit this position into a multi-dimensional lattice of dominant tendencies and counter-tendencies that allows us to be more discerning about the relationship of critique to circuits of command and value extraction.

Since it is not a question of different approaches competing for the title of criticality, but rather of assigning each type of critical art its role within the full spectrum of activities required to bring about radical, widespread and sustainable social change, then the task is to forge solidarities where currently there exists only rivalry and recrimination. Differences will remain, and disputes over priorities, strategies and principles should not be suppressed, but social change and art's contribution to it cannot be reduced to a single principle. So, the 'creative disruption of everyday life',[15] the 'call for nonprofit art institutions to pay artists for the work they contract us to do'[16] and proposing that art '[has] practical, beneficial outcomes for its users' in 'responding to current urgencies'[17] are parts of a greater interlaced political project that operates in every dimension of the social totality from the aesthetic to the economic and from structures of feeling to the redesign of structures of political association.

The critique, subversion and supersession of dominant tendencies in capitalism require a broad range of counter-tendencies. The full account of the counter-tendencies of critical artistic practice will need something like a cultural version of what Alan Sears calls the 'infrastructures of dissent'.[18] This means building sustainable collective resources for structural change. This means, in my terms, paying as much attention to the full spectrum of counter-tendencies as it does to charting and condemning 'the extinguishing of the field of art as a site of resistance to the logic, values and power of the market'.[19] Art, I want to suggest, does not exclusively belong to the dominant tendencies of contemporary colonial, patriarchal capitalism but is also a space that hosts the counter-tendencies of decoloniality, desegregation, queering and postcapitalism.

American artist Andrea Fraser, who has been a prominent voice within critical art theory as well as a major artist within the genre of institutional critique, responded to a questionnaire published in *Frieze* magazine in 2005 which included the question 'How has art changed?' Fraser took the opportunity to provide a concise summary of what she saw as the tendency for art and its institutions to be taken over and transformed by corporate interests, markets and neoliberal priorities.[20] Charting the tendencies of capitalism's hostility to art is extremely valuable as part of a postcapitalist political project – not only for art but for an understanding of capitalism

generally. This corresponds to one version of what constitutes an effective counter-tendency against the dominant tendency for capitalism to commodify, marketise, monetise and financialise everything, namely to expose the system's operations in a vigilant confrontation with power and exploitation.

Rather than supply capitalism with the critical commodities that it so easily recuperates, Marc James Léger argues that it is only by 'endorsing a masochistic position inside the system'[21] that artists can take up a critical position to both capitalism and the institutionalised avant-garde.[22] Nato Thompson characterises the variety of activist art practices that have emerged in the twenty-first century through the concept of 'an infrastructure of resonance'.[23] Mostly, these are shaped by dominant, commercial activities but, he argues, '[i]f we want to change meaning in the world, we simply need to diagram an infrastructure, visit it, and radically alter it'.[24] Here, then, the dominant tendencies necessary for the reproduction and expansion of the existing social system are understood as sites of contestation and therefore, potentially, as the material basis for counter-hegemonic culture. At the same time, Thompson identifies ways in which 'alternative infrastructures'[25] can be established to support alternative values and practices.

One way in which current issues within art overlap with the agenda of contemporary postcapitalism is the emphasis placed on the politics of work. Combining the feminist expansion of the category of work with the post-Marxist politics of the withdrawal from work, contemporary postcapitalism confronts the alleged programme of the traditional left – the emancipation *through* labour – with the programme of the emancipation *from* labour.[26] In this book I will reframe the contemporary politics of work through a variant of value theory that challenges the concept of work and the campaign for its abolition as well as undermining the aesthetic conception of labour and the basis of its rejection today. In a word, I want to reject the aesthetics of work *properly*. It is value, I will argue in Chapter 1, that is the acid test of the capitalist mode of production and therefore it is the abolition of the subsumption of production under value that is the litmus test of postcapitalism. In place of visions of an automated release from work, therefore, I will argue that postcapitalism requires the more specific abolition of productive labour.

The universal emancipation of labour from value production is not a panacea for every form of exploitation, domination, bias and exclusion, even if the capitalist world system is an integrated configuration that perpetuates and exacerbates gender, racial, colonial and sexual structures of inequality. My ambition, in this respect, is very humble. I am merely fixing a hole or two in contemporary postcapitalist theory. However, I hope that

my discussion of capitalism, labour, technology, value and art proves to be useful to a range of political projects that do not foreground issues around capitalism but nevertheless turn on the politics of the differential field of human activity (work, rest, leisure, exploitation, self-activity, self-expression, self-fashioning, and so on).

Paul Gilroy, for instance, stresses that 'in the critical thought of blacks in the West, social self-creation through labour is not the centre-piece of emancipatory hopes' and yet, these questions are central to his politics insofar as he puts a strong emphasis on cultural *production*, especially making, remaking, authoring and altering culture through 'autobiographical writing, special and uniquely creative ways of manipulating spoken language, and, above all, the music'. For 'descendants of slaves',[27] Gilroy states, 'artistic expression' is 'the means towards both individual self-fashioning and communal liberation'. This book aims to contribute to an understanding of the relationship between these activities and the capitalist drive for value production.

Srnicek and Williams describe non-work in postcapitalism as follows: 'all involve varying degrees of effort – but these are things that we freely choose to do.'[28] A survey of the literature of historical postcapitalism casts this image of unforced activity as a diluted version of the aesthetics of work. I will discuss this in more detail in relation to the Utopian Socialist idea of 'attractive labour', the Marxist idea of 'nonalienated labour' and the technological emancipation from 'degrading work', which in the nineteenth century typically referred to artistic labour as a model for postcapitalist labour. Moses Hess in the 1840s, for instance, defined communism through a conception of labour that 'becomes totally identical with "pleasure"'.[29] This resonates with Srnicek and Williams' account, specifically because Hess identifies pleasure not with leisure but with whether activity is forced or free. 'Free activity is all that grows out of an inner drive', he says, whereas a worker 'who looks for the wages of his work outside himself is a slave'.[30]

Art, which initially prompted the Marxist theory of commodification in the mid-1970s, appears troubling to contemporary postcapitalist theory because artworks seem to be commodities and artistic labour seems to be politicised by associating it with work. The insistence that the artist is a worker like any other cancels art's hostility to capitalism while enacting a pragmatic confrontation with art's economies. I will draw on value theory to determine exactly what kind of work the artist performs and how this work relates both to capitalism and postcapitalism. I will also acknowledge the political merit of extending the recognition of the work of interns, studio assistants and fabricators in the production of art,[31] but I will refute the idea that such workers produce value and reveal the error

of recasting viewers as value producing labourers within a global division of art production.

These questions about the artist and work are essential to the political assessment of contemporary postcapitalism and particularly the absence of art within its visions of emancipation. One of the main reasons why art plays a negligible role within postcapitalist theory today is because the artist no longer appears as exemplary of an exceptional type of nonalienated labour but has come to signify the typical worker of post-Fordism.

Contemporary postcapitalism abandons art and the artist so long as the artist is taken to be the original 24/7 worker who cannot distinguish between work and life. Postcapitalist theory does not risk the reference to art and the artist in case this gives the impression that postcapitalism means the reorganisation of work as pleasure or work as an end in itself rather than the complete abolition of work.

Kathi Weeks, who is a prominent exponent of the anti-work movement, draws on Arendt and Gorz alike in a systemic critique of capitalism and a 'political project of "life against work"'.[32] André Gorz argues that 'to go beyond capitalism we must, above all, end the supremacy of commodity relations – including sale of labour – by prioritising voluntary exchange and activities which are ends in themselves'.[33] Arendt affirms a version of idleness – the freedom from toil – as the precondition for living politically and therefore living fully. Paolo Virno follows Arendt in his opposition of politics and work so that the refusal of work becomes the prerequisite of the resistance to capitalism. 'The key to political action (or rather the only possibility of extracting it from its present state of paralysis)', he says, 'consists in developing the publicness of Intellect outside of Work, and in opposition to it.'[34] This plays a part in Weeks' argument too, which confronts the alleged productivism of traditional Marxism, insofar as she argues that Marxists 'confine their critique of capitalism to the exploitation and alienation of work without attending to its overvaluation'[35] within the workers' movement. In some passages, Weeks calls for something very moderate, such as 'to be creative outside the boundaries of work'.[36] Always, though, her emphasis is on the culture of work or the values placed on work rather than on the social relations of work in capitalism specifically.

Work does not disappear, for Weeks, but certainly the work ethic does. It is in this spirit that she endorses Lafargue's demand for the right to be lazy and his objection to 'the dogma of work'.[37] Marxism becomes an obstacle to the abolition of work, she argues, insofar as the concept of labour extends beyond wage labour and work within the capitalist mode of production and therefore 'is haunted by the very same essentialized conception of work and inflated notion of its meaning that should be called into question'.[38] By turning the question back from the Marxist inquiry into

what kind of labour is constitutive of capitalist work to the Baudrillardian binary of whether a certain political position is for or against labour *per se*, Weeks expands the politics of the refusal of work by narrowing the inquiry into the social relations of labour.

Harry Cleaver follows the same political line, saying capitalism diminishes our 'time and energy to resist'[39] through work and therefore it is 'best to frame *all* our struggles, as much as possible, to help reduce the subordination of all our lives to work, with the ultimate aim of ending that subordination'.[40] However, the call for the reduction or abolition of work is too generic. Contemporary postcapitalist critiques of work fail to identify with any precision the specifically capitalist form of work and therefore do not devise measures or strategies for the abolition of work that correlate with an abolition of capitalism. Indeed, the preference for speaking of work rather than labour in postcapitalist theory has to be understood as conceptually impoverishing insofar as the discourses of work (from Weber onwards, especially) sacrifice the analytical precision of the subcategories of labour such as concrete labour, abstract labour, necessary labour, surplus labour, living labour, dead labour, productive, unproductive and reproductive labour, as well as the formula of average socially-necessary labour time. The discourses of work do not have equivalents for these subcategories of labour and therefore inevitably conflate and confuse them.

This extends the inquiry into what constitutes postcapitalism. To be for or against work is too blunt, since capitalism is not characterised specifically by the presence of work but only by the dominance of abstract labour (value production) over concrete labour (the production and maintenance of material wealth). The politics of work must acknowledge the fact, as Peter Hudis puts it, that 'Only with capitalism – that is, only when commodity-exchange becomes the primary and indeed universal medium of social interaction through the commodification of labour power – does value becomes the defining principle of social reproduction.'[41] Anti-work is a resonant political slogan, but the only route to postcapitalism, strictly speaking, is through the unfettering of material production from the drive to produce value and therefore the abolition of *labour reduced to average socially necessary labour time*.

Postcapitalism has its origins in the Utopian Socialism of the nineteenth century which, I will argue in Chapter 1, is usually understood as future-oriented but operated, in fact, through a process of geographical displacement along the global paths cleared by colonialism. At the outset, revolutionary communism contrasted itself with utopianism by demanding that social change takes place within the European centres of capitalist development rather than escaping from them into colonies established in colonised lands. For this reason, amongst others, Marxism

and the revolutionary left in the West has been thought of as a Eurocentric tradition incapable of grasping the specific forms of postcolonial struggles or of imagining that postcapitalism might emerge first in the peripheries of capitalist development.

Kevin Anderson[42] has studied Marx's published and unpublished texts with this question in mind and he has shown that although Marx originally believed that communism would be won first in England, France or Germany, after 1848 Marx's political investigations increasingly analyse non-European developments. Marx had never held the view which became dominant during the Stalinist period that the passage to communism follows a linear path from feudalism to capitalism to socialism and so on. In fact, Marx confronted an early version of this when supporters ascribed to him a linear theory of historical development. Marx's analysis of Russian village-communism from 1877 to 1882 demonstrates his theory of uneven development by stressing that only 'if Russia is tending to become a capitalist nation like the nations of Western Europe' would it have to expropriate its peasantry and make them into workers prior to the transition to communism, but otherwise this would not be necessary.

Trotsky extended Marx's theory of uneven development by arguing that underdeveloped nations and regions could make leaps towards socialism and communism by drawing on technologies and knowledge already operative within the advanced nations. Imperialism establishes global networks and geographical transfers of value[43] and information. Trotsky argued that preexisting modes of production were not fully supplanted in the global capitalist system and therefore consisted of an 'amalgam of archaic with more contemporary forms'. The Ugandan writer Mahmood Mamdani confirms this when he points out that the colonial powers imposed capitalist modes of production onto colonial territories but simultaneously preserved traditional hierarchies, tribal divisions and indigenous cultural patterns.[44]

The Warwick Research Collective (WReC) apply Trotsky's theory of uneven and combined development to world literature. For them, world literature must be understood not only as literature on a world scale but as an ordering system for literary production and consumption that structurally intersects with the colonial world order. In other words, 'the world-system exists unforgoably as the matrix within which all modern literature takes shape'.[45] Art, too, is born as simultaneously European and global, and as both modern and ancient, insofar as modernity appears to be limited to the colonial centres while ancient art is characteristic of the colonised regions and the subordinate nations of Europe.

'There is no modernity without coloniality' as Walter Mignolo argues,[46] and modernity does not reside 'solely in Europe or in the colonies but

in the power relation that straddles the two', as Hardt and Negri put it.[47] We might add that there is no category of art without modernity and therefore no art without colonialism or that art is formulated as a category that connects Europe and the rest of the world in a specific colonial relationship. Nevertheless, art cannot be reduced to a cultural instantiation of capitalist colonial Enlightenment modernity. Drawing on Fredric Jameson's important thesis on the singularity of modernity, WReC argue: 'Uneven development is not a characteristic of "backward" formations only.'[48] Modernity, they argue,

> does not mark the relationship between some formations (that are 'modern') and others (that are not 'modern', or not yet so). So, it is not a matter of pitting France against Mali, say, or New York City against Elk City, Oklahoma. ... Middlesbrough and North East Lincolnshire are in the United Kingdom as well as London and the Home Counties – and London itself, of course, is among the more radically unevenly developed cities in the world.[49]

The picture of modernity that WReC compose is one that demands that commentators acknowledge that unevenness does not describe the under-development of former colonies but characterises every space and every place. This means that 'the face of modernity is not worn exclusively by the "futuristic" skyline of the Pudong District in Shanghai or the Shard and Gherkin buildings in London; just as emblematic of modernity as these are the favelas of Rocinha and Jacarezinho in Rio and the slums in Dharavi in Bombay and Makoko in Lagos'.[50] Capitalism produces underdevelopment and maldevelopment as a necessary part of the production of wealth and technological advance.

If considerations of uneven and combined development are brought to bear on the theory of postcapitalism then the hope placed in technological development to eliminate work, argued most forcefully by Left Accelerationism, has to be rethought. First, of course, the theory of uneven and combined development shatters the smooth linearity of technophilic projections of what I will call in this book the *technologies of rest*. This is the thesis that technological developments within capitalism can facilitate the erosion or elimination of work. But also, this approach to development requires a geographical dimension that is characterised by disparities, ruptures, gaps, reversals, fusions and dependencies. Consequently, the proposal of fully automated worklessness must either assume an instantaneous global event or be mapped onto the existing world system of technological imbalance.

I will attempt to rethink how art and the artist can be located within postcapitalism by conceiving of capitalism as an uneven and combined

world system in which noncapitalist activity is widespread but subordinated to the production of value. Recognising that global capitalism is characterised by regional and local differences, it has been claimed that the linear connotations of the concept of modernity and therefore the passage from capitalism to postmodernism needs to be reformulated in relativist terms through the concept of 'alternative modernities' or what curator Nicolas Bourriaud has called the 'altermodern'.[51] WReC argues that the idea of a Chinese modernity, Arab modernity or African modernity derives from the mistaken assumption of 'the "western" provenance of modernity – rather than situating it in the context of *capitalism as a world-system*'.[52] That is to say, the mistake is to recognise only uneven development and not how this unevenness is combined within a single global system.

Just as world capitalism is a single system of asymmetrical flows, world literature and the category of art can be described as cultural systems that reproduce the core and periphery of colonial capitalism. The uneven and combined development of capitalist globality means that pockets of noncapitalist activity already exist everywhere. 'How to build a political movement at a variety of spatial scales as an answer to the geographical and geopolitical strategies of capital', David Harvey says, 'is a problem that in outline at least the *Manifesto* clearly articulates. How to do it for our times is an imperative issue for us to resolve.'[53]

It is essential to acknowledge 'the paramount importance of culture in consolidating imperial feeling',[54] as Edward Said put it. This does not mean that art has to be regarded as a falsely universalised conception of European high culture. Art, therefore, is neither simply the name given by Enlightenment and Romantic Europeans to the white, Western culture that was being produced for the recipients of colonial super-profits nor was it the neutral and universal heading under which the highest achievements of world culture were collected. One of the problems with saying that art is a European invention or a European category is that this statement obscures the fact that Europe, at the time when the category of art is first formulated as distinct from the arts, was in no sense isolated from the rest of the world. Any radical response to art as a world system which rejects it on the basis that it is code for Eurocentric culture merely exchanges one kind of abstraction for another: extracting Europe out of the total ensemble of colonial relations is itself a form of abstraction. Both the global art system and the critical tendencies that lodge themselves within it must be understood, therefore, not 'from the point of view of Europe as the protagonist',[55] to use Doreen Massey's phrase. This is why postcapitalism must include what Stuart Hall called a 're-narrativisation' that 'displaces the "story" of capitalist modernity from its European centering to its dispersed global "peripheries"'.[56]

Since my primary concern is to establish precisely what constitutes postcapitalism and what repercussions this has for the politics of art, I will not assume that the supposed transition to the development of 'technologies of rest' follows from the capitalist drive to develop technologies of value production. It could be argued, in fact, that the development of technologies of rest implies that the revolutionary overthrow of the capitalist mode of production has already taken place. However, I will also question the vision of technologically driven worklessness from the perspective of the history of the condemnation of work first within an aristocratic ethos of the liberal arts and later within a bourgeois ethos of leisure. In this way I will reinsert technological postcapitalism into the history of the contested meanings of mechanisation and automation as well as the contested meanings of rest. This is essential for a critical reassessment of contemporary postcapitalism since disputes about the threat and promise of technology have been features of postcapitalist thinking from the outset and therefore have a broader and deeper significance than the choice between a nostalgia for handicraft or an embrace of automation.

It is to this question that I first turn. Chapter 1 will reconsider contemporary postcapitalism in terms of a lineage that passes from the Old Peasant Dreams of Cockayne to Fully Automated Luxury Communism. My aim is to resituate the aspiration for workless abundance into a longer history of utopianism, Romantic anticapitalism, colonialism, the workers' movement, communist revolution and indigenous struggles against globalisation. I will conclude this chapter with a proposal: the litmus test of postcapitalism.

In Chapter 2, I will extend my argument, presented briefly in *Art and Value*,[57] that art is hostile to capitalism. Rather than arguing that art is economically exceptional, I will reconsider the social and discursive basis for the taboo on commerce in art, which begins as an aristocratic norm against capitalist practices in precapitalism but is transposed into a tenet of Romantic anticapitalism and a guiding principle of the critique of capitalism in modernism, the avant-garde and contemporary art. In Chapters 3 and 4, I will complexify the relationship between art, work, automation, anti-art, idleness and the critique of capitalism, being guided along the way by the proposed litmus test of postcapitalism which is the eradication of value production. In the final chapter I will reconsider the vindication of laziness and the Left Accelerationist anticipation of the end of exploitation through automation. In my conclusion I will review current debates on the commons, economies of gratuity, digital production and revisit the theory of the value extraction of Web 2.0 users and the tendency of the costs of digital production to zero, to establish a path towards a postcapitalist art through a value theory conception of postcapitalism.

1

What is Postcapitalism?

As a term, 'postcapitalism' – with or without a hyphen – is a recent addition to the political vocabulary. It has been argued, however, that it was the birth of capitalism, not its professed death, that initially prompted postcapitalist speculations. Karl Kautsky, in his classic study of Thomas More's *Utopia* (published originally in 1516), argued that utopianism emerges when the capitalist mode of production is only just finding its feet and therefore 'Socialism found a theoretical expression earlier than Capitalism'.[1]

The deep historical roots of this contemporary political trope are captured by Rob Lucas' description of the central argument of Paul Mason's 2015 book, *Postcapitalism: A Guide to Our Future*, as 'a high-tech Cockaigne of "full automation", where everything from foodstuff production to infrastructure maintenance required no labour inputs at all'.[2] Contemporary postcapitalism revives the fantasy of a fourteenth-century poem, *The Land of Cokaygne*, in which geese roast on the spit and larks smothered in stew fly down into open mouths and 'Every man may drink his fill/And needn't sweat to pay the bill.' Automation, as it is lauded in Aaron Bastani's theory of 'fully automated luxury communism' and Nick Srnicek and Alex Williams's 'Left Accelerationism', recodes the imaginary land of luxury and idleness as a feasible future.

Cockayne takes on a new significance in late nineteenth-century Europe with the rise of a revolutionary working-class movement. Cockayne is a scene of agricultural life purified of agricultural work. A. L. Morton, the great historian of utopia, dubbed the Land of Cockayne a 'poor man's heaven'[3] and Walter Benjamin called it 'the primal wish symbol'.[4] Steve Edwards correctly describes Cockayne as pastoral from below. Aristocratic idleness, which is depicted in pastoral literature and painting (noble types in peasant costume lazily tending flocks and inactively reaping the agricultural harvest), is universalised by abolishing the labour that in pastoral is merely off-stage or just completed or not-yet-begun. If, for the nobility, scenes of rest within a fictional day's work resonate with a life of idleness, for the agricultural workers themselves, scenes of idleness could only evoke a lifetime of rest if they were inserted into fictions of unlimited naturally-occurring produce.

Cockayne and its modern variants, including the Bluegrass song 'The Big Rock Candy Mountain', have been incorporated into a utopian strain of Marxism.[5] In his two-volume study, *The Principle of Hope*,[6] Ernst Bloch, the principal defender of utopian thinking within the Frankfurt School, associated Cockayne with stories of Eden and the New Jerusalem, fairy tales of dragon-slaying and the sales pitches of pedlars of age-reversing ointments, all of which are, in Bloch's analysis, poetic images of hope. But what do we hope for when we hope for idleness? Bloch recognised that hope can be expressed in reactionary as well as revolutionary forms of utopianism. Similarly, I want to say that postcapitalism straddles a spectrum of political positions, and not only with regard to its prominent advocacy of a Cockaignean condition of worklessness.

Fredric Jameson, who has done more than anyone to rekindle interest in utopian thought after the alleged decline of history, refers to the early tradition of utopian images of natural plenty as 'old peasant dreams',[7] implying that they are reactionary rather than revolutionary. William Morris, who E. P. Thompson noted 'had become one of the two or three acknowledged leaders of the Socialist movement in England' in the mid-1880s, was similarly concerned about the 'Cockney Paradise' of visions of lavish idleness. In a class-divided society of workless owners and propertyless workers, the affirmation of idleness represents a genuine aspiration of the worker. However, what troubles Jameson and Morris is how much the wish for idleness replicates the reality and values of the dominant class.

Silvia Federici is nonetheless right to raise the question of a deeper submission to the 'work ethic' within the socialist suspicion of idleness. Narrating the birth of capitalism through the seemingly impossible task of converting the poor from the dream of a lawless luxury worklessness to the ideal of hard work and honest pay,[8] it is vital to understand that the affirmation of hard work and the demand for higher wages preserves capitalism rather than contributing to its abolition. Does this mean, therefore, that it is universal idleness that holds the more radical threat to capitalism than the elimination of the unearned incomes of capitalists – that the problem with capitalism is labour, not capital?

Although Federici articulates her critique of the 'work ethic' more pointedly as a critique of the workers' movement than of capitalism, her opposition of the abolition of work and the affirmation of work can be mapped onto rival strains within the workers' movement and her preference corresponds, roughly speaking, with the revolutionary tradition as opposed to the more reformist, social democratic and trade union tradition. For the early socialists and communists, worklessness had the specific connotation of the abolition of wage labour, forced labour, wage

slavery and alienated labour. If, however, Federici means something more expansive, then the closest precedents of her argument can be found not in the workers' movement itself but the condemnation of work in nineteenth-century anarchism and aestheticism, which I will discuss in more detail later.

So, to what extent is universal idleness required by a theory of post-capitalism? Is it possible for a fully automated and workless future to remain capitalist or is universal worklessness incompatible with capitalism? What kind of idleness, if any, does postcapitalism require? In certain branches of the contemporary politics of work it is possible to come away with the idea that postcapitalism consists of the affirmation of idleness against the 'work ethic'. Bruno Gulli makes a strong case that what disappears in postcapital-ism is 'productivity, which is proper to the concept of wage labor and "job" not labor or production',[9] but I will try to refine this argument to identify the decisive factor in differentiating capitalist and postcapitalist social relations of production. Or, to put the question in a different register, if capitalist social relations put fetters[10] on the forces of production, as Marx argued, what might we mean by unfettered production?

In the period between the Levellers of seventeenth-century England and the Utopian Socialists of early-nineteenth-century France, the struggle against the enclosure of the commons, the lengthening of the working day, the technical division of labour, mechanisation and deskilling was conceived primarily through geographical forms of rupture.[11] Socialism, initially, could be imagined only as a harmoniously administered colony. Utopian Socialism, as it was expressed by Owen, Fourier and Saint-Simon, lacked historical agency and therefore represented not proletarian fantasies of postcapitalism but the dreams of capitalists, lapsed minor aristocrats and bureaucrats for harmony[12] and cooperation.[13] Louis Marin, the author of *Utopics*,[14] identifies the geographical character of Utopian Socialism. What was utopian about Utopian Socialism was its depiction of a *place* where people lived in harmony. As a long-established literary genre, utopia had always conjured up images of far-off lands in which a people untainted by 'our' modes of governance and property relations managed their affairs more humanely than European nations.

Saint-Simon, Fourier and Owen were utopians, in this reading, not simply because they believed that a better society was possible but also, and more precisely, because they believed that this new society could be fashioned by providing land to a colony of volunteers. Utopian Socialism was a colonial dream that might more accurately be named Settler Socialism, and for that reason its technique of geographical displacement needs to be highlighted above the common perception that utopianism is a plan for a society that exists only in the future. Utopianism may

legitimately claim to be postcapitalist insofar as it always hoped that its colonies would act as a prompt to social change in the societies from which they fled, but this clearly requires a second phase of social transformation that is not brought about by utopian strategies alone. Hence, Utopian Socialism was not a form of postcapitalism, strictly speaking, but an exodus from industrial capitalism through the formation and administration of colonies.

When the hope of establishing utopian colonies was supplanted by the revolutionary project of the abolition of capitalism, the spatial politics that had always been suppressed within Settler Socialism was dissolved altogether in a temporal order of supersession. The political difference between socialism and communism showed itself for the first time in the 1840s when communists 'demanded a radical reconstruction of society', as Engels later described the event. Early communists mocked Utopian Socialism for its administrative methods, charismatic leaders, religiosity and barrack lifestyle. If socialism consisted of an exodus from capitalism, communism was postcapitalism. Rejecting the utopian construction of distant colonies, communists nursed the idea of a revolutionary transformation of the existing society modelled after the French Revolution. Postcapitalism, understood as a political project of immanent social change plotted in a temporal sequence after capitalism, is an 1840s idea.

Spatial considerations reasserted themselves in speculations during Marx's lifetime about where the imminent world revolution would strike first. In David Harvey's geographical reading, Marx and Engels' *Communist Manifesto* (which was written in English and translated into French, German, Italian, Flemish and Danish), was 'Eurocentric rather than international'.[15] Initially, postcapitalism slotted into the spatial configuration set by colonial modernity. 'The organization of working-class struggle concentrates and diffuses across space in a way that mirrors the actions of capital.'[16] It was assumed that the greatest challenge to capitalism would emerge from within the most advanced nations themselves as a result of the formation of the intensity of working-class organisation attendant to industrialisation. However, given the February Revolution in Paris, the revolutionary movement of March in Prussia, Austria and neighbouring states, revolutions in Milan and Venice, the Prague Rising, Chartism in England and the success of Belgian workers in demanding reforms, the emphasis on Europe had more than chauvinism behind it in 1848. David Fernbach, the eminent Marx scholar and translator, holds that 1848 was an 'unparalleled' year for 'Marx as a revolutionary militant',[17] but before the end of the year the 'communist revolution had proved to be a much longer and harder struggle than Marx had originally anticipated'.[18] And, we can add, the geography of revolution was never as narrow afterwards.

The shift from socialism to communism was acknowledged at the time by Lorenz von Stein, who characterised it as a shift from the organisation of the workers by an enlightened elite to the self-organisation of workers. His widely-read book, *Socialism and Communism in Contemporary France*, published in 1841, presented the first comparative political assessment of leftwing political theories and became a major sourcebook for subsequent accounts of socialism and communism. For von Stein, communism was the spontaneous political expression of the working class, whereas socialism was the theoretical product of bourgeois social reformers. The early-twentieth-century opposition of reform and revolution translates von Stein's analysis of the class composition of socialism and communism into two rival political strategies.

Michael Löwy has surveyed this 'transitional stage between the "utopian socialism" of Fourier or Cabet and proletarian communism, between the appeal to Tsar Alexander I and the self-liberating workers' revolution'.[19] For Neo-Hegelian philosophers such as Bruno Bauer and Arnold Ruge, who opposed the 'crude communism' of militant artisans with 'true communism', the primary dispute was whether the masses were the enemy of 'critical thinking' or whether it was necessary 'to set the masses in motion in the direction indicated by theory'.[20] Viewed from the perspective of communist workers, though, there is a perceptible shift from philosophical to proletarian communism that itself can be divided into 'the "materialist communism" of the 1840s (Dézamy), the efforts of self-organization and self-emancipation (Chartism, Flora Tristam), and the praxis of revolutionary action by the masses (the Chartist riots, the revolt of the Silesian weavers)'.[21]

While a utopian, territorial socialism marks itself out by leaving one place and occupying another, forming itself through an act of rupture that divides the land into separate social entities, the revolutionary socialism or proletarian communism of the 1840s proceeded through the abolition of one social totality and the construction of another in the same place. Socialist colonies are their own totality, whereas communism, which grows out of the existing society, has to change the world to have any hope of establishing itself. Communism is a postcapitalist politics because it intends, ultimately, to eradicate every last trace of capitalism.

The Reinvention of Revolution

What constitutes postcapitalism, and how it might be brought about, has been radically reconceived since 2000 and then again, arguably, since 2007.[22] Contemporary postcapitalism challenges the principal criterion by which nineteenth-century postcapitalism originally differentiated

itself from reformism, utopianism and liberal democracy, namely the necessity of revolution. Postcapitalism emerged as a new style of political thought in the wake of the Zapatista insurrection, the antiglobalisation movement, anticapitalist street protests, the Arab Spring, the *indignados*, Occupy and the politics of the '99%'. Although writers such as Paul Mason, Nick Srnicek and Alex Williams have become prominent contributors on postcapitalism in the last five years, the agenda was set during the 1990s and the 2000s by writers such as John Holloway, the Midnight Notes Collective, the theorist duo Gibson–Graham and the post-Marxist political philosophers Michael Hardt and Antonio Negri.

Hardt and Negri's *Empire*, published in 2000, was a turning point in the formation of contemporary postcapitalist theory. *Empire* was a global publishing event that amplified the new agenda for political activism. One of the reasons for the appeal of this book is that its political agent – the multitude – is an open category that retains a loose affiliation with the proletariat while extending political significance to the unemployed, peasants, domestic workers, women, people of colour, the colonised, the indigenous, immigrants and LGBQT+ communities. Without using the term itself, this book became the touchstone of what soon crystallised as contemporary postcapitalism.

Hardt and Negri's political theory is rooted in the post-Marxism of 1968 which, among other things, challenged the legacy of revolutionary postcapitalism that had been established in the nineteenth century by confronting the official response of the Communist Party, the trade union movement and orthodox Marxism to the student movement, civil rights activism and feminism. The great achievement of Hardt and Negri was to interlace disparate political struggles within a coherent conception of anti-systematic resistance conjoined with creative constituent projects of world building. Hardt and Negri were not the first to articulate a post-Marxist vision of revolution, but they provided a platform from which theorists such as John Holloway, who had previously developed a new understanding of social change from indigenous struggles in Mexico but cited *Empire* repeatedly in his book, *Change the World Without Taking Power*, first published in 2002.[23]

Even before he used the term 'postcapitalism', Holloway had rejected the communist conception of revolution that had been established in the middle of the nineteenth century and had been indispensable to the Marxist movements of the twentieth century. 'The language of the [Zapatista] communiqués', he noted in a text entitled *Zapatista! Reinventing Revolution*, co-written with Eloína Paláez, 'is not that of other revolutionary movements of the twentieth century',[24] noting that the vocabulary of socialism – proletariat, socialism, vanguard – is absent from

them. 'Talk of hope, rebellion and revolution, cannot', they argue, 'simply
be a revival of the revolutionary ideals of earlier years.'[25] Since revolution
was the *sine qua non ultra* of nineteenth- and twentieth-century postcapi-
talism, the farewell to revolution might be taken as the most effective way
to block the route to postcapitalism, but instead this was the prerequisite
for contemporary postcapitalist theory.

If there was a single event that transformed the perception of revolu-
tionary social reconstruction, it was the success of the Zapatista movement
in the 1990s. What has been vital within the emergence of contemporary
postcapitalism is not only the rebooting of the critique of capitalism as
a critique of colonialism and the state, but the Zapatistas' methods of
resistance and social change. The Zapatista Army of National Liberation
(*Ejército Zapatista de Liberación Nacional*/EZLN) began as a Leninist or
Maoist revolutionary vanguard using methods derived from Che Guevara,
before reevaluating the conventions of the revolutionary tradition in order
to 'weave a network of "speaking and listening" among all individuals and
organisations interested in promoting radical political transformation'.[26]

The Midnight Notes Collective, who were also early advocates of what
we might now call postcapitalist social change, argued that the Zapatis-
tas 'gave many the hope that a new kind of anti-capitalism was in the
making, one capable of inspiring the deepest commitments in people, but
not locked into the losing game of "taking power" at the very moment
capital has created systems that would immediately render powerless such
revolutionary states'.[27] Zapatista methods, which were forged from a mix
of social democracy, Leninism, anarchism, the Che Guevarian revolution-
ary tradition and indigenous communalism, reject the authoritarianism
characteristic of Soviet and Maoist communism in favour of a politics of
'one no, many yeses'[28] to which Gustavo Esteva, the 'mestizo' historian and
philosopher of the Zapatista movement, has given a distinctive voice and
vocabulary. Zapatista methods are radically and immanently democratic
and therefore reject in particular the Leninist understanding of the transi-
tion to postcapitalism as dependent on seizing state power and dismiss the
communist conception of revolutionary social change in general.

Katherine Gibson and Julie Graham cited the Zapatistas as 'the most
frequently acknowledged wellspring of this new imaginary',[29] which their
book collects under the heading 'A Postcapitalist Politics'. Gibson–Graham,
whose own intellectual project is the 'deconstruction and queering of
Capitalism',[30] stress the 'use of playfulness and humor'[31] in place-based
struggles. 'Like other movements for whom they have become both ally
and avatar of possibility, the Zapatistas's goal is not to wrest control, but to
create autonomous zones of counterpower.'[32] Postcapitalism, in this queer
feminist reading, consists of local acts of daily resistance to capitalism

and the invention or improvisation of experimental forms of exchange and communal living. The Zapatista model for this kind of reconception of postcapitalism is based on the principle that the community organises itself collectively and therefore lives socialism or communism in the here and now rather than in the future.

As an early indicator of the conception of social change that stands as a model for contemporary postcapitalism, the Zapatista movement is neither utopian nor revolutionary in the nineteenth-century meaning of those terms. Instead, it forms a specific amalgam of the two. Capitalism is not smashed once and for all, but dislodged from specific circumstances. For instance, the Zapatistas have been developing non-state forms of community support systems 'of education, of organization, of mutual support, of justice, of how you deal with criminals etc, which are very much embedded in the community'.[33] Revolution, here, is not the practice of bringing capitalism to its knees but of building communal forms of sustaining life independent of capitalism.[34]

There is a utopian spatial dimension to contemporary postcapitalism modelled on the Zapatista movement. However, insofar as utopianism is a colonial form of exodus, indigenous postcapitalism requires a new spatial model of utopia. In particular, the Zapatista movement inverts the spatial politics of Utopian Socialism which spread into the New World along the paths of Settler Colonialism. Indigenous resistance to capitalism is not predicated on the elimination of capitalism but on being resilient to it and sustainably shielded from it. Spatially, therefore, it locates capitalism as an external condition introduced by colonial expansion. Insofar as neo-colonialism remains active for the continuation of global capitalism, the indigenous resistance to capitalism can be understood as cutting off the supply of goods, labour and surplus at their source. While the Zapatista movement is not postcapitalist in the classic sense of setting about directly to end global capitalism as the precondition for a social revolution, its transformative politics is not utopian in the sense of establishing a colony cut off from tyranny because its local forms of resistance are understood to undermine the system that it rejects.

Also, unlike colonial utopianism, the indigenous occupation of Chiapas is not the realisation of a design of a harmonious society drawn up by a social reformer. In some sense the Zapatista movement does not operate only according to a predesigned scheme because it defends an existing community, but also because 'the need to change customs and traditions'[35] is determined through open discussions, cooperative organisations and community participation in decision-making processes through consultation and consensus building. As an ongoing experiment in social organisation and communal provision, it is postcapitalist insofar as it can

be said to put into practice a postcapitalist life that is itself formed through consensual measures.

And yet, the Zapatista insurrection has also been understood as more revolutionary than the revolutionary tradition. Holloway argues, for instance, that the revolution is self-defeating if it does nothing but occupy the places of power, authority and control that have been established by the existing social order. Monty Neil, too, argues that 'those who seek anti-capitalist revolution must not wear blinkers that hinder their seeing how capitalism functions on a planetary level and how revolution against capital emerges in different forms and places'.[36] As well as the importance of recognising the validity of the specific form of peasant revolutions as opposed to proletarian ones, the example of the Zapatistas proposes 'a pluralistic, diverse and democratic approach to revolution'.[37]

Evident in these remarks, but not limited to them, the reinvention of revolution in contemporary postcapitalism (whether on the Zapatista model or guided by the post-Marxist agenda of post-1968 political theory more generally), distances itself from the revolutionary tradition generally and the twentieth-century practice of revolutionary vanguardism and state-controlled communism in particular. Before comparing contemporary postcapitalism's reinvention of revolution and the revolutionary overthrow of capitalism as conceived within early communism, I will review the arguments marshalled by contemporary postcapitalism against what has come to be called the 'traditional left'.

Contemporary Postcapitalism and the Traditional Left

Contemporary postcapitalism marks an intellectual project tangential to the Marxist, socialist and communist traditions of superseding capitalism. Taken together, and amalgamated with the trade union movement, welfare state social democracy and the reformist tendency, these political rivals have been classified at least since the early 1990s as the 'traditional left'. This critical project of reclassifying revolutionary, reformist and utopian strains of the left under the same heading is the specific product of the 1968 generation of thinkers (specifically the objection to workerism or productivism), but it can also be seen as belonging to a longer history of disputes within the left that go back to the rivalry between Marxism and anarchism in the nineteenth century and includes the Leninist critique of terrorism on the one hand and trade unionism on the other, as well as the division between Western Marxism, Classical Marxism and Soviet Marxism that Maurice Merleau-Ponty devised in 1955.

Contemporary postcapitalism, which includes a variety of prefigurative political positions, communisation theory, Left Accelerationism, a

certain strain of value theory and Italian autonomism, is characterised by its objection to revolution as the seizure of the state apparatus, but also to the workers' movement and work itself. In the words of Théorie Communiste, '"May 68" was the liquidation of all the old forms of the workers' movement. The revolution was no longer a question of the establishment of the proletariat as a ruling class which generalises its situation.'[38] Typically, contemporary postcapitalism regards the history of the workers' movement not only as a 'historical failure',[39] as Giles Dauvé and Karl Nesic put it in 2002, but as an obstacle to postcapitalism. 'Until a recent period', Théorie Communiste argue, 'there was no revolution without this "identification with work" (or else there has never been a revolutionary movement).'[40] This is because, in their argument (which is shared by contemporary postcapitalism generally), the 'revolution can only be the negation of the worker's condition',[41] not its universalisation.

Moishe Postone, who took issue primarily with Soviet-style state socialism and welfare-state socialism, defined the traditional left in 1993 as bearing a twin commitment to redistributive economics and the affirmation of work.[42] The affirmation of the worker, or 'productivism', is the chief error of the traditional left from the point of view of contemporary postcapitalism. This idea, which is pivotal to Kathi Weeks' account of the contemporary politics of anti-work, has its origin in Jean Baudrillard's 'break with Marx' in the years following 1968. When Baudrillard asserted that production 'reemerges, idealized, behind the critique of the capitalist mode of production',[43] he attempted to snare Marxism by discovering a common denominator for capitalism and its critique.[44] André Gorz, too, built his critique of work, the workers' movement and industrial capitalism around the concept of 'productivism' saying '[t]he forward march of productivism now brings the advance of barbarism and oppression'.[45]

Anti-productivism does not always adequately distinguish between the revolutionary supersession of the category of the worker and anti-worker sentiment within the capitalist global order. Gorz, for instance, argued that 'to reject work is also to reject the traditional strategy and organisational forms of the working-class movement'.[46] Often, in fact, contemporary postcapitalist theory expresses its disaffection with the working class and its organisations through the political euphemism of the radical rejection of work.

The rage against productivism can take the form not only of the affirmation of alternative figures of exploitation and oppression (women, people of colour, the colonised, the indigenous, peasants and so on) but also of the affirmation of capital itself as the true agent of postcapitalism, as Postone argues, or the affirmation of technology as the emancipator of workers from work. For the Endnotes group, the rejection of productiv-

ism takes the form of a refusal of the universalisation of the worker and the workers' movement, which they interpret narrowly as corresponding to the interests of a semi-skilled factory wage labourer (in contrast with white-collar workers, workers in the service sector, domestic workers, engineers, scientists and technicians). In their essay 'The History of Separation', Endnotes chronicles the history of the labour movement as a sequence of blunders, betrayals, catastrophes and cul-de-sacs that testify to the historical limits of class politics itself. The story does not end well.

All that remains of the workers movement, are unions that manage the slow bleed-out of stable employment; social democratic parties that implement austerity measures when conservative parties fail to do so; and communist and anarchist sects that wait (actively or passively) for their chance to rush the stage.[47]

Endnotes present their narrative of the decline of the workers' movement as if it depends entirely on an internal trait rather than as an outcome imposed on it through the violence of class struggle. The workers' movement reappears in this timeline of compromise and false promises as the result of the growth of a certain type of industry, the rise of the state and the economic function of the nation rather than as a consequence of the kind of social, cultural and political processes that E. P. Thompson reconstructs in his history of the living tradition of the working class during the period of its formation.[48]

Claiming that it is 'not obvious from the historical record that the workers' movement points in the direction of communism',[49] and also that the 'fundamental problem ... is how the struggle of a class that is a class of capitalist society can abolish that society',[50] Gilles Dauvé argues that the abolition of capitalism cannot be brought about by 'the self-affirmation of one pole within the capital–labour relation'.[51] Despite their disagreements with Dauvé, Théorie Communiste argue that 'the proletariat is nothing if it is separated from capital and that it bears no future within itself, from its own nature, other than the abolition of that by which it exists'.[52]

Recalling that postcapitalism was inaugurated in the 1840s through a distinction between two types of anticapitalism, namely socialism, which the Communist Manifesto described as 'a middle-class movement', and communism, which understood itself to be a working-class movement committed to the notion that 'the emancipation of the workers must be the act of the working class itself', the argument that the proletariat is incapable of bringing about communism cuts deeper than objections against redistribution, state socialism or the affirmation of work which apply more specifically to features of the twentieth-century workers'

movement. For this reason, I will begin my reassessment of the contemporary critique of the traditional left here. I will start with what I take to be a rather obvious political error and then proceed to outline a more satisfactory basis for assessing the viability of postcapitalism in terms of what precisely must be abolished in order for capitalism to be rendered inoperable or obsolete.

First, then, within postcapitalist theory the traditional left is a term that identifies only those specific elements of the history of the left to be jettisoned by the new politics. As such, the category of the traditional left does not represent the breadth of socialist and communist traditions but separates the workers' movement from its alliances with anticolonial, feminist, ecological and peace movements. Non-class struggles are extracted from the traditional left as if they did not belong there. The concept of the traditional left is therefore necessarily a misrepresentation of the historical movement that it names.

At the same time, the anti-workerist tendency within the concept of the traditional left is also flawed. Compare the anti-workerist political logic of the non-affirmation of one side of a systemic social division with the equivalent affirmation of women and people of colour in feminism and anti-racism. The partisan affirmation of Black Lives Matter is justified, I would argue, under the existing condition of the legacy of slavery[53] and colonialism but this does not mean that it should be extrapolated to an ahistorical and permanent affirmation of black lives and blackness that eventually stands as a blockage on the abolition of racial categories. Likewise, the affirmation of women today should not be abstracted from the conditions of struggle that require this partisanship. If there is a theoretical error in affirming the working class that has lodged itself within certain quarters of the workers' movement, this needs to be understood in conjunctural terms as historically necessary rather than in absolute terms as always already a block on the abolition of capitalism. This failure to acknowledge the historical justification of affirming the dominated pole of a specific social configuration is the most graphic manifestation of what I would call the inverted projection of political priorities in contemporary postcapitalism. I will expand on this point in my discussion of *dominant tendencies* and *counter-tendencies* in the conclusion to this book.

I now want to assess the arguments that contemporary postcapitalism advances against the revolutionary left (e.g. the seizure of the state, the viability of the workers' movement leading to communism, the association of the workers' movement with policies of redistribution, the 'productivist' emphasis on labour in Marxism and the workerist affirmation of work). Instead of entering into these disputes by taking sides with the avowed positions of contemporary postcapitalism or the attributed commitments

of the traditional left, I will ask what constitutes postcapitalism. So, for instance, rather than choosing between the emancipation through work or the emancipation from work, I will reconsider the bundle of questions around the expansion of the category of work,[54] the transformation of the labour process in post-Fordism and post-industrialism, the postcapitalist hostility to workers, anti-work technologies of rest and the workerist complicity in the wage system, among other things, by asking what specific and decisive transformations of work take place from precapitalism to capitalism and from capitalism to postcapitalism.

The Litmus Test of Postcapitalism

What constitutes postcapitalism? What, in other words, is essential to capitalism and therefore the negation of which is the precondition for postcapitalism? Various aspects or elements of capitalism have been proposed throughout the history of postcapitalist theory as decisive in the transition from capitalism to socialism or communism or anarchism. Prominent among them have been the dissolution of the state, private property, the private ownership of the means of production, class relations, exploitation, inequality, money, markets or work. Indeed, disputes over what constitutes postcapitalism are as old as postcapitalist theory itself. This catalogue of controversy has been extended since the 1990s with the number of concerns raised about the traditional left by contemporary postcapitalists and the proliferation of proposals for communisation, commoning, automation, the decoupling of work and the wage and the abolition of the working class as goals of postcapitalist politics. However, there are also signs in recent scholarship of an increased clarity in the question of what is characteristic of capitalism and what is characteristic of its supersession.

Economists, philosophers, historians and political theorists in the 1990s and 2000s have paid close attention to the logical and historical features of capitalism. There has been no miraculous consensus among theorists of capitalism, but theories of the supersession of capitalism (especially, value theory, the theory of uneven and combined development and social reproduction theory) have successfully narrowed the field. For instance, longstanding confusions of the logical elements of capitalism with its various contingent historical manifestations have begun to be disentangled from each other. Capitalism varies over time and from region to region, therefore it is not possible to describe the components of capitalism and their configuration in a timeless and invariant system. It follows that there can be no single formula for postcapitalism.

Among the accumulation of voices insisting on the multiplicity of capitalisms (and therefore the multiplicity of postcapitalisms), the historian Jairus Banaji has demonstrated that 'there are "national" "paths of transition"'[55] to capitalism that are not captured by any fixed theoretical schema of the historical stages through which society must pass. Kevin Anderson's postcolonial re-reading of Marx acknowledges that prior to 1853 'Marx held to an implicitly unilinear model of development, according to which non-Western societies would, as they were swept into the world capitalist system, soon develop similar contradictions to those of the already industrializing countries',[56] but thereafter Marx developed 'a multilinear and non-reductionist theory of history ... [and] refused to bind himself into a single model of development or revolution'.[57] Marcello Musto, in his rigorous reading of Marx's notes, confirms that Marx had restricted his analysis of the historical passage from feudalism to capitalism to the countries of Western Europe and did not 'claim that a new economic system, based on the association of producers, could come about through a fixed sequence of predefined stages'.[58]

At the same time, social reproduction theorists have underlined the importance of conceiving capitalism as a system that combines capitalist and non-capitalist activity rather than consisting exclusively of the former. Although some prominent advocates argue that social reproduction theory 'gives a fuller picture of production and reproduction than Marx's political economic theory does',[59] contemporary Marxian scholarship rejects the narrow, economistic and reductivist interpretation of Marx. Although significant disagreements persist among Marxists, it is fair to say that there are no advocates today for a theory of capitalism limited to economics or to questions of class siphoned off from all other political issues. What's more, one of the things that is shared by the varieties of current Marxisms is that they analyse productive labour as structurally connected to domestic labour, unwaged labour and the production and reproduction of society generally. Capitalism, today, is understood to be a complex lattice-work of different patterns of exploitation and oppression.

Capitalism is not a self-sufficient system but preys on forms of non-capitalist activity without which capitalism could not sustain itself. Not only has capitalism always been dependent, historically, on colonialism, slavery, child labour and the oppression of women, capitalist accumulation is impossible without countless hours of unpaid work, unprofitable production and unrecognised labour. Globally, 'capitalism develops as wage-labour in the centre and slavery in the periphery',[60] while within the colonial centres of capitalist development there is 'a growing mass of the excluded, "without" work, income, qualification, roof, abode, or recognised identity and yet, in this very margin, invariably prey to

super-exploitation'.[61] Moreover, capitalist accumulation itself depends on a portion of wage labour remaining unpaid in order for surplus value to be extracted from the surplus labour of the wage worker. And, finally, the tension between exchange and use characterises everyday life insofar as, for instance, a house is regarded as both a home and an asset, or natural resources are regarded as both elements of a fragile ecological system and sources of profit.

Progress has also been made in recent years by eliminating a bundle of misconceived theories of postcapitalism. Chief among these is the notion that postcapitalism results from the elimination of markets. While variants of this idea can be detected within contemporary postcapitalist theory (e.g. that postcapitalism equals decommodification or results from the imposition of the state over the market, requires the redistribution of the product of labour to the producers, or is enacted by the free distribution of goods), the theoretical basis for them has been eroded since the 1990s. The error of such thinking, according to value theory, is to believe that the capitalist mode of production can be overcome with a socialist mode of distribution rather than by developing a postcapitalist mode of production.

The rejection of distributional theories of postcapitalism is rooted historically in the case against the Soviet style of state-owned industry, which formally replaces private property with the collective ownership of the means of production and thereby eliminates the capitalist class, but preserves the wage system and the industrial mode of production. Postone, who has done more than any other author to build the case against the distributive theory of postcapitalism, argues, correctly in my view, that the supersession of capitalism depends upon the contradiction between value and material wealth.[62] Peter Hudis, who takes issue with Postone in other respects, agrees on this point, saying 'capitalism is defined by the production of value and surplus-value. Value is not the same as material wealth; it is wealth computed in monetary terms.'[63]

The relation between the two is vital for understanding capitalism and postcapitalism, so I will take a second to explain it in the clearest way I can. First, it is important to note that all societies produce material wealth of various kinds (for example, food, clothes, tools, houses, weapons, jewellery and music), but only capitalist society produces value. One of the obstacles to distinguishing clearly between value and material wealth is that, under capitalism, value appears primarily in the form of commodities and money, that is to say, as material wealth itself. Classical and mainstream economists conflate value with material wealth and confuse both with price by arguing that price is the expression of value as a monetary sum which represents the labour time required to produce

goods and services. Value is produced by labour and realised in exchange, but material wealth can be produced by nature and need not pass through markets or fetch any kind of price at all.

Not all labour produces value even if it always produces or maintains material wealth. Labour that produces goods which are consumed by the producers and their household (e.g. unpaid domestic labour) or their employers (e.g. domestic wage labour), or labour that is unique (e.g. artistic labour), does not produce value. This is because value is exclusive to the capitalist mode of production and only that labour from which capital obtains returns produces value. The feminist critique of Marxism in the 1970s blamed Marxist theory for failing to recognise the production of value in domestic labour while referring to the material wealth produced by domestic workers. The distinction between material wealth and value allows the politics of reproductive labour to form an alliance with Marxism in the critique of capitalism and its systemic privileging of value production over the production and maintenance of material wealth. Discrepancies between value, material wealth and price in capitalism, therefore, are not merely accidental or temporary but structural.

Even productive wage labour employed for the sole purpose of producing value does not always produce value. Labour time itself is not always converted into labour. Workers who take longer than the average amount of time to produce an item do not thereby add more value to it, but work extra hours without adding value. Value corresponds not to the actual amount of time that the individual labourer spends on a given commodity or task, only to the average socially necessary labour time required to produce it. Also, value is not measured by the labour time used to produce something at the time of production but at the time at which the item is exchanged, hence value can be lost if the average socially necessary labour time required to produce something had diminished in the interim. In this and other ways, capitalism systemically privileges value production over actual production and the production of material wealth or the commonwealth.

For Marx, from 1844 onwards, the accumulation of capital is opposed to the richness of life and 'the rich human being' in postcapitalism. A richness that is not reducible to or dominated by the production of value signifies the abolition of capitalism. This richness operates not only at the level of what is produced socially but also at the scale of the individual worker. This is one of Marx's first criticisms of political economy in his notebooks of 1844:

the *proletarian*, i.e. the man who, being without capital and rent, lives purely by labour, and by a one-sided, abstract labour, is considered by

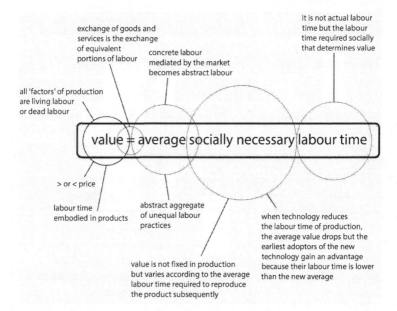

exchange of goods and
services is the exchange
of equivalent
portions of labour

it is not actual labour
time but the labour
time required socially
that determines value

concrete labour
mediated by the market
becomes abstract labour

all 'factors' of production
are living labour
or dead labour

value ≠ average socially necessary labour time

> or < price

labour time
embodied in products

abstract aggregate
of unequal labour
practices

when technology reduces
the labour time of production,
the average value drops but the
earliest adoptors of the new
technology gain an advantage
because their labour time is lower
than the new average

value is not fixed in production
but varies according to the average
labour time required to reproduce
the product subsequently

Figure 3 Value

political economy only as a *worker*. ... It does not consider him when
is not working, as a human being, but leaves such considerations to
criminal law, to doctors, to religion, to the statistical tables, to politics
and to the workhouse beadle.[64]

This is why Postone and others are wrong to rule out labour as a rev-
olutionary force against capitalism. Since, he says, 'the basis of capital is
and remains proletarian labor', Postone concludes that 'labor, then, is not
the basis of the potential negation of the capitalist social formation'.[65] The
error, here, is to reduce the worker to the function of labour for capital.
What Postone neglects is that the tension between value and material
wealth, which for him is the central contradiction of capitalism, is also
expressed in the tension between the worker *qua* worker and the worker
qua living being. Postone repeatedly conflated the abolition of abstract
labour with the political disaffirmation of labour without qualification.
This results in his theory of postcapitalism being distorted by the dread
of 'productivism'.[66] It is not in its capacity for value production that the
proletariat is assigned a revolutionary role by Marx. And for the same
reasons, the dictatorship of the proletariat that Marx envisioned was not
conceived of as a workers' state in which value production continues to
dominate society.

Insofar as contemporary postcapitalism is orchestrated primarily around the decline of the political imaginary of the factory worker, post-industrialism is as important to its historical formation as the theoretical condemnation of productivism. This shows itself in various ways. It is the claim that the white male factory worker represents humanity in general – as the universal class – that, in many cases, justifies the radical reinvention of the aim and methods of anticapitalist struggle in contemporary postcapitalism. Also, part of the sense of the transition from the socialist tradition to contemporary postcapitalism is the technological drift from mechanisation to automation. Finally, the decline of manufacturing in the colonial centres of the capitalist world system is certainly a factor in the falling away of the power of the trade unions, leftwing parliamentary parties and the variety of postcapitalisms that had lodged within those movements.

The litmus test of postcapitalism is the abolition of value production. Postcapitalism, therefore, is more thoroughgoing than the definition of postindustrialism derived from Daniel Bell.[67] What matters for postcapitalism is not the elimination of a certain kind of work (e.g. factory production) but the elimination of a certain social relation (capital–labour). This social relation presides over the production and circulation of information as much as it ever did over the mass production of commodities. Industrialisation characterises any labour process that is made more productive through the use of technology and the division of labour. Hence, instead of thinking of contemporary society as postindustrial we might observe today that industrialisation has spread from the production of mass goods to the technological acceleration of the production of information and services. Online publishing, for instance, is the industrialisation of the publication industry insofar as digital technologies have revolutionised the production and circulation of words and images. Hence, postcapitalism can be understood as postindustrial in this more far-reaching sense. If industrialisation is understood as the process whereby material production is converted into value production, then it is not confined to the narrow variety of production typified by the factory. Industrialisation is the mode of production characteristic of capitalism, and its abolition is the goal of postcapitalism.

It may seem that defining postcapitalism through the supersession of value production is somewhat formalist, technical or oversimplified. It does not provide a vivid picture of a world to come. And yet, the absence of value and the production of value means the release of all human activity from capital and capital accumulation, as well as dissolving the distinction between legitimate work and subordinate kinds of unpaid work. The production of value, understood as hostile to the production and organisation

of material wealth as a commonwealth, must be stopped in order for capitalism to be abolished. In the following chapters I will test postcapitalist theory against the goal of abolishing value production and in doing so I will add more detail to its implications for a genuinely postcapitalist political project. I will begin by considering how historical and contemporary postcapitalism have theorised art and addressing the question of what constitutes a postcapitalist art.

2

Art's Hostility to Capitalism

Contemporary postcapitalist theory has not theorised art as hostile to capitalism, nor has it included art in any significant way within its visions of postcapitalist life.[1] Art's hostility to capitalism, which has arguably been integral to historical postcapitalist theory but has lapsed in contemporary postcapitalism, I will argue in this chapter, has precapitalist roots in the aristocratic scorn of the guild, trade, manual labour and mechanical skill. Art's hostility to capitalism develops out of the elevation of painting and sculpture within the hierarchy of the liberal and mechanical arts that comes to be expressed in terms of Fine Art's hostility to handicraft. In fact, by the end of the eighteenth century the hostility to capitalism generally is conceived by prominent German thinkers through the aesthetic hostility to the mechanical and the mercenary. I want to revisit this history of anti-capitalism in art in order to reconsider current issues around art, work and postcapitalism. In doing so I will recontextualise the critique of the distinction between art and craft within feminist art history within the postcapitalist project and extend the scope for thinking about the relationship between the artist and worker.

Before turning to the weakened thematisation of art in contemporary postcapitalism, I will chart some of the milestones in the development of the argument that art and capitalism are hostile to one another. Kant and Schiller speculated in the late eighteenth century that art and the aesthetic contrast sharply with work. Although neither of them referred to capitalism, the world of work that they objected to was characterised by slave plantations[2] in the colonies and the abolition of the guild system in Western Europe, which was being replaced with the wage system of the Industrial Revolution. It is this context, not the history of ideas leading back to Aristotle's conception of activity as an end in itself, that I will emphasise in my interpretation of the contribution of German Idealism in the discourse of art's hostility to capitalism.

For Kant, the production of art is 'agreeable on its own account'.[3] It is not so much that making art is enjoyable but that art is not a disagreeable means to obtain some other agreeable reward (as paid labour is undertaken for the extraneous purpose of obtaining a wage). Kant goes further,

characterising art in terms of freedom,[4] saying 'fine art must be free in a double sense'. He explains,

> it must be free in the sense of not being a mercenary occupation and hence a kind of labor, whose magnitude can be judged, exacted, or paid for according to a determinate standard; but fine art must also be free in the sense that ... it feels satisfied and aroused ... without looking to some other purpose.[5]

Art is not a means to another end, here, and is instead a form of production that is intimately attached to the personality or subjectivity of the producer. Art, therefore, could not be contrasted more sharply from the activities of the slave or the work of the wage labourer.

Kant separated out artistic production[6] from forced labour of any kind, from the unpaid work of the slave and the paid work of the wage-earner as well as domestic work of any kind, paid or unpaid. If Kant had merely said that art is non-remunerative then he would not have succeeded, on this account, in contrasting art with the bulk of unpaid drudgery and the incessant strife of slave labour. By also being free in the sense of having no other purpose outside itself, Fine Art, in this hyperbolic account, is differentiated from every mechanical, manual and mindless chore or job 'that on its own account is disagreeable (burdensome) and that attracts us only through its effect (e.g., pay)'.[7] It is only on this condition that Kant claims that art is therefore agreeable and free. In this respect, the freedom ascribed to art by Kant is an abstraction that retains traces of the empirical world of the forced labour of slaves, workers and women, with which artistic production was contrasted.

Kant's remarks about artistic labour are amplified by Schiller, who claimed that poetry and the aesthetic occupy an ideal third place between 'on the one hand intensive and exhausting labor, on the other enervating indulgence'.[8] There is a thinly-concealed class politics to the justification for the aesthetic in Schiller's *Letters* in which the aristocrats are despised almost as much as the workers, but aesthetic activity borrows something from both workless work and vigorous contemplation. This he calls play.

Schiller's assertion that '[m]an is only completely human when he plays' is an emphatic expression of the humanising power of aesthetic labour conditional on the discrete separation of this kind of activity from both 'painful labor' and the 'repugnant spectacle of indolence'.[9] Play, therefore, is the third term in Schiller's dialectical method that reconciles the 'two contrary forces'[10] of toil and idleness. This is why play, as aesthetic labour, is the activity of freedom.[11] This is the germ from which the Situationist International cultivated their critique which, as Jasper Bernes puts it,

'targets not just the division of social labor but the division between art making and social labor'.[12]

Kant and Schiller's arguments are rather abstract and they speak about artistic labour and aesthetic activity in its ideal form as an autonomous, self-actualising activity. As such, what they say about the relationship between art and work is susceptible to the kind of critical examination of the actual economic transactions of art that has become common today. Also, their conceptions of freedom and self-realisation hover uncomfortably between, on the one hand, a universal condemnation of slavery, drudgery and waged labour, and, on the other, a privileged disgust of everything connected with slaves, servants, domestic workers, manual workers and so on. Nevertheless, both Kant and Schiller provide elements of what eventually became an emancipatory politics of anti-work.

Although art was absent from the utopian schemes of Saint-Simon, Fourier and Owen, their conceptions of harmony, attractive labour, association and cooperation were subsequently fused with the German Idealist conception of aesthetic labour by German émigrés in Paris in the 1840s such as Moses Hess. For Hess, 'one of the major achievements of communism [is] that in it the contrast between pleasure and work disappears'.[13] Since 'Every man delights in some activity', Hess explained,

and out of the multiplicity of free human inclinations or activities emerges the free, not dead and stilted, but living, ever-young organism of free human society, of free human occupations, which now ceases to be 'labour' and becomes totally identical with 'pleasure'.[14]

Aesthetic activity in this Schillerian sense was for Hess identical with free human activity but he insisted that every worker can participate in this workless work when capitalism is replaced with communism. Hess, therefore, is the first to articulate the aesthetic as a specifically anticapitalist or postcapitalist ideal in opposition to the capitalist social form of work.

Marx came closest to Hess' idea of artistic labour as free activity when he contrasted the 'life-activity' of human beings with the production of nests and dwellings by animals. 'It produces only under the dominion of immediate physical need, whilst man produces even when he is free from physical need and only truly produces in freedom therefrom.'[15] It is in this context that Marx stated, '[m]an therefore also forms things in accordance with the laws of beauty'.[16] Over ten years later, in the *Grundrisse*, Marx contrasted 'labour' with 'really free working', with just one example, that of 'composing',[17] and later still, in Volume 3 of *Capital*, Marx said, '[l]eaving aside works of art, whose consideration by their very nature is excluded

from our discussion',[18] thus exempting art from the analysis of capitalist commodity production.

When Marx said 'the worker's activity is not his spontaneous activity',[19] he negatively delineated a form of labour that his close friend Hess the previous year had identified fully with artistic activity. Consider Marx's description of 'estranged labour' in the 1844 *Manuscripts*:

> labour is *external* to the worker, i.e. it does not belong to his essential being; that in his work, therefore, he does not affirm himself but denies himself, does not feel content but unhappy, does not develop freely his physical and mental energy but mortifies his body and ruins his mind. The worker therefore only feels himself outside his work, and in his work feels outside himself. He is at home when he is not working, and when he is working he is not at home. His labour is therefore not voluntary, but coerced; it is forced labour. It is therefore not the satisfaction of a need; it is merely a *means* to satisfy needs external to it.[20]

Marx became critical of Hess' proposed merging of work and pleasure but nevertheless continued to insist that art and capitalism are at odds with one another. In *Theories of Surplus Value*, Marx stated that 'capitalist production is hostile to certain branches of spiritual production, for example, art and poetry.'[21] This striking statement draws an emphatic line between art and capitalism but it is not self-explanatory.[22] Two contrasting modalities of labour run parallel to one another in Marx's highly-charged description of alienated labour. He highlighted that kind of 'labour in which man alienates himself, [which] is a labour of self-sacrifice, of mortification'[23] by running it up against its opposite.

Marx assumes a hostile relationship between art and capitalism,[24] but it is necessary to reconstruct the historical conditions under which art and the capitalist mode of production diverge from one another. Partly this means retracing the processes of so-called primitive accumulation through which handicraft was converted into industrial production, but it also requires a re-narrativisation of the hostility to handicraft that began with the attempt to elevate painting and sculpture from the mechanical arts to the liberal arts. In order to address the question of whether art is a utopian island within capitalism or participates in the political project of postcapitalism, or both, we will need to reconsider art's simultaneous complicity with, and hostility to, capitalism.

Art's Historical Hostility to Capitalism

Art's hostility to capitalism predates capitalism and predates the modern category of art insofar as the virtues of courtly culture, in which a minority

of the most celebrated painters and sculptors operated, conspicuously included the rejection of commerce and work. When capitalist activity was a minor economic form subordinate to the feudal economy dominated by a landed nobility, anticapitalism took the form of a governing contempt for both profiteering and toil. In order to associate themselves with the liberal arts of their gentleman patrons, Renaissance painters and sculptors distanced themselves from the mechanical arts of their artisan peers that had not passed from the guild to the court. This growing antagonism between art and the commercial enterprise of handicraft is expressed at the time by an exaggerated emphasis on scholarship rather than handicraft.

Romantic anticapitalism in the nineteenth and twentieth centuries has obscured the historical emergence of art's hostility to capitalism within the academic hostility to handicraft by calling for the remodelling of art as a postcapitalist mode of production on a precapitalist and pre-industrial form of craft production. Art's historical hostility to capitalism, which is expressed variously as a commitment to being scholarly, noble, bohemian and revolutionary, first takes shape in the academy's elevation of painting and sculpture above handicraft in seventeenth-century France. It is commonly believed among art historians, however, that the artist separates from the artisan during the Renaissance. Rudolf and Margot Wittkower, for instance, summed up the achievement of the Renaissance masters as follows:

> Their approach to work is characterized by frantic activity alternating with creative pauses; their psychological make-up by agonized introspection; their temperamental endowment by a tendency to melancholy; and their social behaviour by a craving for solitude and by eccentricities of an endless variety.[25]

A small minority of individual painters and sculptors certainly emancipated themselves from the guild by entering the court and establishing academies, but the Renaissance did not do away with apprenticeships for painters and sculptors.

Nevertheless, the Renaissance took the first step on the long journey from painting and sculpture as mechanical arts to the category of art as an autonomous activity through an emphasis on the scholarly dimension of painting and sculpture. Although painters and sculptors in the fifteenth and sixteenth centuries occasionally made explicit declarations of their antipathy towards the vulgarity of working for money and so on, the precapitalist anticapitalism of the noble arts mainly took the form of a repugnance towards the mechanical trades of the guilds. Courtly painters and sculptors elevated themselves above guild artisans by recasting the

latter as a mechanical producer of goods for the market according to standardised methods and generic designs. We do not have to accept this as an accurate account of handicraft in order to acknowledge the results of this campaign. What is significant for our purposes is that the principled resistance to making works of art for money, which too closely resembled the dishonourable purpose of the usurer and merchant, was expressed through an assault on the imputed qualities of handicraft itself.[26]

Simply put, 'the principal aim of the artists in their claim to be regarded as liberal was to dissociate themselves from the craftsmen'[27] by 'explicitly demand[ing] equality with the poets'.[28] Poetry was a liberal art and, although poets were highly educated, there were no apprenticeships in poetry and therefore it appeared, at least since the first century AD, that 'great writers are born, not made',[29] even if Longinus corrected this belief by insisting that talent be refined through study, method, training, practice, good counsel and systematic precepts. What the painters and sculptors of the Renaissance aspired to was a scholarly, liberal art that could not be taught mechanically or through demonstration. In painting and sculpture, geometry, proportion, composition, perspective and design were accentuated and the mechanical and manual aspects diminished through the development of academies, a new spatial organisation of the workshop and the claim that painting and sculpture could not be taught (or not taught mechanically, at least).

It was not until the guild system was abolished by the emergent capitalist mode of production that the elevation of painting and sculpture over the mechanical arts turned into a full-blown hostility to handicraft. The academy system was formed in the seventeenth and eighteenth centuries, on a Renaissance model, as a utopian sanctuary from the guild. Although the aim of the academy and the theory of the Fine Arts was to promote painting and sculpture within the hierarchy of the arts, disassociating them with everything mechanical and aligning them as firmly as possible with the liberal arts, the separation from the guild brought with it a hostility to commerce.

The academy distinguished itself from the guild in order to ensure the distinction of members of the academy from artisans and its students from apprentices. It is this highly-charged politics of labour that is codified in the severing of the Paris Académie from commerce in 1648 and reiterated in 1777, with a statute proclaiming those who

> wish to open a shop and trade in pictures, drawings, and sculptures by other hands, sell colors, gilding, and other accessories of the arts of painting and sculpture ... shall be required to seek admission to the Community [Guild] of Painter-Sculptors.[30]

The statute prohibiting commerce was the precondition for the emergence of two important developments. First, it prompted the invention of the salons – opportunities for its members to exhibit, sell and advertise themselves to patrons and collectors – in which the commercial transactions between artists and patrons were mediated by the academy and thereby replaced the artisan shop with the form of a public exhibition. And second, the statute against commerce ultimately led to the rise of art dealers which sealed off the scholarly practitioner of the Fine Arts from direct economic transactions with customers.

This episode has been characterised by the art historian G. C. Argan as follows: 'Characteristic of the Renaissance throughout Europe was the principle that the artist's task was research rather than the mere development of traditional themes, techniques, and styles.'[31] In Argan's words, the 'artist was no longer a craftsman who learned his trade in the master's workshop by collaborating in the execution of his works but a man of culture educated by the study of history'.[32] Alberti's Euclidean theory of painting and Vasari's biographies of eminent painters, sculptors and architects were prominent examples of a collective attempt to provide an erudite *milieu* for the production and reception of works of art. The academies that sprouted up from the middle of the sixteenth century onwards added to the studious atmosphere.[33] Although historians have often been impatient in ascribing to the Renaissance attributes that were developed in the seventeenth, eighteenth and nineteenth centuries, it is true that the seeds for art's hostility to capitalism are sown at this time, as I will now explain.

Given that both paintings and sculptures continued to require skilled labour to produce, the hostility to handicraft that gained ground in the Renaissance consisted not in the technical elimination of handicraft processes in the production of works of art but in the social and spatial division of their mechanical and liberal processes. The stages of making a painting, from the preparation of the panel, the drawing of the design, the cartoon, grinding colours, manufacturing brushes, preparing grounds and underpainting, transferring the cartoon to the panel, painting the modelled shadow areas, adding colour to each area of the tonal painting, background and clothes, painting hands and faces, to the finishing touches, which Wackernagel enumerated,[34] were no different in the seventeenth century than they were in the fourteenth, but during the Renaissance these jobs were reassigned.[35]

The story of the modern differentiation of art from craft begins with the spatial reconfiguration of the workshop in the Renaissance through the demarcation of the *studiolo* and the *bottega*.[36] The *studiolo* marked the difference between design and handicraft. In retrospect, the *studiolo* appears

to signal the final distinction of the artist from the artisan, but the great masters of the Renaissance continued to occupy a place within the artisan workshop and within the dual system of guild and court. The *studiolo* represents nothing more than the attempt to elevate certain arts within the order of the mechanical and liberal arts. Subsequent historical events give the Renaissance painters and sculptors their appearance of modernity. We must turn, therefore, to the intensification of the battle between the guild and court in the seventeenth century through the development of the academies of painting and sculpture which consolidated the category of the Fine Arts.

When the Renaissance masters divided up the workshop into a *studiolo* and a *bottega*, with the assistants and apprentices occupying the space of skilled manual labour and the master occupying the space of reflection, study and design, they initiated a sequence of events that led to a distinction between the apprentice and the student of art and the official severing of the Fine Arts from commerce by the Académie Royale in Paris. There is some injustice to the accusation that the guilds were institutions driven by commerce,[37] which the academies fabricated and Kant eventually adopted in his description of art as non-mercenary.[38] Master artisans, for instance, 'used guild regulations to thwart attempts by merchants to control production directly',[39] confirming the point made by Marx that the guilds 'tried to prevent by force the transformation of the master of a trade into a capitalist, by limiting the number of labourers that could be employed by one master within a very small maximum'.[40] Indeed, Marx went so far as to say that the 'guilds zealously repelled every encroachment by the capital of merchants, the only form of free capital with which they came in contact'.[41]

The accusation that the guild painters were mercenaries belonged to a discursive assault on handicraft exemplified by the Académie Royale in Paris. Christian Michel, whose historical reconstruction of the founding and functioning of the Académie is the most thorough to date, follows the convention of art historical scholarship when he claims, '[a]dmission to the Académie became the principal means by which an artist was distinguished from a craftsman'.[42] Michel's historical reconstruction is empirically rich but lacks a clear sense of the political conjuncture in which the elevation of the Fine Arts functioned within the aristocratic regime of the mechanical and liberal arts. What the Académie did was to underscore the existing differentiation between artisan–painters (and –sculptors) and scholar–painters (and –sculptors) that had operated across the dual-system of guild and court. The transition which the Académie did so much to realise was not from craft to art but from the mechanical arts

to the Fine Arts as a partial completion of the elevation of painting and sculpture to the liberal arts.

André Félibien, who played a significant role in the academic redescription of painting as a Fine Art in seventeenth-century France, said 'we must not imagine it ought to be considered as purely mechanical, because in painting, the Hand does nothing without being conducted by the Imagination'. This principle was intended to establish divisions within the production of painting. Félibien's famous elaboration of the hierarchy of genres, delivered in a lecture at the Académie in 1669, constructs an elaborate scale of works of art which classified some painting as mechanical and some as liberal. 'That part of the representation of a natural form which consists simply of drawing lines and mixing colours is considered to be work of a mechanical kind',[43] he said, providing a baseline for the various levels of difficulty and nobility. Whatever else it signified, the hierarchy of genres that was initially developed to mark an incremental distance 'from the artisan's manual skill and physical material'[44] is counterposed to the perfection and grandeur of the academician. His rhetoric of 'superior to', 'more respect than' and 'more outstanding by far than'[45] is secured by a binary distinction between the mechanical use of the hand and the liberal use of imagination.[46]

Art does not emerge fully formed as a result of the academy system's struggle against the guild but during the subsequent transition from the academy to the art market, the artist was not required to shed hostility to commerce. Alongside the transition from artisan to worker[47] in Europe between the eighteenth and nineteenth centuries, an anomalous transition takes place in which the artisan–painter and artisan–sculptor metamorphose into the artist. Neither an artisan nor a worker, the artist belongs to neither the guild nor the academy, but operates in and around the art markets, exhibiting artworks to the public mediated by critics and curators. It is not the guild's pragmatic regulation of the market but the academy's moral condemnation of it that survives in the modern art system. Artists, in effect, internalise the academy's statute against opening a shop and therefore adhere to 'a taboo that prevents an artist–dealer relationship from being a normal business relationship'.[48]

Art splits off from craft in a protracted historical struggle for social elevation within the feudal hierarchy of the arts. This meant reconstructing the arts of design (i.e. drawing) as scholarly activities hostile to the mechanical, the manual and the marketplace. By differentiating itself from handicraft, therefore, art preserved the aristocratic project of the eradication of labour in labour itself. This is how it was possible for art to pass itself off from the outset as unteachable, immeasurable, spontaneous and free from rules. Art's hostility to capitalism, therefore, begins

as a hostility to handicraft and the guild, which was expressed negatively as the abhorrence of everything mechanical and expressed positively as the affirmation of artistic labour as liberal, free, noble and an end in itself. Art's historical hostility to handicraft specifically and work generally has operated according to the utopian logic of securing an island of work-lessness within seven seas of drudgery. Both the *studiolo* and the academy were, in effect, actual islands of labourless labour that secured rights and privileges for the recognised inhabitants. Ultimately, the struggle to ennoble the 'arts of design' metamorphosed in the middle of the seventeenth century into a hostility to commerce within the academy system of the Fine Arts. These ideas survive into the eighteenth and nineteenth centuries in various forms, including the Romantic anticapitalist affirmation of the aesthetic, the myth of the artist as an unbiddable and self-governing genius, the anti-bourgeois values of bohemianism and the anti-industrialism of the Arts and Crafts movement. If art came to be associated with the revolutionary purge of the capitalist system during the heyday of the avant-garde around the time of the Russian Revolution, this was made possible, therefore, by the fact that courtly culture was hostile to capitalism all along.

Art and the Postcapitalist Imaginary

One of the legacies of art's historical hostility to commerce in artisanal production is the prominence of art within the vision of postcapitalism in socialist and communist thought. It reappears conspicuously in the Western Marxist theories of art as a form of non-alienated labour. This theoretical strand of Marxism, expressed most forcibly by Adolfo Sánchez Vásquez, Carol Gould[49] and Phillip Kain[50] in the 1970s, and by Bruno Gulli[51] today, is usually described as having its source in Marx's *1844 Manuscripts*, but it makes its historical mark first in the 1930s. It is Marcuse who stands as the key figure in the Marxist theory of art as nonalienated labour. 'Art is a productive force qualitatively different from labor; its essentially subjective qualities assert themselves against the hard objectivity of the class struggle.'[52]

In 1932, shortly after the publication of the *1844 Manuscripts*, Marcuse published a review entitled 'New Sources on the Foundation of Historical Materialism', which argued that the 'basic concept of Marx's critique [of capitalism, was] the concept of alienated labour'[53] and therefore Marx's 'positive theory of revolution'[54] consisted of the historical supersession of alienated labour. Later Marcuse develops the critique of alienated labour into the concept of 'libidinal work'[55] which reduces the universal supersession of alienated labour to 'the moment of play, when people could

attain a freedom denied them in productive activity', as Musto puts it,[56] but initially Marcuse did not speak of nonalienated labour.

The concept of nonalienated labour is introduced in the English language, as far as I can gather, in a review of the *1844 Manuscripts* for *Partisan Review* by Max Braunschweig.[57] In capitalism, for Braunschweig, 'the man who works is a stranger to his labor; he performs it only with disgust; likewise, he is a stranger to the product of his toil, since this product belongs to another.'[58] The proletarian revolution, therefore, according to Braunschweig, 'acquires a larger meaning',[59] namely that the suppression of private property 'will suppress the alienation of work and restore to man his true personality'.[60] Braunschweig defined nonalienated labour with reference to art: 'We all recognise it in the exceptional case of the artist, that is, the creative transformation of nature is, according to Marx, the attribute of every man who works, providing he has broken loose from the fetters of "alienation".'[61] Braunschweig illustrates his theory of nonalienated labour in postcapitalism with a precapitalist example: 'Michelangelo fashions with his chisel an expression of his being.'[62]

The argument for art as nonalienated labour is fully formulated by Adolfo Sánchez Vásquez in 1965. His book, *Art and Society*, argues that 'under capitalism the artist tries to escape alienation, for alienated art is the very negation of art',[63] and his vindication of artistic labour is situated precisely on the opposition between alienated labour and the supersession of alienated labour. This argument is replicated by Hans Jauss and Peter Heath ('If there is a chance of becoming [the] immediate possessor of one's work this will be most likely to be the case with the artist as the least alienated worker'[64]), Meyer Schapiro ('Paintings and sculptures ... are the last hand-made, personal objects within our culture. Almost everything else is produced industrially, in mass, and through a high division of labor'[65]) and John Molyneux ('"art" is the product of non-alienated labour', that is to say, in his terms, 'labour that remains under the control and direction of the producer'[66]), among others.

Insofar as the artist is contrasted with the wage labourer, particularly the industrial factory worker who produces standardised goods through repetitive and mindless tasks, the theory of art as nonalienated labour comes to contrast more sharply with Fordist production than with the social relations of capitalist value production. It is essential to add here, as Owen Hatherley states: 'Fordism meant not just monotony, machinic repetition and the elimination of thought in labour, but also a physically violent regime of enforcement.'[67] In other words, art's hostility to industry was also a rejection of all of the alien powers used against workers. In my argument, though, the stress falls on capitalism not industrialism. It is one thing to describe industrial production in a way that corresponds to

the concept of alienated labour, but quite another to stress the need to supersede the production of value rather than the more limited abolition of the labour process of industrial production.

I want to suggest, therefore, that the hostility between art and capitalism must be resituated within the legacy of the academy critique of the guild and so the affinity between art and postcapitalism must be repositioned. My argument is not that the taboo against commerce in art should be abandoned insofar as it conceals a reactionary and nostalgic aristocratic ethos. The aristocratic heritage of the artist's hostility to capitalism is no reason to question the veracity of art's antagonistic relationship to the capitalist mode of production but rather explains it historically. Acknowledging the twisted history of art's normatively driven economic exceptionalism, however, demands a more precise formulation of art's complex weaving together of precapitalist, capitalist and postcapitalist practices.

3

Artists and the Politics of Work

Contemporary postcapitalism is associated with at least four transformations of the politics of work. First, the contemporary politics of work typically rejects class struggle as the primary lens for the analysis of work. Second, it contests the designation of what counts as work, which the workers' movement shared with capitalists.[1] Third, it scraps the romantic anticapitalist goal of humane work for the complete abolition of work. And fourth, it extends the agency of exploitation to a spectrum of agents in a pragmatic politics of the multiple forms of power operating through racial, gender and other 'dimensions of difference' in a micropolitics of work.

What the contemporary micropolitics of work in art has achieved, more than anything else, I would argue, is the broadening of the political topography of artistic labour from the activities of the artist to the work of assistants, fabricators, technicians, administrators, museum staff, university workers and the whole workforce that maintains the infrastructure of the artworld. When we speak of artistic labour today we must recognise that the artist is not the lone producer that the 'romance of the studio'[2] implied.

The political imaginary of the artist as an exemplar of nonalienated labour hostile to capitalism therefore comes to be replaced with an image of the artist as a privileged exploiter of the 'invisible hands'[3] of assistants and fabricators essential to the global economy of contemporary art. The artist comes to appear as the producer of artworks and as the author[4] of them thanks to a network of uncredited producers and support-workers. In one argument, a wage for artists and payment for internships in art institutions would allow more working-class access to working in art. 'Students from traditional working class and/or migrant backgrounds ... cannot afford to work for free or must subsidise internships with other forms of low-wage exploitation.'[5] It is not always clear, however, whether such proposals are designed specifically to level the playing field or benefit the majority of middle-class members of the art community. It would possibly damage the campaign if the statistically more likely recipients of wages and fees in art were foregrounded in the argument. These campaigns, we

can say, have not adequately distinguished between (1) measures designed to increase access to careers in art and (2) the middle-class professionalisation implied in the demand for artists to be paid for their services to art institutions.

The demand for a wage in art is partly due to the redescription of art production as 'work'. This conflation of unpaid labour with wage labour is usually achieved by substituting more specific terms with the more generic word 'work'. Also, the case for payment highlights two other factors. First, that artists cannot earn a living without such payments and, second, that artists are exploited by the art economy and therefore are due part of the revenue that they contribute to producing (for instance, W.A.G.E. claims to serve 'artists who need to earn money in order to survive, and who refuse to support a multi-billion dollar industry through their exploitation by it'[6]). I want to try to shed light on the politics of work in the demand for an income for artists by revisiting the Marxist analysis of productive, unproductive and useful labour.

The assertion that artists are workers and the related exposé of the unheralded producers of art and workers in art's institutions rejects the Romantic anticapitalist argument that art is incompatible with the capitalist category of work. Hence, artist and writer Bojana Kunst argues that the performance artist 'becomes the ideal virtuoso worker of contemporary capitalism',[7] Anton Vidokle asks 'what is work for an artist within our post-Fordist blur between life and work, freedom and alienation?'[8] and Steven Shaviro asserts 'everything in life must now be seen as a kind of labor: we are still working, even when we consume, and even when we are asleep'.[9] The politics of art's hostility to capitalism has been replaced with diverse struggles that assume art's complicity with capitalism. My task in this chapter is to reconcile the two.

The Politics of Work in Art

It is almost impossible to overstate the impact of feminism on the transformation of the politics of work. Feminism challenged many of the theoretical and social assumptions on which large sections of the workers' movement had been operating. The reorientation of the politics of work around issues of domestic labour rather than wage labour and social reproduction rather than commodity production swelled the category of work, recoded the wage as a gendered legitimation of male-dominated industry, and disputed the implied affirmation of paid work marked by the theoretical distinction between productive and unproductive labour. At the same time, for thinkers and activists informed by the feminist politics of work, art and aesthetic activity lost a significant portion of the political promise

that they held within the socialist critique of industrialisation and the struggle against mechanisation, the assembly line and deskilling within the factory.

Linda Nochlin, Roszika Parker and Griselda Pollock, all brilliant scholars and prominent figures in a generation of feminist art historians in the 1970s and 1980s, made substantial contributions to the revision of thinking on labour in art by foregrounding questions of gender. Exemplary in this challenge to the masculinist discourses of labour is Linda Nochlin's studies of the representation of work and the work of representation, such as her essay 'Morisot's Wet Nurse'. Nochlin reconstructed the painted scene as only half of an encounter in which 'two working women confront each other'[10] and two types of work resonate with the politics of paid and unpaid housework and the activity of the painting as work. Nochlin highlighted the social construction of the opposition of motherhood and waged labour (evident in paintings of mothers and children by other – male – impressionists), and the gendering of both work and the act of painting. Nochlin's feminist analysis of *The Wet Nurse and Julie* also pointed out that the painting enacts an encounter between a 'poor country woman'[11] and a member of the Parisian 'upper bourgeoisie',[12] and therefore inscribes into the artist's gaze contrasting relations to work and the wage between two women belonging to the same household.

Helen Molesworth has noted the seditious presence of 'motherhood, cleaning, cooking, and entertaining' in feminist art in the 1970s and 1980s which interlaced the politics of maintenance work with 'the most "advanced" artistic practices of the day – Minimalism, Performance, and Conceptual art'.[13] Julia Bryan-Wilson, whose book *Art Workers: Radical Practice in the Vietnam War Era* is a major contribution to the study of the politics of art and work, has contextualised the association of the artist with the worker in the 1970s by referring to an intellectual *milieu* charged by the feminist critique of the concept of work, humanist Marxist theories of labour as human self-realising activity and the testimonies of men and women in the 1970s who were struggling to establish a career and earn an income in the artworld.

Since the 1970s, in Bryan-Wilson's narrative, instead of artists struggling to differentiate themselves from the wage labourer in a gesture of hostility to capitalism, artists increasingly labelled themselves as workers. She argues that in New York in the 1970s 'the notion of the art worker offered artists an up-to-date politically relevant model of identity',[14] including 'basic questions about their working conditions',[15] rights over the use and resale of their products, and demands for 'greater racial and gender diversity within museums'.[16] The income for artist's campaigns reject the Enlightenment and Romantic notion that the artist is a non-mercenary

producer who works out of an inner compulsion or overriding commit-
ment to art, or, in the words of the Precarious Workers Brigade (PWB),
'the principle of art as a higher calling' attached to the idea of the genius.
'Through this idea of vocation', PWB explain, 'creative labour becomes
something intrinsic to the artist's subjectivity and therefore not definable
within the terms of wage relations.'[17]

Bryan-Wilson argues that artists of the 1960s and 1970s 'looked back
to the 1930s as the moment of the most ardent championing of art and/
as labor in the U.S context',[18] particularly the Works Progress Administra-
tion (WPA) which funded artists to produce murals, paintings, sculpture,
posters, photography and other things. Since the same fund employed
millions of workers to carry out public works projects, the artist appeared
to be closer to the worker than ever before. When, in the 1970s, the Art
Workers' Coalition (AWC) was set up in New York, it drew on the precedent
of artists being paid a 'wage' within the WPA as part of the politicisation of
the artist as worker. Referring to the example of Francis O'Connor's book,
Federal Support for the Visual Arts,[19] which endorsed the employment of
artists within the WPA, Bryan-Wilson notes that this book 'circulated in
the AWC'[20] and that O'Connor made recommendations to the National
Endowment for the Arts to revive a similar arrangement. Bryan-Wilson
reports that 'some AWC artists supported a wage system for artists'.[21]

It was in this context that Lucy Lippard, the great feminist art critic,
claimed in 1976 to be a 'proletarian of the Institute'[22] and the polemi-
cist Germaine Greer claimed that 'Women are the true proletariat.'[23]
The political force of such statements is undeniable, and yet, in pushing
back against the male-dominated workers' movement of the 1970s, they
suppress real class differences.[24] Nevertheless, these polemical statements
belong to an important emancipatory project that reset the conditions
under which the politics of labour intersected with the politics of art.

To interpret the myth of the artist only through the lens of the liberation
of the artist from the guild by sculptors and painters demonstrating their
scholarship is unsatisfactory insofar as these events are inscribed with a
conception of the human that is charged with gendered – and racial[25]–
norms. The myth of the artist as an unfathomable, driven exemplar of
independence and talent emerges in the fifteenth and sixteenth centuries
with anecdotes of natural talent, such as Giotto drawing a sheep by
scratching a sharp stone on a flat rock near Florence when he is discovered
by Cimabue, as Vasari tells the story, or accounts of Leonardo working on
The Last Supper from dawn 'til dusk without eating.[26]

On the face of it this opens up a point of contention between historical
postcapitalism, which tended to valorise the artist as an exemplary type
of producer, and feminism, which recasts this narrative of emancipation

as another episode in the chronicle of relentless subjugation. I want to propose a way out of this impasse. The acknowledgement that 'the very concept of genius, of greatness, was itself gendered masculine',[27] must be interwoven with the history of the emergence of the hostility of art to handicraft which subsequently formed the bedrock of art's hostility to capitalism.

For contemporary postcapitalist theory, following the feminist critique of the myth of the artist, art's elevation above work is a fraudulent idea that misrepresents the multiple ways in which artists are complicit with capitalism. Theoretically, this debunking of the artist is simultaneously a critique of a prominent strain of postcapitalist thinking on art and aesthetic labour from Moses Hess, John Ruskin and William Morris in the nineteenth century to Marcuse and the existential Marxists of the twentieth century, as well as their adherents today.

The ghosts of John Ruskin and William Morris still haunt the politics of labour. Although they belong to a wider circle and a deeper heritage of political thinking about labour, it is a popular version of their formulation of the affirmation of handicraft that is still the governing conception of postcapitalist work associated with the traditional left.[28] Ruskin set the tone for the Arts and Crafts movement, saying: 'we manufacture everything ... but men',[29] or rather: 'we blanch cotton, and strengthen steel, and refine sugar, and shape pottery; but to brighten, to strengthen, to refine, or to form a single living spirit, never enters into our estimate of advantages.'[30] In response, he asked, 'what kinds of labour are good for men, raising them, and making them happy?'[31] His answer to this question, though partially given through the advocacy of specific qualities (variation, invention, unity of design and execution, and so on), is provided more generally through the concept of 'Vital Beauty', which refers to 'the joyful and right exertion of perfect life in man'. That is to say, labour is an indispensable component of human happiness.

Morris declared that his conception of pleasure in work derived from Ruskin's writing on the subject,[32] and E. P. Thompson was right to stress that 'it was from John Ruskin that Morris gained a new outlook on the role of creative satisfaction in labour'.[33] However, when Morris came to elaborate his proposals for work in *Useful Work Versus Useless Toil*, in 1884,[34] he did so through Fourier's theory of attractive work: namely, the introduction of variety, the short duration of labour, pleasant surroundings, and the day's work divided between agriculture, handicraft and science. Where Morris diverges from Fourier is not in his conception of how the conditions of work can make it more pleasant, but in his argument that the 'first step towards making labour more attractive is to get the means of making

labour fruitful, the Capital, including the land, machinery, factories, etc., into the hands of the community.'[35]

These ideas became prominent once again in the 1930s, in the writings of Marcuse's generation, and also in the 1970s, when writers such as Patrick Brantlinger argued that William Morris' *News From Nowhere* implies the joint supersession of the categories of art and work, saying

> the distinction between 'artist' and 'artisan' or worker has been abolished: labor has become 'attractive labor', and everyone is an artist. The products which the characters make, the tasks which they perform, and the communal relations between them are all based on Morris' interpretation of what nonalienated labor would be like.[36]

So, he continues, 'under the most favorable socialist conditions "art" might cease to exist altogether. "Popular art" would be indistinguishable from common labor; there would be no need for systems of substitute gratifications because life itself would be gratifying.'[37]

André Gorz's two books, *Farewell to the Working Class* and *Paths to Paradise: On the Liberation from Work*, represent a sea change in the politics of work. Rather than transforming the workplace or installing a postcapitalist mode of production, the post-industrial proletariat, according to Gorz, should 'appropriate areas of autonomy outside of, and in opposition to, the logic of society, so as to allow the unobstructed realisation of individual development alongside and over that machine-like structure'.[38] His concept of the liberation from work is relative rather than absolute. He calls for a '[r]eduction of work time and simultaneous expansion of the sphere of autonomous activity and non-market relations'.[39]

Gorz carefully folds his antipathy to the workers' movement into a narrative of the emancipation of workers from work. 'For workers, it is no longer a question of freeing themselves *within* work, putting themselves in control of work, or seizing power within the framework of their work. The point now is to free oneself *from* work by rejecting its nature, content, necessity and modalities.'[40] And yet, his conception of postcapitalism turns on the opposition of the production of material wealth and the production of value. 'Only with capitalism does work, or the heteronomous production of exchange-values, become a full-time activity and the self-supply of goods and services (by the family or community) become a marginal and subordinate activity', he argues, therefore, '[a]n inversion of this relationship will signify the end of political economy and the advent of "post-industrial socialism" or communism.'[41]

In the meantime, however, Gorz counsels workers to reduce their working hours, even if this means a reduction in pay, because in this with-

drawal from work can be detected an historical tendency with radical implications, not least because this implies both a 'disaffection from work'[42] and an abandonment of the traditional trade union demand for higher wages. This is why the 'preference for time over money', he argues, 'represents the most important cultural transformation of the current period'.[43]

Today the politics of work carries the opposition between work and life in two directions. On the one hand, Sarah Brouillette and others reveal that academics become more susceptible to exploitation precisely insofar as they do what they love: 'our faith that our work offers non-material rewards, and is more integral to our identity than a "regular" job would be, makes us ideal employees when the goal of management is to extract our labor's maximum value at minimum cost.'[44] On the other hand, Åke Sandberg and others advocate the Swedish experiment in creating humane work in Volvo's Uddevalla plant which was 'outstanding in its human-centredness and the quality of work with groups building whole cars based on theories of holistic human learning'.[45]

Peter Frase, in his compact book *Four Futures: Life After Capitalism*, extrapolates the effects of automation and the implementation of a universal basic income to decommodify labour to the extent that 'work wouldn't be work at all any more, it would be what we actually choose to do with our free time'.[46] Whereas Miya Tokumitsu demands 'drastically reduced working hours' and the 'freedom made possible by working less',[47] but rejects all traces of the early socialist demand for the transformation of work as a pleasurable activity by re-reading the slogan 'do what you love' through the feminist critique of domestic work in which women were expected to work without pay because they performed childcare and housework out of love.

Tokumitsu overturns the affirmation of nonalienated labour by associating it with the hegemonic norm that affirms domestic labour as the self-realisation of the feminised members of a family. This reconfirms a critical tradition in which, as Eva Kaluzynska noted in 1980, when the housewife is asked whether she works she 'is supposed to answer "no"'.[48] In this context, Tokumitsu wants work to be called work and for pleasure to be distinct from work. By shifting the emphasis from the workplace to the home, therefore, the suspicion that behind every enjoyable day's work someone else is benefitting, blocks the project of abolishing the distinction between work and rest to which the politics of artistic labour has historically been attached.

Andrew Ross's analysis of high-tech startups of Manhattan in the 1990s does not reject all hope in humane work and the humane workplace but focuses on its hidden costs. As well as charting the passage from digital

handicraft to digital drudgery, Ross acknowledges the serious shortfall between the politics of the humane workplace and the 'just workplace (with protection for all, democratic control over the enterprise, and assurances of security beyond the job)'.[49] This narrative of the progressive decline of creative work and intellectual handicraft in the just workplace into the unskilled protocols of the immaterial labourer repeats the Marxist account of the conversion of handicrafts into factory work and reverses the anticipated development of postcapitalist work by Ruskin and Morris.

The old socialist idea that work would merge with pleasure in a post-capitalist reorganisation of labour in which the worker recognises herself in her product has succumbed to the image of complete recuperation. Bifo and Virno, who are exemplars of contemporary post-Fordist theories of work, describe current patterns of work as 'the progressive mentalization of working processes and the consequent enslavement of the soul',[50] in which the individual 'sees her or his own ability to relate to the "presence of others", or her or his possession of language, reduced to waged labor'.[51] For Bifo, therefore, '[p]utting the soul to work: this is the new form of alienation',[52] and for Virno, the appearance of the worker's personality at work is 'a parody of self-realization'.[53] So, whereas for the nineteenth-century workers' movement it was the exclusion of the workers' personality from work that characterised alienated labour, the micropolitics of work today proposes that cognitive workers are alienated by bringing their personality to the workplace.[54]

Similarly, Luc Boltanski and Eve Chiapello argue that the new spirit of capitalism forged in the literature on management between the 1960s and 1990s adopted the rhetorics of creativity, flexibility, improvisation and innovation. Boltanski and Chiapello identify this revolution as a 'transition from control to self-control'[55] in which the manager becomes a team leader or coach who encourages workers to find 'personal fulfilment'[56] through work. In one way of reading it, they argue that the dreams of socialists like Ruskin and Morris have come true in dystopian form. The old hostility between art and capitalism (and between artistic activity and alienated labour) no longer holds because 'the new spirit of capitalism incorporated much of the artistic critique that flourished at the end of the 1960s', which has led to the 'economically rather marginal domain of cultural enterprises' not only being brought into commodity production but also becoming the model for a new kind of business in which managers develop 'skills approximate to those of the artist', using 'intuition' to sniff out opportunities that correspond to 'their own desires'.[57]

Pascal Gielen arrives at the same conclusion from the opposite direction, so to speak, saying many artists 'can probably identify to a large extent with the ... immaterial worker'.[58] He explains:

For the artist too, working hours are not neatly nine-to-five, and constant demands are made on forthcoming good ideas, on potential. And since the undermining of the craft side of creativity – at least in the contemporary visual arts – the artist has come to depend on communication, linguistic virtuosity and the performance of his ideas.[59]

He says 'the modern art world has been a social laboratory for immaterial labour, and thus for Post-Fordism'.[60] The alignment of post-Fordist labour patterns with long-established patterns of artistic production is evident. We can even agree that art has become 'a laboratory for developing new forms of capital accumulation', as Stevphen Shukaitis claims,[61] and that art may be analogous with contemporary work patterns. It is also true that current management techniques have replicated certain features of artistic practice within the production of value. However, it does not follow that artistic labour itself is a form of value production or that value extraction actually takes place in the production and circulation of art.

This tendency within the politics of work in art since the 1990s culminates in activism around the precarity of cultural workers. So, this micropolitics of artistic labour swaps the discrepancy between wage labour and artistic activity for a diverse range of direct, pragmatic activisms over wages, value extraction, rights and recognition. The central opposition of the politics of work today is expressed clearly by Kathi Weeks as follows.

Whatever else it may be, the vision of postcapitalism privileged in the autonomist tradition, is not a vision of the work society perfected, with its labors rationally organized, equally required, and justly distributed. Rather, it is a vision of the work society overcome.[62]

In its broadest sense, the refusal of work is a political slogan that has the potential to unite communists, anarchists, socialists, libertarians, bohemians and aesthetes insofar as it promises 'to reduce the time spent at work, thereby offering the possibility to pursue opportunities for pleasure and creativity that are outside the economic realm of production'.[63]

If we can say that the political opposition to the Industrial Revolution sparked the utopian demand for 'attractive labour' and the realisation of the personality of the worker in labour and its products, then we can equally say that the political opposition to the alleged post-Fordist incorporation of the worker's personality into wage labour has resulted in the rejection of the aestheticisation of work and the political project of its abolition. We can narrate a passage from the socialist affirmation of attractive labour in the nineteenth century to the advent of the anti-work movement in the late twentieth and early twenty-first centuries or we can place them in

parallel as constantly opposed to one another or even as different inter-
twined strands of the same critical history. In the present circumstances
they appear as rival arguments within a broad politics of work.

Marxism After Feminism

Arguably, the feminist politics of work has been a more successful tool
for activists in recent years than the Marxist theory of labour. It has led
to the resistance to 'the marginalization and underestimation of unwaged
forms of reproductive labor'[64] which has contributed to the acquisition of
symbolic and material recognition to a wide range of unheralded workers.
Hardt and Negri's influential concept of 'affective labour', too, 'is better
understood by beginning from what feminist analyses of "women's work"
have called "labor in the bodily mode"'.[65] A vast array of unwaged labour,
the work of social reproduction, teaching, sex work and work in the
creative industries, has become politicised in new and powerful ways as a
result of the feminist remapping of work.

I want to revisit this transformation of the politics of work from the
specific perspective of postcapitalism. It is important for this re-reading
to contextualise the feminist politics of work as belonging to a general
post-1968 critique of the workers' movement. The legacy of this critique
has been clarified recently by Chantal Mouffe, who recalls that in the
1970s and 1980s 'the challenge for left-wing politics was to recognize
the demands of the "new movements"' but 'it could be argued that the
situation today is the opposite of the one we criticized thirty years ago,
and that it is "working-class" demands that are now neglected'.[66] Among
other things, I think it is fair to say, this critique has diluted attentiveness
to questions of value production. My purpose is not to reassert the class
politics of labour but to build a bridge between the two traditions without
blocking off the route to postcapitalism.

Bridges have been built between feminism and Marxism before, of
course. I want to single out one attempt in particular that is exemplary
in the field. Gibson–Graham's affirmation of noncapitalism within capi-
talism overlaps with my understanding of art's economic exceptionalism
but describes it in such a way that it draws the Marxist analysis of noncap-
italist modes of production more graphically into the feminist discourses
of social reproduction. For Gibson–Graham, capitalist society is a 'diverse
economy'[67] in which the capitalist proportion of capitalism is just a drop in
the ocean of 'a much messier informal economy – a mix of "not for market"
and "not monetized" activity, including gifts and volunteer work, barter,
non-capitalist cooperatives, self-employment and children's labour'[68]
which problematises orthodox knowledges of capitalism[69] to clear a space

for 'deliberate attempts to develop noncapitalist economic practices and institutions'.[70]

Gibson–Graham's postcapitalism overlaps with Chto Delat's assertion that 'a world without the dominion of profit and exploitation not only can be created but always already exists in the micropolitics and microeconomics of human relationships and creative labour.'[71] But what precisely constitutes capitalist and noncapitalist pursuits? Gibson–Graham define capitalist activity as that which is subject to surplus extraction. According to this criterion, 'the personal investment manager who is a self-employed entrepreneur and appropriates only her own surplus labor'[72] is therefore noncapitalist. Although I will want to propose a different pivot point, I want to state first that it is more important to make distinctions of this kind (between work that directly produces a surplus for others and work that does not), than it is to belittle the range of noncapitalist activity within capitalism as 'commonist playgrounds'.[73]

For most purposes, there is little to choose between an emphasis on surplus labour and an emphasis on value production as distinct from the production of material wealth. Both define capitalist activity through value theory on a case-by-case basis rather than once and for all in a social organism defined by commodification, reification, market exchange, money, speculation, real subsumption or some such. Slight as it is, the difference is nonetheless significant. Politically, I would say, the difference is that the focus on surplus labour calls for the contestation of techniques of surplus extraction, whereas my emphasis on the distinction between value and material wealth calls for the supersession of the production of surplus value altogether.

I want to test the relative merits of these two approaches through the example of the campaign for an artist's wage. Based jointly on the Wages for Housework movement and the feminist critique of the myth of the artist, the call for an artist's wage presumes the assertion that the artist is a worker according to the expanded category of work. For example, consider the event at Gallery Tegen2 in Stockholm in September 2018 by a group of artists who set up a headquarters to demand a wage for artists in Sweden. Like the prominent campaigns by Working Artists in the Greater Economy (W.A.G.E.) in the USA and the Precarious Workers Brigade in the UK, the demand for wages is a form of politicisation in which, as Marina Vishmidt puts it, 'a social relation accepted as natural and exceptional to the laws of the market exchange is re-defined as labour ... and thus a matter of social concern and contestation.'[74]

To demand a wage is always a political act. It resembles in some respects the 'antagonistic struggle between capitalist and worker'[75] that determines wages, which is the first observation that Marx makes about capitalism

in his *1844 Manuscripts*. As such, the campaign for an artist's wage is a case study for the inquiry into art and postcapitalism. However, while it is important to recognise the political worth of such a project, to what extent is the demand for wages and the reclassification of a so-called 'labour of love'[76] as 'work' an attempt, in Gibson–Graham's terms, either to foster noncapitalist practices within 'a space of economic diversity' or to reclaim surplus labour? Or, in my own terms, in what sense can it be said that the artist's wage is a specifically postcapitalist measure that asserts the production of material wealth over and above the production of value?

Without assuming that the welfare state is the cure for capitalism, it must be conceded that the demand for an artist's wage has re-emerged in recent years at the same time that collective measures such as free education, rent controls and child support have been abolished or cut back by neoliberal policies – leaving individuals to look for individual solutions. Artists and artworkers seek wages at precisely the point at which this has become the only legitimate form for individuals to receive income, according to neoliberal doctrine. Also, to call what you do 'work' rather than something that has a benefit to society or because it is self-realising, as previous generations did, means that even if the economics of the artist's wage are postcapitalist, the normative values underlying it are certainly compatible with the neoliberal doctrine of 'capitalist realism'.[77] Is the demand for wages a demand for the extension of capitalism into noncapitalist forms of life, or does it erode capitalism by extending noncapitalist forms of life? If we think of artists as statistically middle class, white and well educated, then the artist's wage, in Gibson–Graham's terms, might be described as an attempt to grab the surplus labour of others that has been extracted from them in taxes.

What remains indeterminate, in my reading of the campaigns, is whether the artist's wage is best interpreted as a step towards the further incorporation of art into capitalism, or makes a demand that is designed specifically to negate the relationship between wage labour and value production without which capitalism would grind to a halt. I am not asking for the campaign for the fair payment of artists and other workers in art and education to be judged on whether or not it brings down capitalism, but to locate it politically.

In another version of the argument for the artist as a worker, Bryan-Wilson turns to a Marcusean branch of Western Marxist philosophy to establish the commensurability of the artistic activity and wage labour. She singles out a book by Adolfo Sánchez Vásquez published in 1973. A passage that she quotes from Vásquez ends with the exclamation 'there is no radical opposition between art and work'. Bryan-Wilson reports that '[a]rt workers took this sentiment as a rallying point'.[78] Correctly

linking Vásquez's writing to Marcuse's postcapitalist hope that work could 'become gratifying without losing its *work* content', Bryan-Wilson asserts that '[o]ne of the legacies of Marx's thought is his assertion that art is a mode of skilled production – a form of work'.[79] This is true and important and there is justification for Bryan-Wilson to construct this particular argument in the context of her book, but a different argument can also be made that also draws on Marx's thought which differentiates artistic labour from the capitalist mode of production. Vásquez adds this second argument to the one previously cited.

While it is true that Vásquez argues vigorously that Marxists must overcome 'the idea that art and work are antagonistic activities, an idea which resulted either from the failure to see the creative character of human work ... therefore excluding it from the sphere of freedom, or from reducing work to a merely economic category',[80] this is only the first stage of his argument. Although, for him, art and work share the same root in 'the creative capacity of man',[81] artistic labour, he argues, is superior to wage labour insofar as the former represents the 'objectification' of the producer whereas the latter represents the 'alienation' of the worker. Hence: 'Capitalist material production opposes itself to the creative essence of man; it is thus incompatible with free, creative labor and can only recognize work as a forced and uncreative activity, that is, as *alienated* labor in its concrete form of wage labor.'[82] At this stage of the argument he contradicts his previous statement, arguing that, '[f]rom this point of view, art and labor are not identical'.[83]

It is possible, in both Gibson–Graham's argument and my own, to retain Vásquez's argument about the mutual hostility of art and capitalism without endorsing the claim that art is a paradigm of nonalienated labour.[84] Artistic production is not capitalist commodity production. I take it that the demand for artists to obtain a greater proportion of the profits of sales on the secondary market and to receive fees for museum exhibitions and the publishing of their images in books and magazines is consonant with Gibson–Graham's politics of surplus extraction.

For my reading of value theory, however, artworks have no value. Marx is the first to make this point, saying:

the price of things which have in themselves no value, i.e., are not the product of labour, such as land, or which at least cannot be reproduced by labour, such as antiques and works of art by certain masters, etc., may be determined by many fortuitous combinations. In order to sell a thing, nothing more is required than its capacity to be monopolized and alienated.[85]

Artworks have no value because they are not produced by productive labour. Let me explain.

Marx took the distinction between 'productive' and 'unproductive' labour from Adam Smith, who believed that only the production of commodities is productive and therefore all kinds of service labour are unproductive, but correctly distinguished between things paid for out of capital and things funded from revenue (the difference being that capital is advanced with the expectation of an augmented return – i.e. profit – whereas revenue is expenditure without return). All wage labour is either productive or unproductive and this is determined by whether the wage comes from capital or revenue. As such, it is possible for unproductive labour to be paid (and consumed) by workers rather than capitalists, but all productive labour is funded by capital and its agents.

Productive labour produces value, whereas unproductive labour does not, even if it produces or maintains material wealth. All this means is that, if a capitalist employer or firm draws profit from work then that work is productive. Michael Heinrich states categorically, 'whether a specific type of labor expenditure is productive labor in the capitalist sense does not depend upon the concrete character of the labor, but upon the concrete economic circumstances in which it occurs'. It follows that unwaged labour is neither productive nor unproductive. Marx is very clear about this, saying:

> within capitalist production there are always certain parts of the productive process that are carried out in a way typical of earlier modes of production, in which the relations of capital and wage-labour did not yet exist and where in consequence the capitalist concepts of productive and unproductive labour are quite inapplicable.[86]

There is a misconception that the difference between productive and unproductive labour is cancelled as soon as we acknowledge that reproductive labour produces various use-values that are essential to

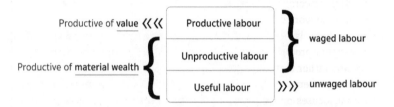

Figure 4 Types of labour

life. Heinrich explains the error of this misconception by distinguishing between different social forms of making a pizza.

> If I bake a pizza in order to eat it myself or offer it to my friends, then I have created a use value, but not a commodity (the pizza isn't sold), and for that reason I have also not produced any value or surplus value. But if I am hired as a cook in a capitalist restaurant, and if I bake a pizza that is eaten by paying guests, then I have not only produced value but also surplus value, and in this respect my labor was 'productive'.[87]

The unproductive labourer is not another name for the unwaged labourer. All unproductive labour is waged. Heinrich explains:

> if I'm a cook in a capitalist restaurant, my labor is productive. But now let's assume the owner of the restaurant is able to afford a private cook and I switch from working in the restaurant to working in the household of the restaurant owner. I remain a wage-laborer, but I no longer produce any commodities, only use values: the pizza that I prepare in the household kitchen of the restaurant owner is not sold, but is consumed by the restaurant owner and his friends. I have produced neither value nor surplus value, and am therefore an 'unproductive' wage-laborer.[88]

Heinrich is right in that what matters is not the modality of the labour – its concrete character as the production of a particular thing or the provision of a particular service. We can go further and say that the Marxist definition of productive and unproductive labour redirects the politics of work away from questions about whether the labour is manual or cognitive, whether the work excludes or deploys the labourer's personality, or whether it is degrading or not, in order for the politics of work to be a politics of the social and economic relations of labour. So, if I clean my own house, I perform useful labour, but if I pay someone to clean my house, that person is an unproductive labourer unless the cleaner works for a cleaning company, in which case the cleaner is a productive labourer (because the worker produces surplus value for their employer). What is decisive, here, is not the simple fact that someone is paid to work but whether they produce value for a capitalist employer who obtains a return on capital rather than the expenditure of revenue.

If the chief error of the claim that art is a form of nonalienated labour is that it focuses on the presence of pleasure or self-actualisation in the labour process itself (i.e. concrete labour), theories of the artist as worker do not adequately specify whether artistic labour is a form of value pro-

duction or not. Irene Bruegel, the late socialist feminist economist and activist, said in 1976 that the issues raised by the wages for housework campaign

> warrant far more serious consideration from socialists than we have yet seen. Women do need an income of their own: women, forced to go grovelling to their men for every penny as millions of women do, remain chattels. It would seem from the record that the whole of the labour movement accepts and even upholds this fundamental dependence. Even revolutionaries who tend to be concerned with the ultimate abolition of housework, tacitly accept the existing oppression.[89]

Nevertheless, she is critical of a libertarian feminist perspective which she describes as 'concerned, above all else, to develop a theory and strategy which unites all women, regardless of class, while at the same time avoiding any contamination by the existing organised working class'.[90] And she criticises the wages for housework campaign as formulated precisely as a libertarian feminist slogan, as well as warning that '*Wages* for housework within capitalism ... would mean an expansion of capital's control and domination.'[91] This is a point that resonates with Marx's own critique of the campaign for 'fair wages'. During two addresses to the General Council of the First International delivered in 1865, Marx argued in place of 'the conservative motto: A fair day's wage for a fair day's work!', the workers' movement would be advised 'to inscribe on their banner the revolutionary watchword: Abolition of the wages system!' Wage struggles, Marx said, belong to a 'war against the effects of the existing system', not its dissolution.

Bruegel singled out Selma James for criticism for arguing 'that housework is productive in the Marxist sense of the term; the housewife produces a commodity – labour power – just as, say, an electricity supply worker produces electrical power or a car worker, cars'.[92] Her counter-argument points out the contrast between the production and reproduction of material wealth and the production of value.

> Though the housewife may undertake the same physical tasks as for example, a canteen worker in a factory, the social relations are quite different. Housework is not wage labour. The housewife has not sold her labour power; she is not in fact a free labourer able to move from job to job; her work is not directly controlled, in time or intensity; there is thus no relationship between the time she puts in and the value of the commodity she is held to produce, as is the case for wage labour under capitalist social relations.[93]

'While housework is certainly necessary to make a labour force available for capital', Bruegel concludes, 'it is not productive for capital in that it doesn't itself create surplus value. In fact housework is one of the few remaining areas where production takes place for use and not directly for exchange.'[94] In all fairness, Ian Gough's brilliant study of Marx's theory of productive and unproductive labour, published in *New Left Review* in 1972, acknowledges that these theoretical differences were only vaguely understood and disputed at the time.[95] Nevertheless, Gough confirms Bruegel's interpretation by distinguishing between 'useful labour' which produces useful things or use-values, which is 'a necessary condition of human existence',[96] and productive labour, which is specific to capitalism and is defined as that labour which produces surplus value. This warrants the rejection of the political strategy of affirming varieties of 'useful labour' by demanding that it be reclassified as productive labour and therefore justifies a 'wage'.

When an artist receives a fee from the state, the payment resembles a wage but generally takes the form of a grant, stipend or fee. Receiving a stipend or a grant does not convert an artist into a worker even if this is paid on a weekly or monthly basis.[97] We need to determine whether the payment under consideration is a wage or not. A gift is not a wage, nor is a bequest, commission, pension or allowance.[98] Also, slaves are not wage labourers, nor were indentured apprentices in the Middle Ages even when they received board and lodgings in return for their work. Marx defined the wage as 'a certain quantity of money that is paid for a certain quantity of labour'. A wage is a payment for work measured either in the volume of product (e.g. piecework) or the amount of time spent working (e.g. on an hourly rate).

However, to demand wages from the state or publicly-funded institutions rather than capitalists directly, entails a different kind of confrontation. If Marx envisioned the struggle between workers and capitalists over the wage as a necessary but not sufficient element of revolutionary struggle, this is not necessarily duplicated in the confrontation with the state and non-profit art organisations. If the artist's wage is not dependent on the artist being converted into a productive or unproductive labourer, then the demand for a wage for artists has to be explained differently. While the artist's wage appears to affiliate the artist with the worker, it is more accurately understood, I would argue, as an expression of entitlement and privilege – a demand for a proportion of the common wealth justified by the status of art – rather than a cancellation of the division between the artist and the working class. In this context, the argument that the artist is a worker has acted as the perfect

alibi for the amplification of the real social division between the artist and the wage labourer insofar as the artist aims to secure an increase in resources and social esteem. This is why we need to ask whether the demand for income for artists uses the social esteem of art to redistribute public funds to artists.

Consumer sovereignty applies to all wage labour insofar as the payer of the wage, as its consumer, is therefore in a position of authority over the worker (albeit within limits set by both custom and struggle). When artists have campaigned for a wage, they have done so without demanding, at the same time, that artistic production should be subject to the interference of employers and overseers, of course. Viewed historically, the fact that 'WPA artists experienced some degree of artistic freedom in their projects',[99] and AWC artists were 'worried that governmental oversight would rob aesthetic production of its transgressive status',[100] is indicative of the concrete economic difference between artistic production and wage labour.

While the issues that were raised by AWC resemble or intersect with those of the trade unions, none of them is decisive with regard to the question of whether artists were, had always been or had recently become workers in any standard sense: such control of wage labour by capital is not only standard for wage labourers generally but is essential to that social form of labour. That the consumer sovereignty of the payer of wages has long been disputed in the case of payments to artists is evidence that the demand for wages for artists has never been a demand for artists to become wage labourers, nor that it constituted a demand for the proletarianisation of artists.

What the (explicit or implicit) critique of the historical postcapitalist politics of artistic labour (including the Hegelian Marxist theory of art as nonalienated labour) is has not been adequately formulated within the contemporary politics of labour in art. The task is to support the strategic value of extending the category of legitimate work to include unpaid cleaning, caring, cooking, shopping, childrearing and so on, and yet to build on a forensic differentiation of social forms of labour. I want to keep in mind the full spectrum of social forms of labour and to locate the artist and other producers of art within it. The purpose of my argument is not, therefore, to re-describe the artist according to the model of the wage labourer or the domestic worker in contrast with the Romantic anticapitalist description of the artist as a non-worker.

A comparative analysis of the artist and worker informed by the Marxist distinction between productive, unproductive and useful labour, and therefore of the relationship between artistic labour, waged and unwaged

support labour, and value production, cannot revert to nostalgic visions of the concrete labour of artistic activity as self-realising handicraft production. If, for this reason, we reject the Romantic anticapitalist objection to industrial production, mechanisation and automation, then the politics of artistic labour must reevaluate the discourses of the machine, the robot and AI as resources for a postcapitalist art. It is to this that I will now turn.

4

Avant-Gardism and the Meanings of Automation

I will build a composite image of the politics of automation by revisiting the history of modernist art and the avant-garde. This means reconsidering the relationship between art and technology. If we start at the end, so to speak, the question of art and the machine (and the mechanisation of art) terminates in the question of whether robots are capable of becoming artists. If robots and machines might one day produce art rather than merely replicas of art objects, then, according to Benjamin Bratton,[1] they will produce a different kind of art. I am less interested in questioning whether this expanded field of art consisting of human art and robot art preserves the distinction between the human and the machine than insisting that humans are incapable of making art without technology.[2]

Art is always produced by cyborgs.[3] The human is not a fixed, natural and eternal configuration of properties, qualities and capacities but has itself been perpetually reformed and reconstituted by its own products including the development of technologies. What human individuals are capable of at various points in human history (hunting and fishing or agriculture and philosophy or handicraft and commerce) often serve as specific models of the human as such, but the human should not be identified with any of these particular cyborgs, only with the metamorphosis between them. Human being is the condition of transforming the condition of human being by the self-transformations that result from transforming the world.

To say the artist was always a cyborg is to recast the romantic view of the genius (as an expressive, creative authorial soul) as dependent on forms of labour that it abjures. The labourless labour of the artist–genius, we can say, was made possible by forces and relations of production in which the producer of works of art was for the first time able to purchase industrially produced supplies (paints, brushes, pencils, paper, canvas, etc.) rather than working alongside artisans in a single workshop.[4] Artistic labour splits from work normatively when the handicraft elements of artistic production are displaced from the studio and industrialised.[5] This is the material basis for the modern distinction between mindless work and

aesthetic activity that is inflated in the opposition between the robot and the genius. Rather than restating the distinction between the robot and genius, therefore, we need to acknowledge the unacknowledged dependence of the artist on the industrialisation of handicraft.

Machine Art and Philistinism

Insofar as various avant-garde movements of the early twentieth century embrace the machine, the normative condition for the condemnation of everything mechanical is subjected to critique and begins to erode. In part, the machinic sublime in avant-gardism is a coded critique of aesthetic activity that is simultaneously a rejection of the bourgeois world from the route mapped by an Arts and Crafts version of socialism and the aestheticist horror of manual labour. Did avant-gardism therefore open up other pathways to postcapitalism?

In the first decades of the twentieth century, the machine and mechanisation became carriers of multiple conflicting meanings. While the nineteenth century gave the dream of automation a specifically anticapitalist meaning in modernist aestheticism, the avant-garde in the early twentieth century would satirically blend the meanings of automation in images of machines that signify the involuntary motions of the human body. The opposition between the worker and the machine was reconceived as a tension within each individual, within the machine itself, within nature and within every product made by hand or machine.

Every machine appeared to belong to a world transformed by the automobile, typewriter, cinema, x-rays, flight, radio and the telephone in Cubism's hard-edged fragmentations of homely subjects, Giacomo Balla's paintings of movement in dogs, runners, cars and bicycles, Sonia Delauney's geometrical abstraction, Natalia Goncharova's paintings of bicycles and automobiles, the machinic nudes and robotic workers depicted in Léger's paintings, Hannah Hoch's photomontages of human figures mingling with machines and text, Man Ray's photograph of an egg beater entitled L'Homme, Raoul Housmann's Mechanical Head (Spirit of the Age) assemblage, and Brancusi's streamlined forms.

What remained undecided, however, was the significance, value and meaning of the machine. Between 1859 and 1885, with the invention of the internal combustion engine, power 'was generated by exploding volatile new fuels – oil and gas – directly inside the machine. The machine thus came to contain violence within itself'.[6] And the Romantic sublime which was prompted by the experience of the vastness of nature began to recede next to the new machinic sublime. At the same time, however, the machine could be detected in handicraft activities such as jazz per-

formance, which 'was perceived as both stereotypically primitive and ultra-modern [and] machine-like'.[7]

Being faced with a machine, a diagram or a mechanically-produced object in the years between 1900 and 1930 was to be posed a taxing question that tied together progress, dehumanisation, mass production, mass culture, profit and war. Hence, the machine was the sign of a struggle over the meaning of modernity. For Dada artists, the machine was an exhilarating anti-human and anti-aesthetic force against the bourgeois world of taste, handmade luxury and academic skill. However, one of the leading theorists of Expressionism, Herman Bahr, warned: 'All that we experience is but the strenuous battle between the soul and the machine for the possession of man.'[8] For Kasimir Malevich, 'two worlds have collided/ The world of meat and the world of iron', not as loss of the human but its extension: '[t]he new life of iron and the machine, the roar of automobiles, the glitter of electric lights, the whirring of propellers, have awoken the soul, which was stifling in the catacombs of ancient reason.'[9]

Duchamp always played on the multiple conflicting meanings of the human as nothing-but-a-machine and the machine as surrogate human. Steve Edwards has noted how the 'analogy of body and machine … operates in the capitalist imaginary of work'[10] through real and symbolic substitutions. Ultimately, Edwards notes, in Marx's analysis, the difference between the use of machines in precapitalism and in capitalism is that it is not only that the body is replaced by a machine but that the subject–object relationship is itself inverted so that the machine 'was itself the subject of the productive process'.[11]

Machines in Duchamp's work break with the bourgeois dream of the automaton of industry by connoting both sexual activity and the mindless or passionless body at leisure. The machine, for him, is a socially acceptable substitute for a pornographic scene as well as the demotion of old-fashioned ideas about civilisation, skill and virtue. His diagram of the chocolate grinder, for instance, is at once a euphemism for sexual activity and a nihilist reduction of marriage to a mechanical encounter. In the words of Camfield, Duchamp's late works 'construct an anti-rational universe peopled by fantastic machines and governed by absurd physics and metaphysics that culminates in the *Bride Stripped Bare by Her Bachelors, Even*'.[12]

Futurism was the first avant-garde movement to reconcile art and the machine, to inject art with speed and to envision the mechanisation of art itself. Prior to this a small number of individuals had merged art and the machine. Blaise Cendrars, a Swiss poet originally named Frédéric Sauser, who famously collaborated on a poem-painting homage to the trans-Siberian railway with Sonia Delauney, was among them. He wrote:

Since the origin of his species, the horse has been moving, supple and mathematical. Machines are already catching up with him, passing him by. Locomotives rear up and steamers whinny over the water. A typewriter may never make an etymological spelling mistake, while the scholar stammers, swallows his words, wears out his dentures on antique consonants.[13]

These literary images serve as a vivid background and rationale for the typewriter as a replacement for the poet's pen. The transition from the pen to the typewriter may appear to be trivial, leaving the poet to select words in the customary aesthetic manner, and yet it underscores a deeper shift from the voice to the page and from the presence of the poet to the dispersed and multiplied reception of the published poem. Although not implementing anything like the mechanisation of poetic authorship, the typewriter is a metonym for the mechanisation of literary distribution.

Marinetti, we might say, was a pioneer of rightwing accelerationism. The first Futurist Manifesto in 1909 was militaristic and misogynist. Its leaders enthusiastically embraced Fascism and were ardent supporters of Mussolini. 'Vain attempts have been made to fit Marinetti's works into various artistic and political categories', Paul Virilio says, 'but Futurism in fact comes from a single art – that of war and its essence, speed.'[14] In fact, if, as Virilio says, 'history progresses at the speed of its weapon systems',[15] then Futurism's advocacy of war is simply the logical extrapolation of their accelerationist advocacy of speed.

And yet there is another politics of the machine in Futurism. Like Dada, Surrealism, Constructivism and Situationism, Futurism also often appropriated popular forms such as the circus, sport, vaudeville and news, as well as incorporating mundane materials such as bus tickets, newspapers and sheet music. In a word, the avant-garde was philistine. The cultivation of bad taste did not signify an alliance with the working class, even as it denounced bourgeois society through the celebration of modernity. Rather than reading the politics of the avant-garde from its philistinism, we need to embed anti-bourgeois philistinism into a politics of the machine and the mechanical.

Marinetti declared 'the earth shrunk by speed' and rejoiced in the technological advancements of the train, the aeroplane, the car, the newspaper, the cinema and the radio, which extended the ability of an 'ordinary man' to travel from his 'little dead town' to 'a great capital city', to follow insurrections across the globe, to witness a hunt in the Congo and to listen to Caruso while lying in bed.[16] This is a modernist vision of the mechanisation of life, of the technologies that propel individuals into the world and propel the world into the village and the home.

At the same time, the Futurists demanded a transformation of art in accordance with the modern condition of industrial and automated existence, inciting the poet to adopt a different relationship to the world and acknowledge the transformation of life by industrialisation, mechanisation and the technologies of communication. Marinetti did not mechanise poetry in any literal sense but he attempted to become more machine-like in his poetic process and in the presentation of his poetry. This is why, in his poem *Zang Tumb Tuuum*, written in 1914, Marinetti presented a 'sequence of nouns and noun phrases [that] is closer to newspaper or to film captioning than to lyric practice'.[17] Marjorie Perloff expresses her frustrations with Marinetti's poetry as a criticism precisely of its mechanical processes of production and its unpoetical outcome. Perloff complains that the 'variety of typefaces ... cannot disguise the fact that Marinetti's *parole in libertá* are basically just lists';[18] the 'structural principle operative ... is less that of collage than of catalog', and finally, the poem is 'merely what we might call a montage-string ... rendering sensations at a level so generalized that anyone might feel them'.[19] Within the terms of the machinic critique of bourgeois culture, the shortfalls of Marinetti's poetry are arguably his highest achievement.

Frances Stracey addressed these issues in her study of Giuseppe Pinot-Gallizio's partly mechanised *Industrial Painting* in the late 1950s.[20] Produced on long rolls of canvas, Pinot-Gallizio sold his industrial paintings by the metre and produced them with an 'art-machine', according to the catalogue essay written for his first exhibition in Turin in 1958 by Michèle Bernstein. Stracey is justified in her suspicions of this 'eulogy', which fails to disclose that the 'industrial painting machine' was 'a rickety printing-table'. Machine art in the twentieth century is necessarily 'a parody of automation', but the embellishments and occlusions of those who prematurely announce the arrival of machine art bear witness to the mythic structure of the art machine. The desire for an art machine outstripped technological capacity and a phoney machine that could only effect a parrot fashion version of automation still 'signalled the death of the professional artist'.[21]

Avant-garde artists developed 'mechanical' techniques for the production of their works. Avant-garde procedures are anti-art techniques because they dispense with specifically artistic skills (drawing, painting, carving, composing, etc.) and substitute mechanical or automatic processes that are technically perfunctory.[22] Dropping cut-out pieces of paper to create a composition according to chance, as Hans Arp did, for instance, was a method for eliminating the cultivated distinction between composition and accident[23] by following simple instructions to assemble a work out of readymade materials.

Tristan Tzara's instructions for producing a Dada poem are mechanical in this sense, too. Tzara provides a recipe consisting of step-by-step operations that begins with a readymade example of mechanically reproducible culture (an article in a magazine chosen by the number of words it contains) which is cut up with scissors, placed in a bag, drawn out from the bag and then copied out in the order that chance has determined. Also, Duchamp's readymade technique not only displayed a mechanically-produced object within the gallery but also mimicked the camera – the machine for making pictures – in the relationship between the artist and the surrounding world in which seeing something and 'capturing' it was more modern than constructing it by hand from scratch.

In the machine portraits of Francis Picabia, in which a girl could be represented as a spark plug or a poet could be represented by a diagram of electrical symbols, the machine connotes both the robot and the inner dynamism of unpredictable and spontaneous behaviour. Picabia's machinic artworks were 'scurrilous sexual parallels'[24] and 'a Dadaist insult to art and technology',[25] but also, for him, machines were mysterious and miraculous, absurd and cold. In a picture such as *Ici, c'est Stieglitz*, a collage and ink drawing made in 1915, Picabia depicts his close friend and perhaps America's preeminent photographer of the day, as a diagram of a camera.

The camera that Picabia used to portray Stieglitz was, I believe, the Vest Pocket Kodak, commonly known as the VPK, which, during WWI, was nicknamed the Soldier's Kodak. In the portrait, the bellows have come loose from the lens and hang lifelessly on the left, while a car's gearstick is drawn in red ink rising up along the right-hand side of the camera to almost touch the viewfinder. Advertisements in printed media for the VPK often contain an illustration of the camera which, if this is the source of Picabia's image, has been rotated 90 degrees to appear upright. One advertisement, published in *Life* magazine at the time, had the tagline, 'the very essence of efficiency', while another boasted, 'as small as your note book and tells the story better'. The camera is a machine for making pictures at an unprecedented speed and placed the photographer in a new dynamic relationship to the city.

In Picabia's machine portrait of Stieglitz, the man is a machine and the machine takes on the characteristics of the man. As image, the machine becomes readable as a likeness of its user but also as a sign of the mysterious powers of the great photographer. If the camera is the Soldier's Kodak, then Stieglitz is portrayed perhaps as armed with a camera on the streets of New York. According to the advertising blurb at the time, this is a camera for those who have not planned to take pictures but who are able instead to capture the unexpected. Picabia portrays Stieglitz as a machine

– a robot – who manufactures images in the machine age with the speed and power of a Ford motorcar.

This is a picture that enacts a collision between the mechanised image and the handmade painting or drawing insofar as Picabia, like Warhol after him, traced the image from the advertising illustration that he found in a popular magazine. Here, the artist meets the mechanical image halfway, so to speak, and the hand of the painter literally follows the paths laid out by the manufactured and reproducible picture. As such, the portrait of Stieglitz is also a mini-manifesto for Picabia's own output of this period in which the artist is reduced to an attendant of the machine-image rather than a producer and author of original handmade pictures.

If technologies of reproduction allow everyone to be an author or everyone to be an artist, then it is not only the aura of the art object that dissolves in modernity, but also the aura of the artist. Instead of protecting the handicraft production of the individual artist (which conceals the aura of the artist behind the vision of artistic production as nonalienated labour), the avant-garde of the early twentieth century proposed that the production of art might be set free from its ancient exclusivity by the adoption of mechanical techniques. In this respect, I want to suggest, the artist is cancelled as a category by being remodelled as a robot.

However, the robot has at least two roles to play within the politics of work in art. First, the robot, as a sign of the machine, represents the technologies that break down the old order of the author, the artist, the genius and so on. Second, the robot, as the principal emblem of the extent to which technology replaces human activity, represents a rival to the author, artist, genius, etc. In one version, the robot and the genius–artist are incommensurable and therefore the rise of technologies of reproducibility – and the use of those technologies by artists – is correlated with the demise of the myth of the artist as an heroic, creative individual.

In Fritz Lang's expressionist sci-fi movie *Metropolis*, which was released in 1927, the first robot is built on the instructions of the master of industry by his genius inventor. His brief: to build a machine to replace the workers in his mechanised factory. The robot, in the words of its genius creator, is 'a machine in the image of man that never tires or makes a mistake'. Simultaneously a perfect servant and an embodiment of the permanent menace of the working class, the robot is a figure through which the threat against workers by mechanisation is transplanted into a signifier of the threat of workers against owners (when robots no longer act as good servants and turn on their human masters). The robot is a manufactured good and therefore is a representation of labour as a commodity (i.e. a slave rather than wage labourer).[26] Slavery reappears within the industrial imaginary of the cult of technology as both technically and ethically preferable to the

waged worker. Robots are more productive than wage labourers and, at least in the early literature, raise none of the concerns about exploitation, ownership and mastery of the slave or worker.

Remarkably, the first robot in *Metropolis* is given the shape of a woman. Within this narrative, the ideal worker is a mechanical woman. Andreas Huyssen's critique of the Marxist interpretation of *Metropolis* focuses on 'technology and female sexuality',[27] and how the robot reiterates familiar tropes of femininity. In another classic feminist study of the robot, Mary Ann Doane[28] interpreted the robot or cyborg in terms of gendered discourses of the body. Science fiction, she said, frequently thematises social anxieties about technology through unsettling images of the human body, particularly the female body. Political tensions embodied in the machine are displaced, therefore, into gendered discourses of the nature of the feminine so that the manufactured woman signifies machine, nature and woman all at once. Cinema, she noted, is also a prosthetic extension of the human body.

Neither Huyssen nor Doane say anything about what these depictions of the mechanised woman say about technology in industrial capitalism or the technological promise of postcapitalism. While this emphasis on the deployment of gendered tropes has its benefits, the focus on the asymmetries of power between men and women is misleading when it comes to the question of technology in industry. 'Technology seems completely under male control',[29] Huyssen says, forgetting to point out that it is the owner–master who controls the machinery and gives orders to the robot, whereas the factory workers (all men) have no control over the technology whatsoever. Even if technology is controlled exclusively by men, it is not 'man' who controls technology but the dominant class of industrialists.

Huyssen, in particular, makes the mistake of pressing for a feminist reading of the robot against a class analysis rather than remarking on how class and gender dovetail in the depiction of the robot as the simultaneous saviour and grave-digger of industry and capitalism. Surprisingly, perhaps, therefore, it may be that gender is the perfect lens through which to analyse the politics of work and technology. Whatever other reasons can be given for the feminisation of the robot, the gendered connotations operative within the narrative allow the robot, as the epitome of the potential and threat of the machine, to appear initially as subservient (wife) but later as a destructive force (vamp) that can seduce the upper class and stir up the workers to violent action, in both cases with immediate and murderous consequences. While gender is an essential component of the narrative, it is important to note that the robot remains a worker (either in the form of a cabaret dancer or a priest-like leader of the mass of workers who is turned into an *agent provocateur* by the man who had her built). As such,

the robot remains a depiction of the worker as both absolutely subordinate and absolutely uncontrollable, simultaneously wife and vamp, worker and revolutionary.

From its inception in the fantasies attendant to the cult of technology in the 1920s, the robot solves the riddle of industrial capitalism. The central contradiction of the capitalist mode of production, namely that the forces of production (technology, etc.) are permanently in tension with the social relations of production (private property, the labour–capital relation, class, gender and race divisions), is overcome in fantasies of a specific means of production in which machines replace workers and all humans live off the products produced by manufactured workers.

Symbolically, the antagonism between machinery and labour is abolished in the manufactured worker insofar as the machine no longer merely puts a proportion of workers out of work but replaces the entire class of workers. At its most optimistic, this vision of the obsolescence of the proletariat is the technological foundation of a new Cockaigne in which the whole of humanity now belongs to a single class of non-worker consumers of the bounty of automatic industrial production. More sinister narratives develop from the basis that roboticisation is consciously designed by the masters of industry and the genius inventor for the specific purpose of the complete domination and pauperisation of the propertyless, or when the superhuman power of the robot turns against its masters. All the instability and catastrophe brought about by the robot results from the impossibility of assigning to it only those social roles for which it is initially produced. When the mechanical slave becomes the equal of the scientist, artist, priest or company director, chaos ensues.

Chaos is held off, according to Isaac Asimov,[30] through his proposal of the three laws of robotics.[31] The obvious superhuman power of the robot has not been contained by Asimov's laws in the subsequent history of the sci-fi depiction of robots. It is the transgression of these laws or their inapplicability that has been more resonant for the genre. Amongst its other meanings, the guarantee that robots will not harm humans and always obey human instructions is a false promise that mechanisation and automation can be nothing but beneficial to their producers, users and owners. For one thing, it bypasses the question of alienation which roboticisation poses. In the words of Alexander Rodchenko, a leading member of the Russian avant-garde, prior to the Revolution, the machine was a threat internal to humanity:

The world has been transformed into a monstrous, fantastic, perpetually moving machine; into an enormous automatic organism, inanimate, a gigantic whole constructed on a strict correspondence and balance of

parts. ... Robot-like, we have become habituated to life – getting up, going to bed, eating and working to set times; and this sense of rhythm and mechanical harmony is reflected in our entire life, cannot but be reflected in our mode of thought, in our spiritual life, in art.[32]

Fear of the robot and all attempts to discipline it belong to a history of the politics of labour in which the robot thematises both the revolutionary potential of the working class as a threat to the whole of humanity and transposes the displacement of workers by machines into the extinction of humanity by an automated world that has no more use for such inferior beings. Also, the robot is located conceptually at the junction between intellectual and manual labour and therefore calls into question the possibility of sustaining the division between them. Insofar as the robot is a mechanical subjectless worker, technology appears to accomplish the final separation of humanity and work. As the narrative shifts from the robot as the product of the superhuman intellect of the genius to the superhuman powers of the robot, postcapitalism merges with post-industrialism, posthumanism and post-Marxism in such images of the fatal antagonism between 'man' and machine that is resolved in the fully automated elimination not only of the working class but also of humanity in general.

Accelerationism and Contemporary Postcapitalism

Nick Land, the influential philosopher of nihilist accelerationism, claimed in the 1990s that the machinic revolution must 'go in the opposite direction to socialistic regulation; pressing towards ever more uninhibited marketization of the processes that are tearing down the social field'.[33] This is what he calls the 'escape velocity of self-reinforcing machinic intelligence'.[34] 'Socialism has typically been a nostalgic diatribe against underdeveloped capitalism, finding its eschatological soap-boxes amongst the relics of precapitalist territorialities.'[35] Capitalism's 'true terminator',[36] he argues, is not to be found in 'left dreams of good government',[37] but the autonomous reproduction of 'Cyberia'.[38] Hence, for him, postcapitalism is imminent because 'the forces of production are going for the revolution on their own'.[39]

Land's postcapitalism is an anti-humanist affirmation of the machine. His nihilist dynamism advocates a promethean system that is meant to bury capitalism by liberating one of its own forces against all the others. This is spelt out by Robin Mackay and Armen Avanessian in the introduction to the Accelerationist reader: 'Accelerationism seeks to side with the emancipatory dynamic that broke the chains of feudalism and ushered

in the constantly ramifying range of practical possibilities characteristic of modernity.'[40]

One of the historical limits of Land's rightwing accelerationism is its confidence in absolute deregulation to deliver.[41] Naively, Land believes that full exposure to machine logic brings only 'creative destruction' and the laying to waste of the technologically obsolete, including humanity itself. Benjamin Noys has noted, however, that while it was possible for Land to celebrate '[c]apitalism's drive to accumulation, its squeezing of labor, and its penetration of existence through abstraction', what accelerationism 'could not grasp was the future of crash and crisis'.[42] Unleashed technology produces systemic overproduction and massive haemorrhaging of value as 'the processes of crisis formation and resolution are bound together by the way crises get moved around from production to realisation and back again'.[43]

Land is an inverted Carlyle. For the great Victorian Romantic, the machine had come to dominate not only production and its products but also their producers and the whole culture of modernity. In response, Carlyle deployed the concept of the machine in countless variations, literal and metaphoric, to characterise the inhumanity of industrial processes, industrial society and the subjectivities and experiences of individuals marked by and adapted to mechanisation. Anticipating Deleuze, Carlyle detected 'religious machines', 'machines for education', 'the machine of society', 'a taxing machine', a 'machine for securing property' and so on. It is in this context that Carlyle describes the new subjectivity of the industrial age: 'Men are grown mechanical in head and in heart, as well as in hand.'[44] What Carlyle found abhorrrent, Land commends.

Rightwing accelerationism anticipates the replacement of the human by the machine, the robot and the cyborg and therefore stresses the nihilistic force of technology as an alien power that confronts both human beings and the norms of humanism. Land commends mechanisation and automation to replace labour[45] without this affecting in any way his own speculative labour as a writer. Unlike the writers of the avant-garde, Land never roboticised his own writing. His practice is essentially a form of intellectual handicraft that thematises high-tech rather than being transformed by it as a form of cognitive labour. Is there not a fundamental flaw in Land's characterisation of the relationship between technology and labour so long as he continued to think and to craft his thoughts in the manner of a philosopher while his nihilism only thematised the annihilation of labour? In other words, while constructing his texts as meticulous sites of experimental composition, Land supplements his assault on labour with a blindness to it in his own 'work'. The inconsistency between his theory

and practice ought to be resolved, I would argue, by acknowledging the persistence of handicraft in his theory of modernity rather than denying it.

The manufactured worker in *Metropolis*, however, is not a worker made by proletariats, but a worker designed and constructed by an individual scientist, technician and genius. As such, the final and complete stage of industrialisation, which is also the greatest threat to the capitalist mode of production, is predicated on the individual handicraft production of the innovative individual who typically blends the characteristics of the scientist, inventor and artist. The genius and the robot are partners. They are opposites, of course, if we think of the robot as a mechanical servant and the genius as a lawless virtuoso. However, we might say that there is a structural relationship between them that goes beyond the observation that, within the literature of the robot, robots are initially produced by geniuses.

The genius is born, historically, as a rejection of the mechanical and reaches its zenith as a genre as part of the Romantic critique of industrialisation.[46] What's more, the genius rises above the mechanical by a mythic version of the social division of labour in which the talent of the genius is contrasted with the mindless drudgery of the proletariat and women, who are thereby reduced to a life of mechanical work that makes them appear to be robots. Insofar as these men and women produce and maintain the necessities of life on which the genius depends, therefore, the genius and the human 'robot' form a single social unit.

When the robot is conceived of as a mechanical servant who follows instructions, the genius and the human retain their privileges, but when the robot appears as insubordinate, internally driven or sentimental, then the robot begins to occupy the ground that had been laid out for the revolutionary, the human and the genius. However, the robot does not have 'periods of inactivity', 'uneven inspiration' and 'periods of languor and weakness' that the genius suffers as a result of their need for 'enthusiasm',[47] but the robot extends the genealogy of what Herbert Dieckmann calls 'the highest human type' which the genius exemplifies at the end of the eighteenth century, replacing such earlier ideal types as 'the hero, the "sage", the Saint, the *uomo universale*, the *cortigiano*, the *honnête homme*'.[48] The robot is a posthuman[49] genius but also a posthuman street-cleaner, charwoman or factory worker. Every human emancipated from work by the robot is a genius: free to choose what to do in the absence of external direction from a boss or the market or social need.

Technology is a mediator within the ongoing struggle between capital and labour. Since all capital is dead labour, the machine embodies the confrontation between the two but it is also the direct experience of the subsumption to capital by the worker in the work process itself. Inversely,

the worker appears to the processes of mechanisation and the speed-up of surplus extraction as a drag on production and profit by comparison to the machine. 'The struggle between the capitalist and the wage-labourer starts with the capital-relation itself', Marx said, '[b]ut only with the introduction of machinery has the worker fought against the instrument of labour itself, capital's material mode of existence.'[50]

As Marx explained, with the imposition of machinery, the machine becomes a rival and antagonist of the worker so that radicalised workers at the beginning of the nineteenth century who had been driven out of work by mechanisation, and had not yet 'learnt to distinguish between machinery and its employment by capital',[51] destroyed the instruments of production rather than the exploitative social system that weaponises those instruments.[52] Labour is not only the labour process, that is to say the activities associated with agriculture, industry, transport, services, the media and so on, but is also, for instance, *crystallised* in products and infrastructure. When labour is confronted by tools, machinery, buildings, roads, geographical divisions, social structures, cultural formations and the vast accumulation of knowledge, opinion and information, therefore, labour is confronted with itself in another form. Since labour is congealed in money, goods, institutions, images and so on, which stand as objective forces that shape the world in which labour is conducted, labour is therefore on both sides of the antagonism between human activity and the forces that compel and block that activity.

Labour is the living force in the global processes of digital acceleration and also the dead weight of geographically unequal internet infrastructure and the proprietary software that blocks user activity. Walking is labour, but so is the path, the map, the wall, the gate and the laws of private property that determine the route. Labour continues to confront nature as an external limit both as a raw material and an obstacle, but increasingly, living labour confronts dead labour – capital, machinery, information, infrastructure – as its chief resource and delimiting power.

Technology is neither the problem nor the solution to the limits of capitalism. Marx explains,

> since machinery in itself shortens the hours of labour, but when employed by capital it lengthens them; since in itself it lightens labour, but when employed by capital is heightens its intensity; since in itself it is a victory of man over the forces of nature but in the hands of capital it makes man the slave of those forces; since in itself it increases the wealth of the producers, but in the hands of capital it makes them into paupers.[53]

It is a mistake to focus on technology in isolation from its social form.

Left Accelerationism stresses the robot as a benign servant of humans, releasing them from toil and drudgery.[54] Humans become obsolete for rightwing accelerationism because the superhuman powers of technology can only serve humans by being limited by them, whereas humans become fully realised for Left Accelerationism by being converted from producers to consumers of automated systems of production. For Left Accelerationism, therefore, the historical purpose of roboticisation is to replace the proletariat and all domestic labour so that all human beings are freed from work.[55] Roboticisation, therefore, does not bring about an absolute end to work but a new posthuman division of labour: work gets done, but not by humans. Insofar as the machine and the robot come to represent humanity's salvation from work, therefore, the robot takes the place of the worker while humans, if they survive, occupy the place of the privileged, the propertied and the workless genius.

5

Laziness and the Technologies of Rest

Contemporary postcapitalism differentiates itself from historical post-capitalism primarily through the affirmation of idleness. In this chapter, I will revisit these questions through a critical reading of two of the most prominent arguments for universal worklessness. First, I will reexamine Maurizio Lazzarato's argument in favour of laziness aligned to the Italian post-Marxist affirmation of the refusal of work that uses Duchamp as a paradigm of the anti-work politics of postcapitalism. After this I will reconstruct a history of the vision of the emancipation from work through what I am calling *technologies of rest* that plays a signal role in the Left Accelerationist theory of postcapitalism.

Duchamp, for Lazzarato, is cast as an opponent of capitalism because he represents laziness as the absolute refusal of artistic work and wage labour. Lazzarato poses the problem of the politics of work through a binary of 'freedom from work or freedom through work'. This way of expressing one of the central problems of postcapitalism offers the reader a choice between a prefigurative politics of worklessness or 'freedom through work'. Laziness, he says, 'undercuts the primacy of labor' and 'subverts, one by one, exchange, property, and work and does so outside the Marxist tradition'.

Lazzarato lines himself up against the workers' movement because it 'turned workers into eulogists of their own enslavement'.[1] In classic post-Marxist style he claims polemically that the dominated are 'clamouring'[2] for a job and he credits the workers' movement with nothing other than the invention of the strike while rejecting the communist tradition, in which, he says, 'the notion of work has always been at once the strength and the weakness'.[3] Clearly, Lazzarato is trading on a caricature of Marxism, communism and the workers' movement that allows him to think that his argument against work does not have deep roots in the traditions that he rejects. Nevertheless, he says 'Laziness is not simply a "non-action" or a "minimal action". It involves taking a position with respect to the conditions of existence under capitalism. First of all, it affirms a subjective

refusal of (paid) work and of all the forms of conformist behavior capitalist society demands.'[4]

If we concede that there is a polemical punch to Lazzarato's choice of the most celebrated artist of contemporary art discourse as the exemplar of the critique of labour, we can also credit him with replacing the theory of the readymade as a commodity with sustained attention to the labour of the artist who does not make anything. This transition has been unpicked by John Roberts in his study of deskilling. For Roberts, the readymade enacts a 'thoroughgoing dismantling of the metaphysics of the hand, of handicraft, of the handmade'[5] that is also a prerequisite of the 'appropriation of the labour of others'.[6] Thierry de Duve spies this development in art within a thicket of world-historical changes including the rise of science, mechanisation, the supply of paint in tubes, the invention of photography and the modernist painter's resistance to the division of labour.[7]

Lazzarato's approach to postcapitalism has a familiar liberal, individualist core and yet, within his account is a much more precise understanding of what is at stake in postcapitalism. He tells us that laziness 'is incomparably "richer" than capitalist activity'[8] because 'it contains possibilities that are not based on economic production'.[9] This appears to be a variant of what Postone calls the central contradiction of capitalism, and what Hudis describes as 'continual contradiction between the drive to produce material wealth and to augment value'.[10] However, Lazzarato's defence of Duchamp's laziness does not keep its eye on this particular ball, so to speak, but is distracted from it by the micro-utopianism of the individual's private exodus from capitalism.

The choice of Duchamp and the readymade as a paradigm of laziness redirects the politics of anti-work away from the collective struggle against capital towards the individual's lines of flight from the workplace. Duchamp's challenge to capitalism is strictly limited to the level of the individual non-conformist, the fortunate soul who escapes from the system or enjoys certain privileges within it. Duchamp's remoteness from work was typical of his class although it wasn't typical of artists of his generation. Even so, for an artist to shun work, especially waged labour, is not to disrupt social roles but to confirm the Kantian and Romantic definition of art as non-mercenary.

'The readymade', Lazzarato claims, 'is a lazy technique because it involves no virtuosity, no special know-how, no productive activity, and no manual labor.'[11] Laziness, therefore, becomes a sign of the intellectual's inoculation from handicraft and mechanical forms of activity. The lazy artist, we might say, is opposed to the worker modelled after the robot in Lazzarato's argument. This is brought out when he argues that the problem with work is 'the impoverishment and standardization of

subjectivity imposed by "work".[12] Actually, what Lazzarato's nomination of Duchamp as anti-worker signals is an undeclared bias in his rejection of work. He does not include intellectual work as work. Taken as a bald assertion, his advocacy of laziness would presumably discredit his own efforts in writing this short book but writing, for him, sits on the privileged side of the division between manual and intellectual labour, as well as confirming the norms associated with it.

Given that the independence of artists from employers is real, while the refusal to work is, in the case of Duchamp, a narrative to conceal both his financial independence from work due to family inheritance and his suppressed income from sales of his own works and those of others, the contrast raises more questions than Lazzarato bargains for. The romance of the artist as an embodiment of freedom must be confronted, but the material basis for this myth (namely, artistic labour's non-subsumption to capital) is not the error here. Contrasting the myth of the artist with the myth of Duchamp's laziness does not resolve matters. If there is a problem with the identification of art with anti-work, this is not put right by invoking anti-art in its place. While anti-art is a significant corrective to art and the aesthetic, it is not a satisfactory response to the problem of work or the structural dominance of the production of value over the production and maintenance of material wealth.

There are, for Lazzarato, 'two types of production', capitalist production and the 'production of subjectivity'.[13] It is possible that Lazzarato takes this phrase from Guattari, who uses the same words to distinguish his project from that of Freud and Lacan, saying:

> My perspective involves shifting the human and social sciences from scientific paradigms towards ethico-aesthetic paradigms. It's no longer a question of determining whether the Freudian Unconscious or the Lacanian Unconscious provide scientific answers to the problems of the psyche. From now on these models, along with the others, will only be considered in terms of the production of subjectivity.[14]

It should be noted, however, that Guattari here is discussing the direction of clinical practice, not the political critique of capitalism.

It would be possible to interpret Lazzarato's concept of laziness – i.e. the production of subjectivity – as consonant with Marx's proposal of postcapitalist activity. 'Marx conceives of free activity as not only leisure but also as *exercise*', Hudis says, adding: 'Truly free activity, for Marx, consists of conscious, purposeful activity, which is an arduous exercise.'[15] To clinch the association, though, we might have to speak of a *strenuous laziness* or a *taxing laziness*, which might subvert the bourgeois category of leisure

at the same time as unsubscribing from the work ethic. The problem with the concept of laziness, especially as it is redescribed in terms of the vigilant production of subjectivity, is that it corresponds all too well with the aristocratic and bourgeois condemnation of work in favour of a life devoted to higher things.

This distinction between capitalist production and the production of subjectivity follows the contours of the normative partition between the liberal and mechanical arts which was preserved in the category of the Fine Arts, subsequently internalised within the myth of the artist and eventually formed into the Romantic anticapitalist conception of art. Although the advocacy of laziness deliberately subverts the Arts and Crafts affirmation of humane labour, the opposition of capitalist work and the production of the self could have been cut and pasted from a lecture by John Ruskin. Here, laziness and work that is beneficial to the worker merge into one. Except, of course, that Ruskin also pointed out that the 'ideal of human life ... passed in a pleasant undulating world' presupposed a divided landscape with a mill – or some other producer of value – at the bottom of the hill 'in constant employment from eight hundred to a thousand workers, who never drink, never strike, always go to church on Sunday, and always express themselves in respectful language'.[16]

Lazzarato plays down the dependence of intellectual production on mechanical forms of work. Duchamp's readymades, for instance, may not derive from the manual labour of the artist, but manual labour is necessary for their production nonetheless. The same is true, of course, for the intellectual production of books. Someone – the author or someone else – must make the dinner, as well as print and transport and sell the book that the author has written. From within the studio or the study or the café where the intellectual work gets done, it appears as if manual labour can be eradicated from intellectual production, but this is the great delusion of privilege.

Typically, he conflates anticapitalism with the liberty from work afforded by the wealthy. Modelling anti-work politics on the leisure of those not forced to work is, at best, a short-sighted style of postcapitalism. At worst, it undoes the politicisation of work by generations of critical thinkers. For instance, when Lazzarato says 'Duchamp simply picked them off "the shelf of the lazyman's hardware store"',[17] he neglects the argument, within contemporary feminist theory, that shopping is a form of labour.[18] In doing so he damages his own claim that laziness 'undermines social and sexual identities'.[19]

'Duchamp', Lazzarato claims, 'maintained an obstinate refusal of both artistic and wage-earning work, refusing to submit to the functions, roles, and norms of capitalist society.'[20] Lazzarato detects this trace of postcapi-

talism in Duchamp's judgement that 'working in order to live is idiotic'.[21] However, Duchamp was, at best, uncomfortable accepting his economic role as the seller of products, both his own works and those for whom he acted as a dealer in America. So, his apparent refusal of work and money is overstated by Lazzarato and we might say, in the interests of accuracy, that Duchamp made some display of resisting the market but this was notional or subjective. Also, Duchamp's statement is, in my reading at least, deliberately ambiguous so that it can have two contradictory readings simultaneously, once as a postcapitalist critique of work and second as an aristocratic insult to workers. That is to say, Duchamp and Lazzarato appear to be making a judgement about the mental abilities of workers rather than the system of wage labour.

Lazzarato compares Duchamp's laziness favourably to Warhol's strategic advocacy of business. This comes off partly because he restricts his analysis to Warhol's statements, assuming that they correspond truly to his practice rather than inquiring into the pragmatics of Warhol's deployment of such rhetoric or investigating the actual economics of Warhol's so-called Factory. Duchamp's remoteness from the market appears, by comparison, to belong to an older modernist defence of art's autonomy or an even older school of the noble independence of the Fine Arts from trade, but Lazzarato defends this privilege as only apparently a form of dandyism and actually a form of ancient Greek philosophical cynicism.[22]

Warhol was more disruptive of the social imaginary of the artist than Duchamp even if he did so through the rhetorics of the existing society because Warhol went further than Duchamp in his refusal to work, not only getting others to make his work but getting them to generate his ideas too (and on at least one occasion, having someone else answer questions posed to him in an interview). If Lazzarato prefers Duchamp's version of not-working to Warhol's, this is because Warhol aims at a fuller decentring of the self, to the point of disappearing, whereas Duchamp transposes the work of making art into the work of making a self. And this, presumably, is why he remains silent about collective processes of refusing to work and the revolutionary abolition of work, including the collective, collaborative and participatory art practices of Productivism, Constructivism, Conceptualism and the social turn in contemporary art. Duchamp, therefore, is not only a reactionary choice, politically, but a conservative choice of an artist within the field of art.

Lazzarato's defence of laziness, however, does throw up an important question about the relationship between art, labour and postcapitalism. His choice of Duchamp is at least in part driven by his acknowledgement that artistic labour is not to be taken as nonalienated labour, as the refusal of labour within labour itself, so to speak, or, in his own terms, as *freedom*.

In making this argument, however, he inverts the material and subjective resistance to capitalism. Since the artist 'is not bound to an employer but to a range of apparatuses of power', he says, the artist is attached to 'the illusion of being free'.[23] He opposes this false freedom to the refusal of work which 'frees us from the enchanted circle of production, productivity and producers'.[24]

Lazzarato argues that Duchamp's laziness 'challenges the three mainstays of capitalist society'.[25] First, he says, 'laziness undermines exchange'.[26] Second, 'and still more profoundly, laziness threatens property, the bedrock of exchange'.[27] And thirdly, 'laziness undercuts the primacy of labor'.[28] Exchange, property and labour are certainly prominent features of capitalism, but all three precede capitalism and are transformed by it. So, it is the particular social form of exchange, property and labour that has to be grasped in this analysis. And what this requires, in my reading, is that exchange has to be understood as governed by exchange value, property has to be understood as the accumulation of value rather than material wealth, and labour has to be understood as the labour power that produces value.

Laziness, it goes without saying, is the negation of concrete labour not abstract labour, although in all fairness, if you abolish one, the other goes too. It is possible to read Lazzarato's advocacy of the production of subjectivity as an affirmation of concrete labour against abstract labour, and this could be substantiated by his opposition to capitalist production, but this is not adequately spelt out in his account. Laziness, I contend, is the negation of concrete labour. Since the supersession of capitalism is identical with the supersession of abstract labour (as the motive force for the augmentation of value rather than material wealth), it cannot be taken as a postcapitalist politics of work.

So, if the passage to postcapitalism cannot be brought about by the negation of concrete labour, what are the prospects of automation, understood as the elimination of human labour from production? It is to this question that I now turn.

Technologies of Rest

Automation, as distinct from images of a miraculous bounty of workless produce, originated as a capitalist dreamworld of capital accumulation emancipated from labour. The fully-automated factory without workers is a bosses' Cockaigne in which profit can be plucked from the air. The contemporary postcapitalist vision of the abolition of work was anticipated in the 'capitalist utopia of the production process without labour',[29] as Steve Edwards points out in his reading of Andrew Ure's Victorian fantasy of

the factory as a mechanical organism. The factory, in Ure's description, published in 1835, was 'a vast automaton composed of various mechanical and intellectual organs, acting in uninterrupted concert for the production of a common object, all of them being subordinate to a self-regulated moving force'.[30] A factory without workers is a factory without error, without illness and no longer threatened by the disruption of insubordinate workers. At the same time, it has to be said, a factory without workers is also removed from controversies around child labour, exploitation, overwork and degrading, mindless drudgery that were associated with factory labour at this time.

However, if the contemporary postcapitalist vision of the abolition of work has its origin in a capitalist dream of industry purified of the worker, this does not go uncontested for very long. Taking up the baton from William Morris, Oscar Wilde argued that it is 'mentally and morally injurious to man to do anything in which he does not find pleasure, and many forms of labour are quite pleasureless activities, and should be regarded as such'.[31] Both men are towering figures in British socialism. E. P. Thompson has argued that 'Morris was one of our greatest men, because he was a great revolutionary'.[32] Terry Eagleton has said of Wilde 'he wrote finely about socialism, spoke up for Irish republicanism when the British sneered at it, and despite his carefully nurtured flippancy displayed throughout his life a tenderness and compassion towards the dispossessed'.[33]

It is in recognition of their importance within the socialist movement that I want to take issue with how Morris and Wilde imagine the transformation of labour in postcapitalism. The arts, Morris declared, generate two types of pleasure; the first is derived from their use, principally in the beautiful decoration of well-made things, while the second consists in 'giving us pleasure in our work'.[34] Morris goes further than most commentators on the Arts and Crafts movement recognise, saying, as I have already noted, the 'first step towards making labour more attractive is to get the means of making labour fruitful, the Capital, including the land, machinery, factories, etc., into the hands of the community'.[35]

Wilde followed suit. 'Up to the present', he said, 'man has been, to a certain extent, the slave of machinery and there is something tragic in the fact that as soon as man had invented the machine to do his work he began to starve. This, however, is, of course, the result of our property system.'[36] Hence, it is the social relations of production – the confrontation between capital and labour – that Wilde regards as the key to the universal emancipation of labour through machinery. Taking the example of a machine that puts 500 labourers out of work and enriches a single individual who 'secures the produce of the machine',[37] Wilde proposed, '[w]ere the machine the property of all, every one would benefit by it'.[38]

Different from Ure, who sees mechanisation exclusively through the lens of the efficient maximisation of profit, Wilde speculates about the benefits of mechanisation for the unskilled worker. Whereas for Ure, the problem to solve is the inefficient presence of the worker within the rational organism of the factory, for Wilde what needs to be erased from history is the presence of unpleasant, unrewarding work. Technology held an emancipatory promise for Wilde because he believed that '[a]ll unintellectual labour, all monotonous, dull labour, all labour that deals with dreadful things, and involves unpleasant conditions', he said, 'must be done by machinery.'[39] There is a genuine political opposition between Ure's technologies of value extraction and Wilde's technologies of rest, but while Ure pins his hope on a capitalist use of technology, Wilde's opposition does not constitute a postcapitalist politics of the machine.

Wilde pitted himself directly against the moderate faction of the workers' movement of his day, when he says: 'There is nothing necessarily dignified about manual labour at all, and most of it is absolutely degrading',[40] but ultimately my argument is not simply the inverse of his – i.e. that manual labour is in fact dignified. Instead, I want to contextualise this claim as arising during a period when workers who fought for higher wages and better working conditions were frequently faced with the full force of the state: strikes were put down violently by the police and the military, and the first trade unionists were convicted as criminals. 'Throughout the entire nineteenth century, battles were carried out for the recognition of trade unions and strikes as a legitimate means of struggle.'[41] At exactly the time when Wilde rejected the so-called dignity of work, this slogan was being used to secure the legitimacy of workers and their struggle.

I want to dig a little deeper, though. The postcapitalist politics of work, I want to say, cannot be reduced to the replacement of workers with machines justified by an aesthetics of the activity of work. An aesthetic conception of what constitutes the fully human is the spine of Wilde's condemnation of work. Taking an example that he estimated would be as persuasive to the radical artisans leading the nineteenth-century resistance to capitalism as it would be to the capitalist class itself, Wilde proved his claim that most labour is degrading with the illustration of the street-cleaner. 'To sweep a slushy crossing for eight hours on a day when the east wind is blowing is a disgusting occupation.'[42] Taking another pop at the partisans of labour he asserted categorically: 'To sweep it with mental, moral, or physical dignity seems to me to be impossible. To sweep it with joy would be appalling. Man is made for something better than disturbing dirt. All work of that kind should be done by machine.'[43] The opposition between what men and women are made for and what machines are made for is therefore pivotal for Wilde's post-work prophecy of postcapitalism. Wilde

said, 'machinery will supply the useful things, and ... beautiful things will be made by the individual'.[44]

Like Lazzarato's defence of the production of subjectivity against capitalist production, Wilde's sense of what is proper to the human and what is proper to the machine follows the outlines of the aristocratic distinction between the liberal arts and the mechanical arts. Indeed, this is acknowledged in some respect when Wilde characterised the relationship between people and machines in the future through an image derived from Classical Greece. The Greeks were right, he says, to assert that 'civilization requires slaves'.[45] And while '[h]uman slavery is wrong ... mechanical slavery' is not. In fact, he says, everything depends on it. In proposing that machines become slaves to a human race now universally occupying the place of the idle rich, Wilde thematised a dimension of technological postcapitalism that has been repressed, namely the preservation of the aristocratic concept of labour which regards work as suitable only for slaves or their mechanised or robotic proxies.

The fundamental social distinction between the liberal arts and the mechanical arts was founded on the fact that the former were the arts taught to the sons (and some daughters) of the ruling class. The liberal arts were divided into the trivium and the quadrivium according to a hierarchy of activities governed by the Aristotelian principle of political activity (i.e. governance) as an end in itself. The trivium is the lower division of the seven liberal arts and comprises grammar, logic and rhetoric. The quadrivium, which was preparatory work for the study of philosophy and theology, consisted of arithmetic, geometry, music and astronomy.

In the old aristocratic regime, all activities were pegged to a hierarchy of the arts based on the dominant class's monopoly on education and its valorisation of scholarship but also its monopoly on inactivity. This survives into the early period of Industrial Revolution. John Barrell, the eminent Marxist art historian, explained that 'the use of the words "mechanical" and "servile" carry so heavy a charge in eighteenth-century writings on art' and comments that the word mechanical, in particular, 'continually occurs in contexts which are concerned with the process by which the theory of painting is reduced to a rule of thumb, a practical method'.[46]

It is possible to detect this aristocratic matrix of the human versus the mechanical in the arguments deployed in the seventeenth and eighteenth centuries to campaign for painting to be elevated from the mechanical to the liberal arts by Mengs, Felibien and others which culminated in the establishment of the Fine Arts as a distinct category. Notably, within this debate, the eighteenth-century Spanish humanist Antonio Palomino said 'in liberal art there is more contemplation than toil, and in mechanical art there is more toil than contemplation'.[47] When an art is completely mechan-

ical without any contemplation at all, then, for Palomino, it consists of nothing but 'the repetition of simple material practice and bodily exercise in humble, lowly and rather unworthy operations. It is regarded as contemptible or sordid because it stains, lowers and defiles the excellence of an individual's rank and person, although it is quite fitting for those who don the clothes of labour.'[48] Humanism, here, inherits a concept of the human that is modelled on the contemplative activity of the propertied, privileged, workless minority.

What I want to suggest is that the argument for the elimination of degrading manual labour through automation receives part of its promise from what survives of the aristocratic association of the mechanical with the sub-human. When Wilde says that manual work, or most of it, is utterly degrading, he extends the anticapitalist critique of industrial labour processes to a broader category of activities familiar to Aristotle. There is a novel symmetry to Wilde's argument, however, insofar as his noble horror of the mechanical arts can be allied to the interests of workers themselves by proposing that in the future all mechanical tasks will be completed by machines. Inverting Carlyle's account of the domination of humanity by the machine and therefore the reduction of men and women to mechanical operations, Wilde proposes that the two be kept apart and for humanity to dominate the machine. In place of the mechanisation of humanity, Wilde proposes to humanise the historical processes of mechanisation. Wilde's argument, therefore, can be read as reiterating the classical association of the truly human with an aloofness from manual labour which differs from its historical sources only by virtue of its universalisation through mechanisation.

Now, it is true that the 'subsumption of concrete labour by abstract labour through the medium of socially-necessary labour-time reduces the former to a monotonous, repetitive, and routinised activity'.[49] Hence the rejection of industrial labour is connected to the rejection of the real subsumption of labour under capital. However, the former cannot substitute for the latter. This is the difference between anti-industrialism and anticapitalism and is one of the main reasons why the theories of post-industrial society and post-Fordism generate so many red herrings for postcapitalist theory. For Wilde, anyway, the problem with work is not the problem with value production.

Wilde is forthright about his aversion to labour and models the emancipation from work expressly on the privileged freedom from work by the propertied.

Just as trees grow while the country gentleman is asleep, so while Humanity will be amusing itself, or enjoying cultivated leisure –

which, and not labour, is the aim of man – or making beautiful things, or reading beautiful things, or simply contemplating the world with admiration and delight, machinery will be doing all the necessary and unpleasant work.[50]

In this way, Wilde's descriptions of socialism conceal a class bias insofar as they call for the universalisation of the bourgeois relationship to the machine. Wilde does not take the side of capital against labour but assumes the superiority of a bourgeois life of rest over the proletarian life of work. What machinery promises, therefore, is the release of the workless beneficiaries of the work of others from blame. Wilde's postcapitalism is, I want to suggest, designed to vindicate his own intellectual pursuits cushioned as they are from the labour that is required to reproduce the world in which, for him, work is pleasure.

Both Morris and Wilde judged labour aesthetically and looked forward to the obsolescence of mindless work, but Morris stressed the transformation of the concrete activity of labour into the activity of the worker's self-realisation, whereas Wilde rejected degrading work in favour of modes of activity that are classified as forms of leisure. What made this leisure possible, for Wilde, was the anticipated proliferation of what I will call technologies of rest. Wilde, we can say, repurposed the capitalist utopia of mechanised production with a vision of the technological abolition of drudgery.

Wilde's argument that manual labour is degrading is persuasive only if we accept that it is the work process itself that determines the humanity of an act. Postcapitalism, for Wilde, is understood aesthetically, that is to say as a realm in which all work morphs into pleasure. Wilde, naturally, wished that his maid, the plumber, the cook and the street-cleaner could all enjoy their work as much as he does, but on the condition that their labour is replaced by machines that do all the work that they have abandoned. The aesthetic critique of manual labour is cast from an aristocratic mould of the workless disgust of the mechanical and the 'mechanicks' that performed it.

While it seems necessary to observe that Wilde conceives of a brave new world in the image of his pleasant privileged private life in the grave old world, Terry Eagleton makes a plea for leniency in this instance.

If he sometimes has the offensive irresponsibility of the aesthete, he also restores to us something of the full political force of that term, as a radical rejection of mean-spirited utility and a devotion to human self-realization as an end in itself which is very close to the writings of Karl Marx.[51]

This political project for the aesthetic is a worthy project, of course, but the abolition of mechanical labour also draws from a deep well of privilege in order to characterise work as the enemy of all. Is there not a preservation of the privilege of engaging only in pleasurable work lurking behind the fact that Wilde was disturbed by the affirmation of work within the workers' movement which he could not interpret as the affirmation of the class of labourers confronted with capital, machinery and the state?

Visions of the universal emancipation from work through the soothing prometheanism of technologies of rest are sustained throughout the twentieth century not by the workers' movement or members of the avant-garde but by academic authors of the establishment such as Bertrand Russell and John Maynard Keynes. Russell, in fact, replicated elements of Wilde's argument in his book *In Praise of Idleness*, published originally in 1935. John Maynard Keynes, too, confirmed the optimistic projections of worklessness through the promise of technology, arguing that, given the rate of capital growth due to improvements in productivity and technology, it may be possible, within a single lifetime, to match current outcomes in agriculture, mining and manufacture with only a quarter of labour which has previously been required. Further down the line, he estimated, it would be possible to cut the working week to fifteen hours if, as he assumed, the amount of work required for the reproduction of society is spread evenly amongst society.

Russell not only subscribed to the principle that 'the road to happiness and prosperity lies in an organised diminution of work',[52] but also that '[m]odern methods of production have given us the possibility of ease and security for all' and if, therefore, we continue to work as hard as we did before there were machines, then 'we have been foolish, but there is no reason to go on being foolish for ever'.[53] Mechanisation, here, has none of the threat of the machinic sublime or the robot gone rogue, nor even of the cyborg dissolution of the human essence that Russell hopes will be released by mechanisation. Russell's cultural politics of the machine is perhaps inadequate to contemporary readers, but he makes two related errors that are much more serious from the perspective of postcapitalism.

Russell claimed, '[m]odern technique has made it possible for leisure, within limits, to be not the prerogative of small privileged classes, but a right evenly distributed throughout the community',[54] because '[m]odern technique has made it possible to diminish enormously the amount of labour required to secure the necessaries of life for everyone'.[55] In one sense, of course, this calculation is correct. Capitalism does, in fact, diminish the amount of labour time required to produce the material wealth required to sustain life. However, the purpose of such technology is neither to produce the necessaries of life nor to release workers from work

in a rehabilitated conception of idleness.[56] Marx observed that machinery is at once 'the most powerful means for increasing the productiveness of labour – i.e., for shortening the working-time required in the production of a commodity' and at the same time 'it becomes in the hands of capital the most powerful means … for lengthening the working day beyond all bounds set by human nature.' [57]

If it were true in principle, as Russell suggests, that machines designed to increase the rate of extracting surplus value from labour power brings about a condition under which labour might be reduced for the benefit of workers, there remains the question of under what conditions capitalists would relinquish control over them or how the drive for value would be replaced by the drive for idleness. That is to say, technologies of rest seem to be the material basis for a re-evaluation of leisure and laziness against the work ethic but in fact depend upon a revolution in the material of technological production that is no longer driven by value production. That is to say, if we can read Russell's praise of idleness as a vague depiction of postcapitalism, we have to admit that his vision is only possible if the dominance of capitalist production has already been superseded.

It may seem self-evident that postcapitalism will rid society of degrading work. However, this is a false universalisation of worklessness insofar as it universalises only the privileged term of the binary. Worklessness has historically been a privilege for the few and an agony for the many and, on a global scale, remains so. The social basis for the privileged loathing of work is not undermined by the introduction of the work ethic and the condemnation of laziness nor by the simple affirmation of labour as the activity of human self-realisation, since both retain the binary of work and rest in the form given to these categories by non-working property-owners. That is to say, the problem with work is also the problem with leisure. If we only address the problem of work without addressing at the same time the problem of contemplation as a form of worklessness, the problem of artistic labour as a form of workless work, as well as the problem of intellectual work as not really work at all, then the entire political weight of the social division of labour bears down only on its most subordinate element.

The fact that work is often unpleasant and degrading should not be taken as proof that the aristocracy were right all along that work is sub-human. Normative value attached to the pursuits of propertied non-working owners are part and parcel of the persistent defamation of workers and work. Technological postcapitalism may seem to be a great leap forward for those who have internalised the aristocratic and bourgeois denunciation of work. However, this is a one-sided solution to an historical dilemma in which the subordinate – workers, women, slaves, indigenous communities, migrants, etc. – has always been blamed for its own immiseration.

Just as the end of colonialism means an end to the culture of white supremacism rather than the annihilation of people of colour, and the end of patriarchy means an end to violence against women rather than the complete suppression of women, the problem of work is not resolved by abolishing work in order for everyone to enjoy aristocratic pursuits but by simultaneously developing a critique of the aristocratic model of what constitutes the good life and the revalorisation of all the labour that makes rest comfortable and rewarding (care-giving, social reproduction and the production of goods, infrastructure and services).

It is not surprising that the subordinate term of a political opposition receives the bulk of criticism throughout the history of social division, but it is never justified. This is partly because the distinction between unpleasant or degrading labour on the one hand and aesthetic labour or intellectual work on the other is an expression of the social division of labour from the perspective of privilege. Stuart Hall argued that the cultivated rejection of mass culture is best understood as a thinly-veiled attack on the masses. According to the same logic, when the left today speak of the abolition of work, we must translate this back into the language of class struggle and ask why it is only the abolition of the working class, not the abolition of all classes, which is being advocated.[58]

In addition to the troubling reaffirmation of the noble disgust of mechanical labour, I want to argue, there is a fundamental error in any politics of work that calls for the abolition of work through the development of technologies of rest. The purpose of machinery within the capitalist mode of production, Marx demonstrates, is to shorten that part of the day in which the worker performs necessary labour and extend that portion of the working day in which the worker produces surplus value.

Postcapitalism does not consist of pleasurable work or the abolition of work altogether to make way for uninterrupted leisure but the abolition of value production and the steering of human activity by the social process of accumulating capital. At best, the aesthetic condemnation of manual labour is a false trail in the politics of work. At worst, when manual work appears to be degrading within the noble conception of humanity then the bourgeois work ethic is only overcome with an aristocratic condemnation of mechanical work rather than a postcapitalist critique of how labour is distorted by value production. This error is not corrected by the machinic sublime which emerges in the early decades of the twentieth century.

Walter Benjamin was right, I want to argue, to detect a glimmer of hope in the technological reproducibility of culture.[59] While the legacy of Benjamin's insight has accrued around the idea that mechanical reproducibility cancels the aura of the unique art object – which assigns a subjective, experiential affect to mechanisation[60]– I want to emphasise

the more fundamental point that the politics of art, from the perspective of postcapitalism, does not depend on isolating art from technological developments in order to preserve a mode of allegedly nonalienated handicraft production. Benjamin, I want to say, recognised the two-sided development of technological reproducibility. For instance, while film, photography, sound-recording and other mechanical forms of cultural production reduced the human presence in culture to a minimum, technological developments eroded the longstanding condition of literature in which 'a small number of writers confronted may thousands of readers' and establish the new condition in which 'the reader is ready to become a writer',[61] at any moment.

What is significant, here, is not that Benjamin anticipated the indeterminacy of the producer and consumer (in contemporary ideas about the prosumer, playbour, or the supposed 'exploitation' of the user – as content supplier – of social media[62]), but that his political reading of the impact of technology on art and culture did not limit itself to complaints about standardisation etc. or affirmations of the mass distribution of culture etc., but the dissolution of the social relations of cultural production. Although Benjamin characterises the diminution of the aura along a path from its heyday in prehistorical magic and premodern authorship to the mass entertainment of Charlie Chaplin (i.e. the aura is ousted by the commodity, not by the abolition of capitalist commodity production), this is a vital element of the analysis of art's relationship to technology because postcapitalism (as the supersession of value production) is principally a question of the transformation of the social relations of capitalist commodity production.

Conclusion:
Gratuity, Digitalisation and Value

In Left Accelerationism, contemporary postcapitalism is presented as a post-work world expedited by automation and AI. Whereas the first generation to confront industrialisation and mechanisation saw the machine as a dehumanising tendency, and later the trade union sector of the traditional left regarded roboticisation as a direct threat to jobs, accelerationist postcapitalists on the left such as Srnicek and Williams, Aaron Bastani and Paul Mason look to roboticisation, automation, AI, smart technologies and the internet of things for signs of promise 'to liberate humanity from the drudgery of work while simultaneously producing increasing amounts of wealth'.[1] This image is rooted jointly in a feminist politics of work and a post-Marxist 'refusal of any socialist idolatry of work as the essence of the human'[2] that is also the seedbed of Kathi Weeks' politics of anti-work, which 'is best understood in very broad terms as designating a general political and cultural movement – or, better yet, as a potential mode of life that challenges the mode of life now defined by and subordinated to work'.[3]

If the proposal of the end of work is combined with the universal basic income, or a similar mechanism, then it presupposes the persistence of money, markets, exchange, commodities and capital.[4] It is possible to see the communisation strand of postcapitalism (which, in the words of Théorie Communiste, is 'the extension of the situation where everything is freely available'), as distinct from Left Accelerationism (insofar as it insists that communism is 'immediate' rather than the result of revolutionary social or technological changes). Also, by focusing on 'the destruction of the commodity-form and the simultaneous establishment of immediate social relations between individuals' it places more emphasis on gratuity than the technological emancipation from work. 'Gratuity is the forcible appropriation of commodities on the basis of need and their subsequent destruction as commodities',[5] as John Cunningham puts it. Communisation, therefore, is characterised by the dispute between the advocacy of noncapitalist 'enclaves'[6] (from 'squats, to communal gardening, communes themselves, and other practices of "commoning"'[7]) and proposals for the transition from capitalism to commons.

Art has not featured heavily as an example of the commons in communisation literature, but the commons has become a prominent trope in

the discourses of contemporary art, and commoning has been taken up as a principle for contemporary socially-engaged art practices.[8] Running parallel to projects of commoning in contemporary art, the legacy of the avant-garde shows itself in the long tail of institutional critique which today turns on demands for the remuneration of artworkers. In principle, these two political projects for art point in opposite directions, one anticipating the dissolution of market exchange and the other making demands within it. The Hegelian Marxist argument that artistic labour is a prototype of nonalienated labour in postcapitalism appears to be not only the fruit of the myth of the artist as genius but also a force for the hyper-exploitation of the artist as an unpaid worker. Art's commodification has become a truism, but in current debates on art and capitalism the insistence that the artist is a worker has replaced the Frankfurt School assertion that the artwork is a commodity.

By way of a conclusion for this book, I want to consider how debates on work in art can be guided by a value theory reading of the commons as an anticipation of the supersession of value production. I will do this, in large part, through a dual critique of two prominent value theory models of digital culture. The first, Christian Fuchs' proposal that users of Web 2.0 platforms are unacknowledged workers who produce value for big tech companies through their unpaid work posting content on Facebook, Instagram, Twitter and the like, extrapolates the feminist politics of work in the direction of a Frankfurt School theory of capitalism's expansion into everyday life and the culture industry.[9] The second, Jakob Rigi's theory that the value of digital products tends towards zero because sound files, image files, movie files, apps and so on can be copied instantly, automatically and effortlessly in numberless quantities with an average socially-necessary labour time of nothing, is more closely related to the politics of the commons but also recalls Marxist debates on how the social relations of the capitalist mode of production constrain the capacity of new technologies.[10] (I will revisit this last question at the end of the conclusion.)

First, though, I want to say something about the convergence of the commons, digital technology, value and culture. I take it that the politics of gratuity in contemporary postcapitalism resonates with the romance of free and open source software, which was originally perceived by some as a radical alternative to the proprietary operating systems and applications of big tech companies. Julian Stallabrass recalls that Web 2.0 'was seen as an enclosure of what had been a commons'[11] by the technologically informed left which led, among other things, to a subculture of illegal copying in opposition to the proprietorial control of data. However, this optimism was always contested by 'a darker view of the new technology,

emphasizing its capitalist character and its tendency to extend and deepen the harsh consequences of capitalist relations of production'.[12]

In art, these debates have a familiar ring to them. Hopes that the digital commons would deliver us from capitalism duplicate the error of 'dematerialisation' in the politics of Conceptualist art in the 1970s which hoped that 'art that can be shown inexpensively and unobtrusively in infinite locations at one time' might 'be able to avoid the general commercialization'[13] of art. Insofar as some anticapitalist artists, critics and curators believed that there would be no effective demand in the art market for Xeroxed text works or art that consisted of fleeting acts with temporary material effects (bodily actions, for instance, that survived only in documentary photographs), there are two problems with the dematerialisation argument. First, such practices and products were no less material than painting and sculpture,[14] and second, capitalism is not subverted by modifying the concrete qualities of the commodity.[15] Although art is not an example of capitalist commodity production, what the dematerialisation episode teaches us is that there is nothing in the concrete quality of artistic labour or the concrete quality of artworks themselves that can defy the art market.

If there is a digital commons, it is not because of the concrete qualities of digital products or the concrete qualities of digital labour. Accordingly, a value theory of labour can be applied to digital labour but a *digital labour theory of value* or a *value theory of digital labour* puts the emphasis on the concrete character of the labour rather than its social relations. Fuchs, who is a leading voice in a tendency that politicises digital culture by unmasking the exploitation of users by big tech companies, argues: 'On corporate social media, play and labour converge into play labour that is exploited for capital accumulation.'[16] Drawing on value theory and a substantial history of thinking about the so-called 'audience commodity', Fuchs builds an argument that consumers are exploited and unheralded producers of Web 2.0 super-profits.

This argument resonates with the contemporary politics of work, post-Fordist theories of cognitive capitalism and immaterial labour as well as the critical reassessment of the initial optimism in Web 2.0 technology.[17] Arguing that 'prosumption is used for outsourcing work to users and consumers, who work without payment',[18] Fuchs concludes that 'capitalist prosumption is an extreme form of exploitation in which the prosumers work completely for free.'[19] The internet, he argues, 'stands for the total commodification and exploitation of time – all human time tends to become surplus-value-generating time that is exploited by capital'.[20]

Fuchs' analysis of social media is guided by Dallas Smythe's theory that the audience for advertising on radio and TV should be reconceived as

workers who produce surplus value for media companies who sell the so-called 'audience commodity' to advertisers.[21] The commodity form of mass communications, he said, is the audience itself. The idea of the audience commodity being sold to the advertiser is feasible from the perspective of both those who sell advertising space and those who buy it. Different packages of time and space are priced differently because of the quantity and quality of the audience that corresponds to them. Smythe, Sut Jhally and Bill Lavant all testify that 'network executives and advertisers talk about buying and selling audiences',[22] however, the ostensive ownership of the so-called audience commodity never passes from the seller to the buyer. This point was made at the time, in Michael Lebowitz's original critique of Smythe and his followers. Lebowitz asked how 'the media sells what it can never have property rights over: the audience?'[23] Ultimately, of course, the point of gaining access to these audiences is to convert them into consumers. 'And, we have consumers doing their part by buying',[24] as Lebowitz pointed out.

Fuchs rejects Lebowitz's criticism of the audience commodity idea as an example of 'wage-labour fetishism'. 'Wage-labour fetishists', Fuchs says, are so much fixed on the wage labour–capital relation that 'they exclude non-wage labour … from the category of exploitation'.[25] First, I want to say something about the concept of wage-labour fetishism, and then I will comment on the application of the concept of exploitation in Fuchs. Wage labour is not decisive in value theory. Waged labour can be either productive or unproductive, depending on whether wages are paid by capital or revenue, or whether wages are provided by the consumer of the labour or labour power is purchased for resale (in the form of a commodity or service) to a final consumer. Consequently, if wage-labour fetishists exist, then they are a shoddy bunch.

From a value theory perspective, the audience is not the commodity. Advertisers do not purchase the audience but rent space. Fuchs explains his preference for the audience commodity theory over the value theory of rent by saying 'To speak of Facebook as a rent-seeking[26] organization implies that its users are unproductive,[27] that they do not create value.'[28] This conflates (1) the analysis of the transaction between advertisers and Web 2.0 companies, and (2) the analysis of the role of internet users in the economics of big tech profits. This conflation has its source in Smythe's argument that the audience is both (1) the commodity that is sold to advertisers, and (2) the unpaid workers whose labour (the activity of looking at adverts) produces value for the sellers of advertising space.

Since not all labour produces value, we need to identify those that do. But this does not imply that value production is more legitimate or morally deserving than the production and maintenance of material wealth – in

fact, it is value production that postcapitalism must supersede and so the normative scales might fall in the opposite direction. Fuchs is correct that 'Facebook cannot make money if its users do not constantly use the platform',[29] but it does not follow that these users are therefore productive labourers or that Facebook's relationship to its users is the same as or equivalent to the industrial capitalist's relationship to wage labourers.

Fuchs is correct that 'Facebook exploits them [i.e. users]',[30] but he is mistaken when he argues 'Facebook does not rent out virtual space, but sells a commodity.'[31] Since no commodity is sold to advertisers – not even the attention of users – then Fuchs is wrong when he concludes: 'Users produce this commodity; Facebook exploits them and thereby accumulates capital. Facebook is not a rentier, but a capitalist company that exploits users.'[32]

Lebowitz gave a succinct economic account of the role of advertising for capital in the media that is worth quoting in full because it remains as accurate for Web 2.0 as it was for TV.

> We have industrial capital seeking a means of reducing its total costs of circulation to a minimum in order to maximize the valorisation of capital; we have it choosing among various avenues for its selling expenditures in order to maximize its increase in sales relative to the expenditures undertaken. Profits of media-capitalists are a share of the surplus value of industrial capital.[33]

Prosumers may well be 'exploited' in the colloquial sense of the term but since advertising does not add value but only facilitates the realisation of returns on value production through the sale of what is advertised, value is not produced by looking at adverts or uploading selfies to sites funded by advertising.

Fuchs' argument that unwaged labour can produce value is intertwined with his argument that unwaged workers such as women and slaves can be exploited. For Fuchs, the exploitation of digital labour involves three elements: coercion, alienation and appropriation.[34] What Fuchs does not allow, here, is the possibility that web users might be exploited despite not producing any value at all. Exploitation is not another word for value extraction. Indeed, there is a long history of exploitation before the advent of value production in capitalism.[35] His shift from the discussion of value production to an argument about exploitation, therefore, is either a misreading of Marxism or an exit from it. Another problem with the emphasis on the exploitation of the prosumer cloaks the exploitation of the producers of commodities advertised online (e.g. Chinese factory workers) and the exploitation of digital workers employed by Web 2.0

companies (e.g. Indian call-centre workers). If consumers are exploited, then it follows that the richer they are, and the more leisure time they have, the more they are exploited. Capitalism does not exploit consumers, it realises its returns on the investment of capital through their purchases. This point was made within the original critique of Smythe by Lebowitz.

My criticisms of the theory of the prosumer as value producer do not imply that users are not exploited (although users are clearly not exploited in the principal sense of the ratio between necessary and surplus labour[36]), nor that digital products have no value. What I want to suggest, rather, is that the analysis of the relationship between the internet and capitalism recognises a heterogeneous lattice of productive, unproductive and useful labour. Since the profits of web tech capitalism are a share of the surplus value of industrial capital diverted to them through advertising budgets, no new value is added in the distributional circuits of social media. Gough explains this point with the example of an employee of a merchant capitalist enterprise. Since no value is added in circulation, 'commercial workers are unproductive labourers, despite the characteristics they have in common with workers in the process of production – above all the fact that they are similarly exploited through having to supply unpaid labour.'[37] We can add that consumers enjoined by advertising to purchase goods from this unproductive commercial worker do not add value by actively participating in advertisement-led cultural exchanges.

Jakob Rigi has developed a rival Marxist analysis of digital culture that also draws on value theory in which he claims that digital products are not the result of labour and therefore their value tends to zero. This is based on the observation that digital products such as MP3s and pdfs can be replicated infinitely and instantly. Marx does not provide a value theory for digital products or anything resembling them. In Marx's time, copying something meant making it again and usually involved the same kind of labour as the production of the original. In the case of digital files, this is no longer the case. So, when we apply Marxist value theory to them, we have to be cautious in mapping one form onto another.

In collaboration with Robert Prey, Rigi links the digital product to the commodity in Marx's analysis of value production through a noteworthy divergence in the concrete character of the product: 'The "information commodity" thus differs drastically from physical goods and most services, where, all conditions being equal, the cost and time spent on the reproduction of the commodity are equal to those spent on its production.'[38] The issue turns on the question of reproduction or copying because, as Prey and Rigi correctly put it, for Marx 'it is the social labor time required to reproduce – not produce – a commodity that determines its value'.[39]

The value of a product is determined at the time of exchange not the time of production, and it is set, as Marx learned from Ricardo, not by actual labour time but the abstract labour time required to reproduce it. This is because in exchange the product enters into an object–object relation with equivalents – a process in which abstract labour triumphs over concrete labour. Digital copying does not correspond to the process of reproduction that Ricardo and Marx rightly identified as decisive in the production of value. Digital copying does not partake of the object–object relation in the exchange of equivalents and therefore, rather than reproducing the product so automatically that its value tends to zero, it is a process which bypasses exchange and the determination of value altogether.

I want to try to shed light on this by distinguishing between the labour time required in the original production of a digital production and the distributive act of copying, downloading, retweeting or forwarding digital material. Let's acknowledge that digital reproduction introduces a difficulty in determining whether a certain process counts as production or distri-bution. That is to say, when a digital file is copied, another item appears to be produced and the original item is distributed to another location. Consider a comparison between analogue and digital commercial music production and distribution. A vinyl record was not distributed at the same time that it was produced in the factory, and there were two separate processes in the radio broadcast of a live performance by Hank Williams such that the production of the music (by a band on stage in front of an audience) was technically distinct from the transmission of the music to radios scattered around the geographical area that could receive the radio signal. Now, in the case of digital material, it appears (when looking at the matter from the end of process, i.e. from the product) that the consumer's click both reproduces the item and distributes it simultaneously.

However, we can still say that the performance and recording of a piece of music are both distinct processes, and that these operations are distinct from the copying of the digital file. Now, in the case of recorded music, there is typically a master-tape no matter what format is used to retain the information (magnetic tape, floppy disc, external hard drive). This material must go through a second process in order to be saleable on a mass market rather than saleable only as a unique product to specialist collec-tors of memorabilia. When recordings are converted into vinyl or cassettes there is no problem for value theory – it is no different in principle from the printing of books from a single press. The products remain commodi-ties and these commodities preserve portions of the original value plus the value of producing the vinyl or cassette.

Now consider a song played on the radio. When radio stations played vinyl records, the record itself had a value, but the radio was broadcast to listeners free of charge, either funded by the state or advertising (as well as potential purchasers of the records that were promoted on the radio). It is not the case that the product shifts from having value (as vinyl) to having no value (listening to the song for free on the radio) to having value again (purchased by radio listeners). The product has value but this can be realised by the owner of the product in a number of different ways. The product, in this instance a vinyl record, acts as raw material for the radio presenter and is therefore dead labour (i.e. no new value is added and its value has already been realised through its sale).[40]

When the mass production of a musical performance is superseded by digital reproduction a new situation arises. A performance (or separate performances of individual tracks) remains distinct from the technical process of streaming or uploading or hosting of digital files for consumers. Even if the performance is live and the streaming is immediate, the technical requirements of recording the music are different from the technical requirements of making the recording available online. However, once musical performances have been digitised they are in principle capable of being copied and disseminated in an infinite number at no extra production cost. It is at this stage of the whole process that it appears, in the consumer's perspective, that digital products are effortlessly and immediately duplicated and distributed.

Digital products are neither like land (not produced by labour), nor like antiques (not reproducible), but appear to have no value for Rigi and others because copying is costless and automatic (i.e. produced by a machine not labour). The speed and effortlessness of digital copying does not prove that a product of labour loses its value when it is replicated. Similarly, stealing a commodity does not result in the commodity having no value. A thief can subsequently realise the value of the product through sale, of course. Hence, getting hold of something for free does not mean that the item has no value. When a big tech company pays wages to coders and designers to produce apps or digital content for sale, these workers are productive labourers and the product has value, part of which is the surplus value that is extracted by the company. If the company – in league with the state – develops measures to prevent piracy, illegal downloading, p2p sharing and so forth, this is to protect the value in the product, not a rent-seeking attempt to derive profit from a product that has no value.

Paul Mason, Paul Romer[41] and Jeremy Rifkin[42] come at the same issue from a different angle. Rather than turning to the Marxist theory of value, they draw on the mainstream theory of 'zero marginal cost'. Rob Lucas explains: 'while data costs something to produce, it tends to be free to copy

– like the pdf of an article, for example; duplicated information has "zero marginal cost", and is "non-rivalrous" in the sense that my possession of it does not prevent anyone else from also having it.'[43] Mason describes this technological development in terms of a confrontation between capitalist and noncapitalist activities: 'Peer produced free stuff drives out commercially produced commodities ... In response, capitalism is beginning to reshape itself as a defence mechanism against peer production, through info-monopolies'[44] and other measures.

In Rigi's theory, this push-back from capitalism proves his point. The need for copyright laws covering the sale of digital material is taken as proof that income from such commodities is rent rather than profit, proof in other words that what is being sold has no value. However, the legal buttressing of private property, and the enclosure of the commons, have been necessary for capitalism from the outset. Their appearance signals continuity, not a new kind of crisis for value production. Digitalisation, automation, roboticisation and AI require capitalism to protect value production by imposing new laws that enclose the commons, but this is simply the latest iteration of a long-standing condition that Marx and Engels knew well:

> The forces of production available to society no longer serve for the advancement of bourgeois civilisation and the bourgeois relations of property; on the contrary, the forces of production have become too powerful for these relations, they are impeded by them, and as soon as they overturn this impediment, they bring the whole of bourgeois society into disorder and endanger the existence of bourgeois property.[45]

Postcapitalist theories of the destruction of value and the elimination of marginal costs tend to be underdetermined. Other forces are played down or left out of the account altogether. From Oscar Wilde, Bertrand Russell and John Maynard Keynes to the Left Accelerationists and Paul Mason, they underestimate the battery of forces that rise up to prevent capitalism from being driven out by gratuity. Also, what has not been considered is how the diminishing role of labour in automated production will increase the costs of non-automated labour.[46] Postcapitalism visions of the technological emancipation from work will appear as nothing more than fairy tales if they complain that capitalism seems deliberately to obstruct the development of postcapitalism despite the fact that this would be beneficial.

Jasper Bernes accuses Left Accelerationists of subscribing to the 'fettering thesis'. I will end this conclusion with an alternative reading of the fettering thesis that will bring together issues around technology, capi-

talism and postcapitalism in a way that recasts the politics of work and the theory of art as nonalienated labour so that the analysis can focus on the supersession of value production. This brief rearticulation is intended to fill the gap in contemporary postcapitalism – a political project within the full scope of counter-tendencies, not a rival for them.

Instead of recognising that 'the factory system actualizes capital's control over labour', Bernes says the fettering thesis argues that the factory system, or 3-D printers and self-driving cars, 'contains the germ of a new world in the making'[47] but this development is blocked. The argument was first formulated by Marx and Engels in the *Manifesto*, when they said 'private property has become a fetter and a barrier in relation to the further development of the forces of production' and was given its distinctive formulation by Marx in the preface to the *Contribution to a Critique of Political Economy*, when he wrote:

> At a certain stage of development, the material productive forces of society come into conflict with the existing relations of production or – this merely expresses the same thing in legal terms – with the property relations within the framework of which they have operated hitherto. From forms of development of the productive forces these relations turn into their fetters. Then begins an era of social revolution.[48]

In one reading, the fettering thesis appears to claim that technological developments themselves will bring capitalism to its end insofar as fettering provokes revolution. In another reading, capitalism prevents the full development of technologies. There is also a version of fettering that applies specifically to art.[49] In G. A. Cohen's influential analysis, a central ambiguity in the phrasing is opened up to reveal three different types of fettering.[50] Each of the three types of fettering, he suggests, refers to 'the concept of output'[51] and by 'output' he means Gross National Product.[52] Here, capitalism and postcapitalism are compared according to the same measure: GNP. However, this measure is non-committal[53] about the distinction between value production and the production of material wealth. What Cohen fails to build into his calculations, therefore, is the difference between how production is measured in capitalist and postcapitalist production.

In my reading of Marx, the capacity of the forces of production are fettered by capitalist relations of production and unfettered by postcapitalist relations of production precisely insofar as they are developed specifically for value production rather than the production and maintenance of material wealth. This gives us not a fourth type of fettering but a qualitatively different conception of fettering: namely, that production

driven by the accumulation of value is a fetter on production driven by use and need. Fettering, of this sort, comprises the enclosure[54] of the commons, including the legal apparatuses for enforcing value extraction. This is what gives practices of commoning their political vitality today. Economies of gratuity are the negation of private property and market exchange. Such decommodification undermines capitalist forms of the circulation and ownership of goods. The digital commons is justly reputed to unfetter the development of the productive forces, but it is not always the case that campaigns for the commons target value production specifically.

What Marx's fettering thesis tells us, first and foremost, is that postcapitalism does not depend on another technological revolution. The stage at which the forces of production outstripped capitalism was evident in the middle of the nineteenth century. Each new technological wave in production since then has not changed this, but has provided a fresh – and for each generation, a more vivid – glimpse of the fetters placed on the capacity of technology by the drive to accumulate value. Therefore, the promise of mechanisation, automation, roboticisation, digitalisation and AI is only as imminent now as it was in 1848.

Postcapitalism does not mean the aestheticisation of work or the unfettered use of automation for the purpose of releasing workers from work. Postcapitalism does not result in the merging of work and pleasure or the cancellation of the division between work and art. Art is not the prototype of labour freed from value production. Despite all this, art is aligned with every noncapitalist activity and every subordinate mode of production (including every clash within capitalist activity itself between use value and exchange value) in a hostility to capitalism that is rooted in the rejection of capital accumulation as the rationale for living.

Notes

Introduction

1. Activist artists today often play down questions of artistic transformation and revolutions in technique which characterised the twentieth-century avant-gardes. Instead, a strong emphasis is placed on direct political goals in pragmatic struggles for immediate and urgent changes. Even when art's institutions come under political and ethical scrutiny by contemporary activist artists, such as boycotting art organisations associated with global oil corporations and the arms trade, short-term objectives (e.g. to force a corporate sponsor of art to withdraw from an art institution) do not appear to be guided by any medium-term purpose (e.g. to abolish the corporate sponsorship of art in general) or the long-term strategy of superseding the social system (e.g. to end capitalism).
2. Peter Hudis, *Marx's Concept of the Alternative to Capitalism* (Chicago: Haymarket Books, 2013), p. 2.
3. Gerald Raunig, *Art and Revolution: Transversal Activism in the Long Twentieth Century* (Los Angeles, Ca.: Semiotext(e), 2007), p. 28. Original emphasis.
4. *Ibid.*, p. 30.
5. *Ibid.*, p. 56.
6. Nick Srnicek and Alex Williams, *Inventing the Future: Postcapitalism and a World Without Work* (London: Verso, 2015), p. 28.
7. See Jacques Rancière, *Dissensus: On Politics and Aesthetics*, translated by Steven Corcoran (London: Continuum, 2010).
8. See Chantal Mouffe, *Agonistics: Thinking the World Politically* (London: Verso, 2013).
9. Symptomatic of this conception is the argument that 'critical theory, or "critique", has become a master narrative, is complicit in its domination of aesthetic discourses, and is deserving of critical analysis'. See *Beyond Critique: Contemporary Art in Theory, Practice, and Instruction*, edited by Pamela Fraser and Roger Rothman (New York: Bloomsbury, 2017).
10. If the definition of critique is limited to the emancipatory shadow of power, and therefore critique is defined exclusively by its opposition to whatever is dominant, it is impossible for critique to be pervasive. I adopt a broader conception of critique which recognises that it is possible to have widespread critical practices, long-standing critical approaches and even dominant critical methodologies. Viewed methodologically, critique must constantly reexamine itself but it does not follow that the spread or persistence of critical practices automatically deprives them of their critical character.
11. Anne Paternak, 'Foreword', *Living as Form: Socially Engaged Art From 1991–2011*, edited by Nato Thompson (New York: Creative Time Books, 2012), p. 7.

12. Arguably, today, art is assigned critical status entirely on account of who makes it. So long as the canon remains white, masculine and heterosexual, the inclusion of women, people of colour and queer artists is itself a form of critique regardless of whether the work itself is critical in its form, content or use.

13. Anthony Gardner, *Politically Unbecoming: Postsocialist Art Against Democracy* (Cambridge, Mass.: MIT Press, 2015), p. 179.

14. *Ibid.*, p. 15.

15. Nato Thompson and Greg Sholette, *The Interventionists: Users' Manual for the Creative Disruption of Everyday Life* (North Adams, Mass.: MoCA/MIT Publications, 2004).

16. W.A.G.E., 'News', https://wageforwork.com/home#top (accessed 6 January 2019), np.

17. Tania Brughera, 'Arte Util Criteria', http://www.arte-util.org/tools/structure/ (accessed April 2019).

18. Alan Sears, *The Next New Left: A History of the Future* (Nova Scotia: Fernwood Publishing, 2014), p. 2.

19. Andrea Fraser, 'How Has Art Changed?', *Frieze*, 94 (October 2005) quoted in Marc James Léger, *Brave New Avant Garde: Essays on Contemporary Art and Politics* (London: Zero Books, 2012), p. 8.

20. I will quote her answer in full: 'We're in the midst of the total corporatization and marketization of the artistic field and the historic loss of autonomy won through more than a century of struggle. The field of art and now only nominally public and non-profit institutions has been transformed into a highly competitive global market. The specifically artistic values and criteria that marked the relative autonomy of the artistic field have been overtaken by quantitative criteria in museums, galleries and art discourse, where programmes are increasingly determined by sales – of art, at the box office and of advertising – and where a popular and rich artist is almost invariably considered a good artist, and vice versa. Art works are increasingly reduced to pure instruments of financial investment, as art-focused hedge funds sell shares of single paintings. The threat of instrumentalization by corporate interests has been met in the art world by a wholesale internalization of corporate values, methods and models, which can be seen everywhere from art schools to museums and galleries to the studios of artists who rely on big-money backers for large-scale – and often out-sourced – production. We are living through an historical tragedy: the extinguishing of the field of art as a site of resistance to the logic, values and power of the market' (*ibid.*, p. 8).

21. Léger, *Brave New Avant Garde*, p. 111.

22. 'In an age in which the idealism of art activism substitutes for radical change', Léger says, 'over-identification begins by rejecting "positive" symbolic experience and by directly conceding to capitalism's merciless reduction of the social world to economic markets' (Léger, *Brave New Avant Garde*, p. 113).

23. Nato Thompson, *Seeing Power: Art and Activism in the 21st Century* (Brooklyn, NY: Melville House, 2015), p. 60.

24. *Ibid.*, p. 61.

25. *Ibid.*, p. 70.
26. The former, which has become a caricature of the traditional left, can be illustrated with the example of the Marxist art historian, Meyer Schapiro, who affirmed the 'great importance in painting of the mark, the stroke, the brush, the drip, the quality of the substance of the paint itself, and the surface of the canvas as a texture and field of operation – all signs of the artist's active presence (Schapiro, *Modern Art: 19th and 20th Centuries* (New York: George Braziller, 1979), p. 218). Schapiro contrasts painting with the repetitive drudgery of industrial labour. Against this position, contemporary art's institutions and discourses are marked by the ascendance of various campaigns for wages, recognition, working conditions, workers' rights and so on which are based on the latter argument that the myth of the artist as a self-determined and driven individual 'who works for "love" rather than "money" perpetuates the hyper-exploitation of the culture industries characterised by "the donation of quantities of free labor under the auspices of committed professionalism"' (Sarah Brouillette, 'Academic Labor, the Aesthetics of Management, and the Promise of Autonomous Work', *nonsite.org*, 9, np).
27. Paul Gilroy, *The Black Atlantic* (London: Verso, 1993), p. 40.
28. Srnicek and Williams, *Inventing the Future*, p. 85.
29. Moses Hess, *The Holy History of Mankind and Other Writings*, edited by Shlomo Avineri (Cambridge: Cambridge University Press, 2004), p. 111.
30. *Ibid.*, p. 117.
31. Some of this activism is restricted to questions of redistribution (allocating a fair distribution of the proceeds of art sales according to the amount of work undertaken by a long list of individuals who have previously been excluded from or marginal to the normative concept of the artist as author and creator); some, also, focuses on the so-called rights of highly-educated workers and conflates their struggles for a greater share of the social surplus with the global precariat; and some of it appears to me to press for neoliberal goals, albeit unwittingly, insofar as it seeks to extend the wage system into modes of activity that have until now resisted the capitalist mode of production.
32. Kathi Weeks, *The Problem with Work: Feminism, Marxism, Antiwork Politics, and Postwork Imaginaries* (Durham: Duke University Press, 2011), p. 230. In my argument, the opposition of work and life is a partial glimpse of postcapitalism that can be more accurately expressed as the opposition between life and capital or the opposition of life and the drive for value production.
33. André Gorz, *Paths to Paradise: On the Liberation from Work* (London: Pluto Press, 1985), p. 53.
34. Paolo Virno, 'Virtuosity and Revolution: The Political Theory of Exodus', translated by Ed Emery, *Radical Thought in Italy: A Potential Politics*, edited by Paolo Virno and Michael Hardt (Minneapolis: University of Minnesota Press, 1996), p. 196.
35. Weeks, *The Problem With Work*, p. 13.
36. *Ibid.*, p. 12.
37. Lafargue quoted in Weeks, *The Problem with Work*, p. 98.
38. Weeks, *The Problem with Work*, p. 15.

39. Harry Cleaver, *Rupturing the Dialectic: The Struggle Against Work, Money and Financialization* (Edinburgh: AK Press, 2017), p. 266.
40. *Ibid.*, p. 266.
41. Hudis, *Marx's Concept of the Alternative to Capitalism*, p. 7.
42. Kevin B. Anderson, *Marx at the Margins: on Nationalism, Ethnicity, and Non-White Societies* (Chicago: Chicago University Press, 2016).
43. See Costas Hadajimichalis, *Uneven Development and Regionalism: State, Territory and Class in Southern Europe* (London: Croom Helm, 1987).
44. Mahmood Mamdani, *The Darker Side of Modernity: Global Futures, Decolonial Options* (Durham: Duke University Press, 2011), p. 2.
45. WReC, *Combined and Uneven Development, Towards a New Theory of World-Literature* (Liverpool: Liverpool University Press, 2015), p. 20.
46. Walter Mignolo, *The Darker Side of Modernity: Global Futures, Decolonial Options* (Durham: Duke University Press, 2011), p. 2.
47. Michael Hardt and Antonio Negri, *Commonwealth* (Cambridge, Mass: Harvard University Press), p. 67.
48. WReC, *Combined and Uneven Development*, p. 12.
49. *Ibid.*, p. 12.
50. *Ibid.*, pp. 12–13.
51. Nicolas Bourriaud (ed.), *Altermodern: Tate Triennial* (London: Tate, 2009).
52. WReC, *Combined and Uneven Development*, pp. 14ff.
53. David Harvey, *Spaces of Hope* (Edinburgh: Edinburgh University Press, 2002), p. 52.
54. Edward Said, *Culture and Imperialism* (London: Chatto and Windus,1993), p. 249.
55. Doreen Massey, *For Space* (London: Sage, 2005), p. 63.
56. Stuart Hall, 'When was the "Post-colonial"? Thinking at the Limit', in I. Chambers and L. Curtis (eds), *The Post-colonial question* (London: Routledge, 1996), p. 250.
57. Dave Beech, *Art and Value: Art's Economic Exceptionalism in Classical, Neoclassical and Marxist Economics* (Leiden: Brill, 2015).

Chapter 1

1. Karl Kautsky, *Thomas More and His Utopia* (London: Lawrence and Wishart, 1979 [1888]), p. 162.
2. Rob Lucas, 'The Free Machine', *New Left Review*, 100, 2016, p. 142.
3. A. L. Morton, *The English Utopia* (London: Lawrence and Wishart, 1969 [1952]), pp. 11–34.
4. Walter Benjamin, *Charles Baudelaire: A Lyric Poet in the Era of High Capitalism* (London: Verso, 1997), p. 79.
5. See Maynard Solomon, *Marxism and Art: Essays Classic and Contemporary* (Detroit, MI: Wayne State University Press, 1974), p. 574.
6. Ernst Bloch, *The Principle of Hope*, translated by Neville Plaice, Stephen Plaice and Paul Knight (Cambridge, Mass.: MIT Press, 1986 [1959]).
7. Fredric Jameson, 'The Politics of Utopia', *New Left Review*, 25, 2004, p. 40.

8. Silvia Federici, *Caliban and the Witch* (New York: Autonomedia, 2009), p.154.
9. Bruno Gulli, *Labor of Fire: The Ontology of Labor Between Economy and Culture* (Philadelphia, Pa.: Temple University Press, 2005), p. 4.
10. Jasper Bernes questions the wisdom of the Marxist concept of 'fettering' in his excellent discussion of postcapitalist agriculture: Bernes, 'The Belly of the Revolution: Agriculture, Energy, and the Future of Communism', in *Materialism and the Critique of Energy*, edited by Brent Ryan Bellamy and Jeff Diamanti (Chicago: MCM Publishing, 2018). I will return to the question of fettering in the conclusion.
11. Capitalism in England begins with an agrarian revolution. The Levellers cut into the spatial arithmetic of capitalism at a time when 'English landed estates at home and in the colonies were the primary source of the raw materials necessary for economic activity and the wealth of the nation' (Neal Wood, *John Locke & Agrarian Capitalism* (Berkeley, Ca.: University of California Press, 1984), p. 38), while the justification of private property, trade and wealth was couched, at the time, by Locke's assertion that 'In the beginning all the World was America' (Wood, *John Locke*, p. 51) and later, the Utopian Socialists fled industrial capitalism in Western Europe to set up colonies in North America. What's more, the salve for the damage of industrialisation appeared to the likes of Cadbury, Owen and Peabody to be a paternalistic form of spatial reordering.
12. For a discussion of the concept of harmony in Utopian Socialism see Keith Taylor, *The Political Ideas of the Utopian Socialists* (London: Frank Cass, 1982), pp. 3–4.
13. For Kautsky, Utopian Socialism is utopian 'less on account of the impracticability of its aims than on account of the inadequacy of the means at its disposal for their achievement' (Kautsky, *Thomas More*, p. 249).
14. Louis Marin, *Utopics: Spatial Play*, translated by Robert Vollrath (New Jersey: Humanities Press, 1984).
15. David Harvey, *Spaces of Hope*, p. 24.
16. *Ibid.*, p. 25.
17. David Fernbach, 'Introduction', in Karl Marx, *The Revolutions of 1848: Political Writings*, Volume 1 (London: Verso, 2010), p. 39.
18. *Ibid.*, p. 59.
19. Michael Löwy, *The Theory of Revolution in the Young Marx* (Chicago: Haymarket Books, 2005), p. 75.
20. Ruge quoted in Löwy, *The Theory of Revolution*, p. 97.
21. *Ibid.*, p. 85.
22. One of the earliest references to postcapitalism can be found in Monty Neil's 'Rethinking Class Composition Analysis in the Light of the Zapatistas', written in 1997. (See *Auroras of the Zapatistas: Local and Global Struggles of the Fourth World War*, edited by Midnight Notes (New York: Autonomedia, 2001), p. 127.)
23. John Holloway, *Change the World Without Taking Power: The Meaning of Revolution Today* (London: Pluto Press, 2010).

24. John Holloway and Eloína Peláez, *Zapatista! Reinventing Revolution in Mexico* (London: Pluto Press, 1998), p. 7.
25. *Ibid.*, p. 15.
26. Luis Lorenzano, 'Zapatismo: Recomposition of Labour, Radical Democracy and Revolutionary Project', in Holloway and Peláez, *Zapatista!*, p. 130.
27. Midnight Notes, *Auroras of the Zapatistas*, p. 12.
28. Gustavo Esteva, in *Auroras of the Zapatistas*, p. 60.
29. J.K. Gibson–Graham, *A Postcapitalist Politics* (Minneapolis: University of Minnesota Press, 2006), p. xx.
30. *Ibid.*, p. xxii.
31. *Ibid.*, p. xx.
32. *Ibid.*, p. xx.
33. John Holloway, *In, Against and Beyond Capitalism: The San Francisco Lectures* (Los Angeles, Ca.: PM Press, 2016), p. 20.
34. This is verified in reports of the consensus among the Oaxacans to spend their surplus on planting corn and beans and vegetables 'to provide for their basic subsistence independent of the world market'. Midnight Notes, *Auroras of the Zapatistas*, p. 18.
35. Márgara Millán, 'Zapatista Indigenous Women', in Holloway and Peláez, *Zapatista!*, p. 67.
36. Monty Neil in Midnight Notes, *Auroras of the Zapatistas*, p. 125.
37. *Ibid.*, p. 127.
38. Théorie Communiste, 'Much Ado About Nothing?', *Endnotes*, 1, 2008, p. 184.
39. Gilles Dauvé and Karl Nesic, 'Love of Labour? Love of Labour Lost...', *Endnotes*, 1, 2008 (2002), p. 105.
40. Théorie Communiste, 'Much Ado About Nothing?', p. 204.
41. *Ibid.*, p. 185.
42. The Endnotes collective refer to a more specific conception of 'traditional Marxism' which derives from the humanist Marxist Iring Fetscher, with whom Postone studied (*Endnotes*, 2010, p. 81n).
43. Jean Baudrillard, *The Mirror of Production*, translated by Mark Poster (St Louis: Telos Press, 1975), p. 17.
44. By choosing the vague idea of production and its normative and absolute representation productivism, Baudrillard sacrifices analytical efficacy for the sake of polemical advantage. His merging of capitalism and Marxism renders Baudrillard's own theory incapable of distinguishing between productivity (a measurable increase in the proportion of economic output to economic input), the labour theory of the production of value (i.e. necessary and surplus value), and the social ontology of the production and reproduction of material wealth (i.e. the appropriation and transformation of natural resources and raw materials for material and immaterial use).
45. André Gorz, *Farewell to the Working Class: An Essay on Post-Industrial Society*, translated by Michael Sonenscher (London: Pluto Press, 1982 [1980]), p. 73.
46. *Ibid.*, p. 67.
47. Endnotes, 'Defeat', *Endnotes*, 4, 2015, p. 158.

48. E. P. Thompson, *The Making of the English Working Class* (London: Penguin, 1963).

49. Endnotes, 'Communisation and Value-Form Theory', *Endnotes*, 2, 2010, p. 101.

50. Gilles Dauvé, 'Human, All Too Human', *Endnotes*, 1, 2008, p. 101.

51. *Ibid.*, p. 213.

52. Théorie Communiste, 'Communization in the Present Tense', *Communization and its Discontents: Contestation, Critique, and Contemporary Art,* edited by Benjamin Noys (New York: Autonomedia, 2012), pp. 47–8.

53. Racist deaths are due not to a vague cultural legacy of slavery but the continuation of the colonial condition. 'From the same land, the Belgians took ivory, the Americans cobalt, and now billions of Earthlings everywhere carry little bits of Africa around with them in their pockets'. Benjamin Bratton, *The Stack: On Software and Sovereignty* (Boston, Mass.: MIT, 2015), p. 82.

54. Kathi Weeks argues, persuasively, that socialist feminism's 'most significant contribution to the critical theory of work in the 1970s was the expansion of the category'. Weeks, *The Problem with Work*, p. 24.

55. Jairus Banaji, *Theory as History: Essays on the Modes of Production and Exploitation* (Chicago: Haymarket Books, 2011), p. 347.

56. Kevin B. Anderson, *Marx at the Margins*, p. 10.

57. *Ibid.*, p. 237.

58. Marcello Musto, *Another Marx: Early Manuscripts to the International* (London: Bloomsbury, 2018), p. 247.

59. Nancy Holmstrom quoted in Tithi Bhattacharya, *Social Reproduction Theory: Remapping Class, Representing Oppression* (London: Pluto Press, 2017), p. 3.

60. Jacques Bidet, *Critical Companion to Contemporary Marxism*, edited by Jacques Bidet and Stathis Kouvelakis (Leiden: Brill, 2001), p. 16.

61. *Ibid.*, p. 13.

62. Moishe Postone, *Time, Labour and Social Domination: A Reinterpretation of Marx's Critical Theory* (Cambridge: Cambridge University Press 1993), p. 39. In this passage Postone says: '[his theory allows us] to recover Marx's notion of socialism as a postcapitalist form of social life. I have argued that the historical relationship of socialism to capitalism, for Marx, is not simply a question of the historical preconditions for the abolition of private ownership of the means of production, and the replacement of the market by planning. This relationship should also be conceived in terms of the growing possibility that the historically specific role of labor in capitalism could be superseded by another form of social mediation. This possibility, according to Marx, is grounded in an increasing tension generated by capitalist development between value and "real wealth". This tension points to the possible systemic abolition of value and, hence, of abstract domination' (*ibid.*, p. 39).

63. Hudis, *Marx's Concept of the Alternative to Capitalism*, p. 6.

64. Karl Marx, *Economic and Philosophical Manuscripts*, translated by Martin Milligan (London: Lawrence and Wishart, 1959 [1844]), p. 30.

65. Postone, *Time, Labour, and Social Domination*, p. 37.

66. It is worth pointing out that 'productivism', as a critique of Marxism, has always vacillated between a critique of the workers' movement, a critique of supply-side economics, a critique of Soviet communism and a theory of post-Fordism. For instance, the accusation of productivism for Baudrillard is not oriented around the refusal of work but, as he reveals in the final chapter of his book, the rise of consumerism. 'The bourgeoisie knew how to make the people work, but it also narrowly escaped destruction in 1929 because it did not know how to make them consume ... the problem was no longer one of production but one of circulation. Consumption became the strategic element; the people were henceforth mobilized as consumers; their "needs" became as essential as their labor power' (Baudrillard, *The Mirror of Production*, p. 144). Productivism is problematic for Baudrillard primarily because it fails to recognise the explosion of advertising and the boom in consumption in the 1950s and 1960s as well as the oligopolistic reorganisation of capitalism in Keynesian planning in concert with the rise of identity politics. In this regard, Baudrillard's analysis belongs not to postcapitalist literature but to the theory of the post-industrial society that Daniel Bell was formulating at the same time as characterised by computerisation, service industries, information economies and so on.

67. Daniel Bell distinguishes pre-industrialism, industrialism and post-industrialism through technological stages of development. Pre-industrialism, he says, is extractive; industrialism fabricates; and, post-industrialism processes. Not only does this schema fail to account for handicraft within the pre-industrial mode of production, but it obscures the crucial effects of the industrialisation of extraction (mining, fishing, etc.) and the transformation of fabrication by automation, as well as neglecting pre-industrial forms of information-processing and the mechanisation of knowledge within industrial processes of deskilling. Bell also underplays the role of knowledge and science within industrial production in order to differentiate his conception of post-industrial society from modernity.

Chapter 2

1. This pattern is not followed by Robert Kurz who argues that 'the producers of art, and reflexive thinking ... have to emigrate inwardly and, at least, secretly declare their irreconcilable hostility to the criteria of the market'. Robert Kurz, 'The Degradation of Culture', *Krisis: Contributions to the Critique of Commodity Society* (London: Chronos Publications, 2002), pp. 12–13.

2. It should be noted that the slave trade cast a long shadow over Enlightenment thinking about freedom, work, art, sovereignty and related issues. The urgent task of decolonising aesthetics on the basis of a recognition of 'the history and role of the image of the black in the discussions which found modern cultural axiology' (Gilroy, *The Black Atlantic*, p. 8), includes the rhetorical analysis of the normative contours of the artist, genius, connoisseur, 'man of taste' and so on (namely, freedom, truly human, self-fashioning, etc.) as formed within

a discursive *milieu* structurally determined by the slave, the 'negro' and the 'savage', as exemplars of unfreedom, the sub-human, etc.

3. Immanuel Kant, *Critique of Judgement*, translated by Werner S. Pluhar (Indianapolis: Hackett, 1987 [1790]), p. 171.

4. See Henry Louis Gates, *Figures in Black: Words, Signs and the 'Racial' Self* (Oxford: Oxford University Press, 1987) for a reading of Kant that discloses the racist matrix in which these ideas of freedom, satisfaction and subjectivity operated in the Enlightenment. In this context, Gates observes the 'demands made in European critical discourse that the black master "the arts and sciences" if he or she is to be truly "free"' (p. xxxii) and notes that 'learning to write, as measured against an eighteenth-century scale of culture and society, was an irreversible step away from the cotton field toward a freedom larger even than physical manumission' (p. 4).

5. Kant, *Critique of Judgement*, p. 190.

6. Andrew Hemingway points out (in the context of the English development of aesthetic thought in the eighteenth century) that 'those who were unconcerned with the practicalities of producing art were more likely to see affinities between the arts'. Andrew Hemingway, *Landscape Between Ideology and the Aesthetic: Marxist Essays on British Art and Art Theory, 1750–1850* (Chicago: Haymarket, 2017), p. 43. In this sense, there is no such thing as artistic production in the eighteenth century, only a bundle of distinctive arts that, from the perspective of the consumer, appear to have certain qualities in common. Subsequently, of course, institutions of art (i.e. art in general, not the specific arts of painting, sculpture, music and so forth) are developed so that the abstract category of art becomes a real abstraction.

7. Kant, *Critique of Judgement*, p. 190.

8. *Ibid.*, p. 171.

9. Friedrich Schiller, *Aesthetical and Philosophical Essays*, edited by Nathan Haskell Dole (Boston, Mass,: Francis A. Niccolls, 1954), p. 35.

10. *Ibid.*, p. 64.

11. As Lukàcs pointed out, Schiller was the first to weaponise aesthetics in the critique of existing society by 'extending the aesthetic principle far beyond the confines of aesthetics, by seeing it as the key to the solution of the question of the meaning of man's existence in society'. Georg Lukàcs, *History and Class Consciousness: Studies in Marxist Dialectics*, translated by Rodney Livingstone (Cambridge, Mass.: MIT Press, 1971 [1923]), p. 139.

12. Jasper Bernes, 'Art and Revolution', *The Sage Handbook of Frankfurt School Critical Theory*, Volume 3 (London: Sage, 2018), p. 1278. Bernes goes on to say: 'The integration of art and social production will overcome the industrial division of labor as well as the division between free and compelled activity.' This, in my reading, is partly if not wholly a Schillerian project.

13. Moses Hess, *The Holy History of Mankind and Other Writings*, edited by Shlomo Avineri (Cambridge: Cambridge University Press, 2004), p. 107.

14. *Ibid.*, pp. 110–11.

15. Marx, *Economic and Philosophical Manuscripts*, pp. 75–6.

16. *Ibid.*, p. 76.

17. Marx, *Grundrisse*, p. 611.
18. Karl Marx, *Capital: A Critique of Political Economy Volume 3*, translated by Ben Fowkes (London: Penguin, 1982 [1867]), p. 759.
19. Marx, *Economic and Philosophical Manuscripts*, p. 73.
20. *Ibid.*, p. 72.
21. Karl Marx, *Theories of Surplus Value Part 1*, translated by Emile Burns (Moscow: Progress Publishers, 1978 [1862–75]), p. 285. The term 'spiritual production' is not Marx's own. This statement is a critical reply to Henri Storch's distinction between material production and spiritual production. By spiritual production, Marx says, Storch means 'all kinds of professional activities of the ruling class'. Marx explains that since Storch 'does not conceive material production itself historically ... he deprives himself of the basis on which alone can be understood partly the ideological component parts of the ruling class, partly the spiritual production of this particular social formation'. It is in this context that Marx says, 'the relation is not so simple as he presupposes' and immediately gives the example of art and poetry.
22. Gyorgy Markus says 'Marx regarded the progressive commodification of all products of human activities as constituting an aspect of capitalist production, which made it "hostile to art and poetry" in general.' Markus, 'Walter Benjamin or: The Commodity as Phantasmagoria', *New German Critique*, 83, 2001, p. 3. Art cannot be commodified, Markus says, because commodification 'can only be applied to products which are socially reproducible' and therefore 'it has no meaning for genuine works of art as strictly individual and irreplaceable objects of human objectivity (characteristics Marx accepts as self-evident)'. *Ibid.*, pp. 3–4.
23. Marx, *Economic and Philosophical Manuscripts*, pp. 72–3.
24. Chris Arthur argues that the Marxist case for the supersession of capitalism depends on this understanding of alienation. 'Let us note in particular that, if through productive activity man objectifies himself and lives in a world he has himself made, this is no less true when he alienates himself and fails to recognize himself in the system of estrangement brought about through alienated objectification. It is this conceptual inflection rather than mutual exclusion of the categories "objectification" and "alienation" that permits theoretical space for grasping the objective necessity of a historical supersession, which would otherwise be a utopian "demand".' Chris Arthur, *Dialectics of Labour: Marx and his Relation to Hegel* (Oxford: Basil Blackwell, 1986), p. 16.
25. Rudolf Wittkower, 'Individualism in Art and Artists: A Renaissance Problem', *Journal of the History of Ideas*, Vol. 22, No. 3, 1961, p. 295.
26. This narrative must be set within a global context of uneven and combined development that includes, among other things, an acknowledgement that the confrontation between industrialisation and handicraft took a different form in the colonies. In India, for instance, handicraft persisted in parallel with partial industrialisation even after 1947, when India gained independence from the British Empire. And in North America, the legacy of settler colonialism is today being challenged by, among other things, preserving indigenous handicraft traditions.

27. Anthony Blunt, *Artistic Theory in Italy 1450–1660* (Oxford: Oxford University Press, 1987 [1940]), p. 49.
28. *Ibid.*, p. 51.
29. Longinus, *On Great Writing: On the Sublime*, translated by G. M. A. Grube (Indianapolis: Hackett Publishing, 1991), p. 5.
30. Excerpt from the statutes of the Académie Royale quoted in Christian Michel, *The Académie Royale de Peinture et de Sculpture – The Birth of the French School, 1648–1793*, translated by Chris Miller (Los Angeles, Ca.: The Getty Research Institute, 2018), p. 112.
31. G. C. Argan, *The Renaissance*, translated by Robert Allen (London: Thames and Hudson, 1969), p. 7.
32. *Ibid.*, p. 13.
33. This is confirmed, albeit in a different tone, by Kristeller, who described the elevation of painting and sculpture in the Renaissance as follows: 'What characterizes the period is not only the quality of the works of art but also the close links that were established between the visual arts, the sciences and literature.' Paul O. Kristeller, 'The Modern System of the Arts: A Study in the History of Aesthetics Part I', *Journal of the History of Ideas*, Vol. 12, No. 4, 1951, p. 513.
34. Martin Wackernagel, *The World of the Florentine Renaissance Artist: Projects and Patrons, Workshop and Art Market*, translated by Alison Luchs (New Jersey: Princeton University Press, 1981 [1938]), p. 314.
35. In the case of painting, the preparation of panels and the carving of frames had always been activities executed by carpenters and grinding colours and making brushes were jobs for apprentices. For the guild artisan and the scholarly painter alike, accomplished apprentices and adept assistants were trusted to execute works of art, but for the latter it was essential that the master had planned and sketched beforehand. Likewise, transcribing a drawing to full size or adding colour to an outlined painting, were skilled activities that could be assigned to apprentices and assistants. Whereas paintings within the guild workshop were collectively produced and might be entrusted to assistants and apprentices, and for the scholarly painter a number of processes could be handed over to others, the elevation of painting above handicraft was based, initially, on the insistence that designing the work and composing its elements was reserved exclusively for the master, as was the application of the finishing touches or retouches. In the case of sculpture, sourcing the stone or marble, carving out the block and transporting it could be done by a group of artisans or assistants. Also, carving out the basic shape of a sculpture could be completed by apprentices or assistants. Most of the laborious chiselwork would be assigned by the master to members of his workshop and the full-size clay model would be made by assistants and apprentices with the master supervising and making final adjustments. What differentiated the scholarly sculptor from the artisan was the insistence with which the preliminary drawing and the initial model for the sculpture in wax or clay would be made by the master. Or, alternatively, the sculptor could transform even

the most menial task into an opportunity to improvise, innovate, invent and rethink, as Michelangelo did.

36. For an account of the emergence of the division between the *studiolo* and the *bottega* in the Renaissance see Michael Cole and Mary Pardo, *Inventions of the Studio, Renaissance to Romanticism* (Chapel Hill: University of North Carolina Press, 2005).

37. This is a complex question because it intersects with the dispute over whether the guild regulations retarded economic development. For a mainstream analysis of the guilds as an inefficient mode of production, see Sheilagh Ogilvie, 'Rehabilitating the Guilds: a Reply', *Economic History Review*, 61: 1, 2008, pp. 175–82. And for the original argument that the guilds have been misrepresented by laissez-faire economists, see S. R. Epstein, 'Craft Guilds, Apprenticeship, and Technological Change in Pre-Industrial Europe', *Journal of Economic History*, 58, 1998, pp. 684–713. My argument, however, cuts across the argument within mainstream economics, which accused it of not being commercial enough, by focusing on the Académie's accusation of the guild as principally a commercial institution.

38. Kant, *Critique of Judgement*, p. 190.

39. Donald J. Harreld, 'Craft Guilds in the Early Modern Low Countries', *The Sixteenth Century Journal*, Vol. 39, No. 1, 2008, p. 134.

40. Marx, *Capital*, p. 423.

41. *Ibid.*, p. 480.

42. Michel, *The Académie Royale*, p. 134.

43. André Félibien 'Preface to *Conférence de l'Académie de Peinture et de Sculpture*', *Art and Its Histories* edited by Steve Edwards (New Haven: Yale University Press, 1999 [1669]), p. 35.

44. *Ibid.*, p. 35.

45. *Ibid.*, p. 35.

46. During the same period, the quarrel over whether to privilege colour or drawing in the early years of the Académie Royale reflected in the Académie's recently obtained monopoly on drawing and the guild's longstanding monopoly on colour. Since 'colour' was associated with the manual task of grinding pigments and staining cloths, it was, in some measure, a coded reference to handicraft. Either, colour could be relegated to a low status below drawing and line, or colour could be assigned a new intellectual significance that it did not have for the guilds. Both sides of the quarrel built their arguments on the need to elevate the Académie above the artisan practices of the colour grinders and dyers.

47. I take this phrase from Michael Fitzsimmons, *From Artisan to Worker: Guilds, the French State, and the Organization of Labor 1776–1821* (Cambridge: Cambridge University Press, 2010). Also see William Sewell, *Work and Revolution in France: The Language of Labor from the Old Regime to 1848* (Cambridge: Cambridge University Press, 1980) and James Farr, *Artisans in Europe, 1300–1914* (Cambridge: Cambridge University Press, 2000).

48. Hans Abbing, *Why Are Artists Poor? The Exceptional Economy of the Arts* (Amsterdam: Amsterdam University Press, 2002), p. 36

49. Carol Gould, *Marx's Social Ontology: Individuality and Community in Marx's Theory of Social Reality* (Cambridge, Mass.: MIT Press, 1978).

50. Philip Kain, *Schiller, Hegel and Marx: State, Society, and the Aesthetic Ideal of Ancient Greece* (Kingston: McGill-Queen's University Press, 1982).

51. Bruno Gulli, *Labor of Fire: The Ontology of Labor Between Economy and Culture* (Philadelphia: Temple University, 2005).

52. Herbert Marcuse, *The Aesthetic Dimension: Toward a Critique of Marxist Aesthetics* (Basingstoke: Macmillan, 1990 [1978]), p. 37.

53. Marcuse, *Heideggerian Marxism*, edited by Richard Wolin and John Abromeit (Nebraska: Nebraska University Press, 2005 [1932]), p. 94.

54. *Ibid.*, p. 109.

55. Marcuse, 1955, p. 153.

56. Musto, *Another Marx*, p. 84.

57. Thanks to Andrew Hemingway for drawing my attention to this text.

58. Max Braunschweig, 'The Philosophic Thought of the Young Marx', *Alienation: The Cultural Climate of Our Time*, edited by Gerald Sykes (New York: George Braziller, 1964), p. 504.

59. *Ibid.*, p. 506.

60. *Ibid.*, p. 506.

61. *Ibid.*, pp. 504–5.

62. *Ibid.*, p. 504.

63. Adolfo Sánchez Vásquez, *Art and Society: Essays in Marxist Aesthetics*, translated by Maro Riofrancos (London: Merlin Press, 1973 [1965]), p. 85.

64. Hans Robert Jauss and Peter Heath, 'The Idealist Embarrassment: Observations on Marxist Aesthetics', *New Literary History*, Vol. 7, No. 1, 1975, p. 206.

65. Meyer Schapiro, *Modern Art: 19th and 20th Centuries* (New York: George Braziller, 1979), p. 218. Schapiro did not focus on the rejection of commerce or the antipathy to handicraft but the contrast to industrial production in art's distinctive sensitivity to hand, eye, tool and object.

66. John Molyneux, *The Future Socialist Society* (London: Socialist Workers Party, 1987 [1986]). He explains: 'By non-alienated labour I do not mean labour that exists "outside" of capitalism (which is increasingly non-existent), or labour that does not produce commodities (the massive commodification of art under capitalism is obvious), or even labour that people enjoy (some people "enjoy" some alienated labour and some non-alienated labour is not enjoyable).'

67. Owen Hatherley *The Chaplin Machine: Slapstick, Fordism and the Communist Avant-Garde* (London: Pluto Press, 2016), p. 26.

Chapter 3

1. 'The "worker" is generally thought of as someone white and male, employed in, say, the car industry. Workers have a capitalist boss and belong to unions. Employers and workers (as described above) seem to share a remarkably consistent view of these individuals.' Eva Kaluzynska, 'Wiping the Floor with

Theory: A Survey of Writings on Housework', *Feminist Review*, No. 6, 1980, p. 28.

2. Caroline A. Jones, *Machine in the Studio: Constructing the Postwar American Artist* (Chicago: University of Chicago Press, 1996), pp. 1–59.

3. I take this brilliant description of the unrecognised producers of art from Dani Child's paper at the AAH conference in London in 2018.

4. See Martha Woodmansee, *The Author, Art, and the Market: Rereading the History of Aesthetics* (New York: Columbia University Press, 1994).

5. Precarious Workers Brigade, 'Training for Exploitation', *The Journal of Aesthetics and Protest*, 2012, p. 14.

6. W.A.G.E., 'Wagency', https://wageforwork.com/wagency (accessed March 2019), 2018, np.

7. Bojana Kunst, *Artist at Work: Proximity of Art and Capitalism* (London: Zero Books, 2015), p. 31.

8. Anton Vidokle, 'Art Without Work?', *e-flux*, #29, November 2011 https://www.e-flux.com/journal/29/68096/art-without-work/ (accessed 27 November 2018).

9. Steven Shaviro, 'Accelerationist Aesthetics: Necessary Inefficiency in Times of Real Subsumption', *e-flux* #46 (June 2013) https://www.e-flux.com/journal/46/60070/accelerationist-aesthetics-necessary-inefficiency-in-times-of-real-subsumption/ (accessed 27 November 2018).

10. Linda Nochlin, *Women, Art, and Power and Other Essays* (London: Thames and Hudson, 1989), p. 38.

11. *Ibid.*, p. 46.

12. *Ibid.*, p. 45.

13. Helen Molesworth, 'House Work and Art Work', *October*, Vol. 92, Spring, 2000, p. 80.

14. Julia Bryan-Wilson, *Art Workers: Radical Practice in the Vietnam War* Era (Berkeley, Ca.: University of California Press, 2009), p. 16.

15. *Ibid.*, p. 16.

16. *Ibid.*, p. 18.

17. Precarious Workers Brigade, 'Training for Exploitation', p. 17.

18. Bryan-Wilson, *Art Workers*, p. 28.

19. Francis O'Connor, *Federal Support for the Visual Arts: The New Deal and Now* (New York: New York Graphic Society, 1969).

20. Bryan-Wilson, *Art Workers*, p. 28.

21. *Ibid.*, p. 29.

22. *Ibid.*, p. 130.

23. *Ibid.*, p. 130.

24. It is necessary to point out that working-class women are proletarian in a way that women in academia are not. And, if women are the true proletariat, then middle-class women, in this view, are as proletarian as working-class women, which results in the absurd conclusion that middle-class women belong to the 'true proletariat' whereas working-class men do not.

25. The Renaissance consisted of an intense importation of knowledge from what the nineteenth century called 'the east' in a shared cultural heritage of

the classical world combined with the beginnings of the trans-Atlantic slave trade. By the time that Vasari published his *Lives of Eminent Painters, Sculptors and Architects* in 1550, the European genocide of the Americas in the space of 50 years had reduced the population from 80 million to 10 million and this encounter 'was partly responsible for defining Europe's shift from a medieval world to a more recognizably modern world'. Jerry Brotton, *The Renaissance: A Very Short Introduction* (Oxford: Oxford University Press, 2006), p. 97. The myth of the artist carried within it the differential code which distinguished the European gentleman from the 'savage' and the slave as well as the woman.

26. These hagiographic scenes certainly conform entirely with the gender asymmetries of the Renaissance. Only men could behave in this way. Even cultivated noble women such as Isabella d'Este, who had her own *studiolo* and excelled at Greek and Latin, were assigned a secondary role: 'Her great capacity was left to express itself in patronage.' For the minority of women in the Renaissance who risked everything to achieve great things of their own, there was enormous social pressure, if they wanted to be taken seriously, to 'create "a man within the woman"'. Margaret L. King, *Women of the Renaissance* (Chicago: University of Chicago Press, 1991), p. 197.

27. Griselda Pollock, *Old Mistresses: Women, Art and Ideology* (London: I. B. Taurus, 2013), p. xviii.

28. Richard Sennett's book, *The Craftsman* (London: Penguin, 2008), is a liberal humanist repackaging of the ideas of Ruskin and Morris filtered through C. Wright Mills' concerns about the 'morale of the cheerful robots' in his influential study of office-bound handicraft, *White Collar*. 'As ideal', Wright Mills said, 'craftsmanship stands for the creative nature of work, and for the central place of such work in human development as a whole.' C. Wright Mills, *White Collar* (Oxford: Oxford University Press, 1963 [1951]), p. 383. Andy Merrifield's *The Amateur* (London: Verso, 2017) plots his route out of capitalism along a similar path but with a stronger emphasis on enthusiasms rather than the professions.

29. John Ruskin, *Unto This Last and Other Writings* (London: Penguin, 1985), p. 87.

30. *Ibid.*, p. 87.

31. *Ibid.*, p. 87.

32. This was said during a speech on 'The Decorative Arts' delivered to the Trades Guild of Learning in London in 1877.

33. E. P. Thompson, *William Morris: Romantic to Revolutionary* (Los Angeles, Ca.: PM Press, 2011 [1976]), p. 32.

34. *Ibid.*, p. 17.

35. Patrick Brantlinger, '*News from Nowhere*: Morris's Socialist Anti-Novel', *Victorian Studies*, 19:1, 1975, p. 44.

36. *Ibid.*, p. 38.

37. *Ibid.*, p. 38.

38. Gorz, *Farewell to the Working Class*, p. 73. Gorz clarifies this point by saying: 'The realm of freedom can never arise out of material processes; it can only be established by a constitutive act which, aware of its free subjectivity, asserts itself as an absolute end in itself within each individual' (p. 74).



39. Gorz, *Paths to Paradise*, p. 50. Like Fourier, Gorz puts his hope for the emancipation from work in variety: 'All activities are impoverishing when they cannot be alternated with activities drawing upon other mental and physical energies' (Gorz, *Farewell to the Working Class*, p. 103). Gorz's anti-work politics is closer to a revival of Fourier's concept of 'attractive labour' in which the worker is happy in her work not because the work itself is enjoyable but because she never has to do any particular task for very long.
40. Gorz, *Farewell to the Working Class*, p. 67.
41. *Ibid.*, p. 82.
42. Gorz, *Paths to Paradise*, p. 34.
43. Gorz, *Farewell to the Working Class*, p. 140. He goes on: 'the freeing of time through a free choice of working hours is the best and most rapid way of "changing the quality of life" and, at the same time, of creating jobs' (Gorz, *Farewell to the Working Class*, p. 144).
44. https://nonsite.org/article/academic-labor-the-aesthetics-of-management-and-the-promise-of-autonomous-work (accessed April 2019).
45. Åke Sandberg, *Enriching Production: Perspectives on Volvo's Uddevalla Plant as an Alternative to Lean Production* (Aldershot: Avebury, 1995 [2011]), p. 1.
46. Peter Frase, *Four Futures: Life After Capitalism* (London: Verso, 2016), p. 41.
47. Miya Tokumitsu, *Do What You Love: And Other Lies about Success & Happiness* (New York: Regan Arts, 2018), p. 151.
48. Kaluzynska, 'Wiping the Floor with Theory', p. 29.
49. Andrew Ross, *No Collar: The Humane Workplace and its Hidden Costs* (Philadelphia, Pa.: Temple University Press, 2003), p. 20.
50. Franco 'Bifo' Berardi, *The Soul at Work: From Alienation to Autonomy*, translated by Francesca Cadel and Guiseppina Mecchia (Los Angeles, Ca.: Semiotext(e), 2009), p. 24.
51. Paolo Virno, 'Virtuosity and Revolution: The Political Theory of Exodus', p. 193.
52. Berardi, *The Soul at Work*, p. 24.
53. Virno, 'Virtuosity and Revolution', p. 193.
54. 'Here, staff are required to decorate their uniforms with "seven pieces of flair" (i.e. badges or other personal tokens), to express their "individuality and creativity": a handy illustration of the way in which "creativity" and "self-expression" have become intrinsic to labor in Control societies.' Mark Fisher, *Capitalist Realism: Is There No Alternative?* (London: Zero Books, 2009), p. 39.
55. Luc Boltanski and Eve Chiapello, *The New Spirit of Capitalism* (London: Verso, 2005 [1999]), p. 81.
56. *Ibid.*, pp. 90–6.
57. *Ibid.*, p. 444.
58. Pascal Gielen, *The Murmuring of the Artistic Multitude: Global Art, Memory and Post-Fordism*, translated by Clare McGregor (Amsterdam: Valiz, 2009), p. 24.
59. *Ibid.*, p. 24.
60. *Ibid.*, p. 25.

61. Stevphen Shukaitis, *The Composition of Movements to Come: Aesthetics and Cultural Labor After the Avant-Garde* (London: Rowman and Littlefield, 2016), p. 84.
62. Kathi Weeks, *The Problem with Work*, p.101.
63. *Ibid.*, p. 103.
64. *Ibid.*, p. 13.
65. Michael Hardt and Antonio Negri, *Empire* (Cambridge, Mass.: Harvard University Press, 2000), p. 293. The quotation is from Dorothy Smith, *The Everyday World as Problematic: A Feminist Sociology* (Boston, Mass.: Northeastern University Press, 1987).
66. Chantal Mouffe, *For a Left Populism* (London: Verso, 2018), p. 39.
67. J.K. Gibson–Graham, *The End of Capitalism (As We Knew It)* (Minneapolis: University of Minnesota Press, 2006 [1996]), p. xiv.
68. Sven Lütticken, 'The Coming Exception: Art and the Crisis of Value', *New Left Review*, 99, 2016, p. 134.
69. Their point that most economic discourse is 'capitalocentric' (Gibson–Graham, *The End of Capitalism*, p. 6) anticipates my point, in *Art and Value*, that there has been a troubling convergence of Western Marxism and mainstream economics in which both assert categorically that art – indeed everything – has been commodified.
70. Gibson–Graham, *The End of Capitalism*, p. 3.
71. Chto Delat, 'A Declaration on Politics, Knowledge and Art', https://chtodelat. org/b5-announcements/a-6/a-declaration-on-politics-knowledge-and-art-4/ (accessed March 2019), 2008, np.
72. Gibson–Graham, *The End of Capitalism*, p. 18.
73. Lütticken, 'The Coming Exception', p. 135.
74. Marina Vishmidt, *Speculation as a Mode of Production: Forms of Value Subjectivity in Art and Capital* (Leiden: Brill, 2018), pp. 140–1.
75. Marx, *Economic and Philosophical Manuscripts*, p. 21.
76. Suhail Malik and Andrea Phillips have targeted a distinct but related romance in their critique of the art market's rhetoric that art collectors ought to purchase works that they love rather than calculating which works might prove to be a good investment. See Malik and Phillips, 'Tainted Love: Art's Ethos and Capitalization', *Contemporary Art and Its Commercial Markets: a Report on Current Conditions and Future Scenarios*, edited by Maria Lind and Olav Velthius (Stockholm: Sternberg Press, 2012), pp. 209–40.
77. See Fisher, *Capitalist Realism*.
78. Bryan-Wilson, *Art Workers*, p. 30.
79. *Ibid.*, p. 29.
80. Adolfo Sánchez Vásquez, *Art and Society*, p. 42.
81. *Ibid.*, p. 184.
82. *Ibid.*, p. 183.
83. *Ibid.*, p. 185.
84. See Hans Robert Jauss and Peter Heath, 'The Idealist Embarrassment: Observations on Marxist Aesthetics', *New Literary History*, Vol. 7, No. 1, 1975.

85. Karl Marx, *Capital: A Critique of Political Economy*, Volume One, p. 633.
86. *Ibid.*, p. 1042.
87. Michael Heinrich, *An Introduction to the Three Volumes of Karl Marx's Capital*, translated by Alexander Locascio (New York: Monthly Review Press, 2004), p. 122.
88. *Ibid.*, p. 122.
89. Irene Bruegel, 'Wages for Housework', *International Socialism*, 89, 1976, https://www.marxists.org/history/etol/newspape/isj/1976/no089/bruegel.htm (accessed March 2019) np.
90. *Ibid.*, np.
91. *Ibid.*, np. Emphasis in original.
92. *Ibid.*, np.
93. *Ibid.*, np.
94. *Ibid.*, np.
95. Ian Gough, 'Marx's Theory of Productive and Unproductive Labour', *New Left Review*, 76, November/December 1972, pp. 47–72. Gough says: 'First, as one of the most suspect legacies of classical political economy, its importance in Marxist political economy is disputed. As a result, it has not been accorded a central place in most expositions of Marx's political economy, and its relation to the fundamental concept of surplus value has not been sufficiently emphasized,' p. 47.
96. *Ibid.*, p. 49.
97. What matters here is not what money is earmarked for (i.e. labour of some kind) but to recognise different social forms of work. Although money and labour come into contact with one another in many ways, we need to retain the economic distinctiveness of slavery, indentured service, demesne production, wage-labour, self-employment, and so on. One of the consequences of such differences is that consumer sovereignty does not apply to the so-called 'wage' paid to artists from the public purse.
98. The notion that a pension, or any other regular payment not in exchange for labour, might count in some sense as a wage (or a deferred wage) is a misperception based on the phenomenological resemblance of incomes that derive from very different economic social relations. Just as dividends and interest payments on financial investments are not wages because they do not derive from labour, a pension is not a wage but an income derived from financial investments. Of course, pensions derive, at least in part, from the investment of wages on a social scale but the idea that a pension is a deferred wage is as absurd as claiming that savings from a wage subsequently function as a wage, as if the worker can be paid twice by not spending the whole wage at the same rate as it is received.
99. Bryan-Wilson, *Art Workers*, p. 29.
100. *Ibid.*, p. 29.

Chapter 4

1. Bratton made this comment to me in a taxi ride to the airport after a conference. It came up because I thought I'd heard him say that robots cannot make

art, and he corrected me by saying that his answer would be: if robots can make art, it will be a different kind of art, a robot-art or machine-art, rather than being like the kind of art that humans make.

2. It might be argued that dance and vocal music do not require technology. This is true but beside the point. The argument I am making is not formal but historical. The historical emergence of art as a result of technological developments (not only the tools etc. used to make art but also the technological possibility of the production of surplus which allows members of a society to specialise in the production of art rather than participate full time in sustaining life) cannot be refuted by a hypothetical individual who draws on the history of the arts in order to imagine that she is temporarily independent of the technological capacities of the species. Consider prehistoric cave paintings, for instance. When colour was applied to remote walls directly by hand, the pigments used in this activity were produced using tools and the activity was illuminated by torches and possibly fuelled by hallucinogens.

3. I use this term in the primary sense given to it by Donna Haraway, namely a hybrid of machine and organism, a creature of social reality as well as fiction (Haraway, 'A Manifesto for Cyborgs: Science, Technology, and Socialist Feminism in the 1980s', in *The Gendered Cyborg: A Reader*, edited by Gill Kirkup, Linda Janes and Fiona Hovenden (London: Routledge, 2000), p. 50).

4. See James Ayres, *Art, Artisans and Apprentices* (Oxford: Oxbow Books, 2014), pp. 16–18.

5. For a fuller narrative of this historical transition, see Dave Beech, *Art and Labour*, forthcoming from Brill.

6. James Billington, *Fire in the Minds of Men: The Origins of the Revolutionary Faith* (New York: Basic Books, 1980), p. 368.

7. Peter Wollen, *Raiding the Icebox: Reflections on Twentieth Century Culture* (London: Verso, 2008), p. 192. Wollen goes on to say in this passage: 'in this racist vision, black America was taken to be a fascinating synthesis of the "primitive", and the "futuristic", the body and the machine'.

8. Herman Bahr, 'Expressionism', *Art in Theory 1900–2000: An Anthology of Changing Ideas*, edited by Charles Harrison and Paul Wood (Oxford: Blackwell Publishing, 1992), p. 119.

9. Kasimir Malevich, 'From Cubism and Futurism to Suprematism' (1920) in Charles Harrison and Paul Wood, *Art in Theory 1900–2000: An Anthology of Changing Ideas* (Oxford: Blackwell, 1992), p. 170.

10. Steve Edwards, 'Factory and Fantasy in Andrew Ure', *Journal of Design History*, Vol. 14, No. 1, 2001, p. 18.

11. *Ibid.*, p. 20.

12. William A. Camfield 'The Machinist Style of Francis Picabia', *The Art Bulletin*, Vol. 48, Nos 3–4, 1966, p. 312.

13. Cendrars quoted in Marjorie Perloff, *The Futurist Moment: Avant-Garde, Avant Guerre, and the Language of Rupture* (Chicago: University of Chicago Press, 1986), p. 40–1.

14. Paul Virilio, *Speed and Politics: An Essay of Dromology*, translated by Mark Polizzotti (New York: Semiotext(e), 1986 (1977)), p. 62.

15. *Ibid.*, p. 68.
16. Italian Futurism is a classic instance of the Marxist theory of uneven and combined development that Trotsky developed in the 1920s and 1930s. Italy was not the leading European nation of industrial production when the Futurists sang hymns to the machine. England and Germany, which were the most advanced economic powers in Europe in the first decades of the twentieth century, were initially the most vocal opponents of industrialisation in cultural forms that harked back to the middle ages or protested against the dehumanisation of the machine age.
17. Marjorie Perloff, *The Futurist Moment: Avant-Garde, Avant Guerre, and the Language of Rupture* (Chicago: University of Chicago Press, 1986), p. 59.
18. *Ibid.*, p. 60.
19. *Ibid.*, p. 60.
20. Frances Stracey, 'Pinot-Gallizio's "Industrial Painting": Towards a Surplus of Life', *Oxford Art Journal*, Vol. 28, No. 3, 2005.
21. *Ibid.*, p. 395.
22. This deliberate rejection of the artistic and aesthetic has been understood through the concept of deskilling – which associates the avant-garde with the politics of the workers' movement – but it is more far-reaching to consider these techniques under the political category of the machine.
23. Accident in twentieth-century art was one of the various technical means of giving value to the automatic. Here, rather than turning to the perfection or standardisation of the machine made rather than the handmade, the automatic is perceived in terms of the involuntary, chance and the unintended, all of which were not only opposed to skilled handicraft but also suggestively conflated machinic automation with what is automatic in the bodily or in material processes themselves.
24. Matthew Gale, *Dada and Surrealism* (London: Phaidon, 1997), p. 94.
25. Camfield, 'The Machinist Style of Francis Picabia', p. 317.
26. In a social rather than an economic sense, the wage-labourer is manufactured too. Jonathan Crary provides vivid descriptions of how soldiers, for instance, are manufactured by the state. In one example, Crary notes that sleeplessness research should be understood as one part of a quest for soldiers whose physical capabilities will more closely approximate the functionalities of non-human apparatuses and networks (Crary, *24/7* (London: Verso, 2014), p. 3).
27. Andreas Huyssen, 'The Vamp and the Machine: Technology and Sexuality in Fritz Lang's *Metropolis*', *New German Critique*, Nos 24/25, 1981, p. 230.
28. Mary Ann Doanne, 'Technophilia: Technology, Representation, and the Feminine', in *The Gendered Cyborg: A Reader,* edited by Linda Janes, Kath Woodward and Fiona Hovenden (London: Routledge 2000), pp. 110–21.
29. Huyssen, 'The Vamp and the Machine', p. 229. Sadie Plant used similar language in her cyberfeminist affirmation of the computer and cybernetic systems: 'Like woman, software systems are used as man's tools, his media and his weapons; all are developed in the interests of man, but all are poised

to betray him' (Plant 'The Future Looms: Weaving Women and Cybernetics', *Body and Society*, Vol. 1, Nos 3–4, 1995, p. 58).

30. Isaac Asimov, *The Rest of the Robots* (London: Harper, 2018 [1967]), p. 61.

31. The three laws are: 1. A robot may not injure a human being, or, through inaction, allow a human being to come to harm. 2. A robot must obey the orders given it by human beings except where such orders would conflict with the First Law. 3. A robot must protect its own existence as long as such protection does not conflict with the First or Second Law. It is also worth noting that Asimov devised these laws, which prevent robots from harming humans, partly to open up the robot genre to stories beyond speculations about their immediate threat to their inventors. Also, he believed that these stories led to the cultural rejection of robots and technological progress which he saw as a kind of blockage on the future. The legacy of the three laws is also worth noting. Susan Leigh Anderson currently belongs to a group of academics who are studying how to ensure that robots and machines – autonomous systems – are ethical, while Paul Richard Blum reads Asimov's laws as an allegorical representation of the slave and therefore belonging to the philosophical inquiry into what counts as human.

32. Rodchenko (1913) in Charles Harrison and Paul Wood, *Art in Theory 1900–2000: An Anthology of Changing Ideas* (Oxford: Blackwell, 1992), p. 105.

33. Nick Land, 'Machinic Desire', *Fanged Noumena: Collected Writings 1987–2007* (Falmouth: Urbanomic, 2014 [1993]), p. 340. Leaving aside Land's apologetics for the toxic programme of neoliberal deregulation, this narrative runs along tramlines laid by the Cold War (liberalism is superior to central planning) but draws on a deeper historical association of the political left with the resistance to new technology. Either Luddism is regarded as a permanent feature of the left or it is the only leftwing tradition with which Land engages.

34. *Ibid.*, p. 341.

35. *Ibid.*, p. 340. By contrast, Land's nihilism reiterates a familiar cultural confrontation between wouldn't-it-be-lovely and there-is-no-alternative. Turning every theoretical debate into the choice between 'ought' and 'is', he chooses 'is'. However, he does not choose harsh reality over idealistic fantasy but extrapolates a machinic nihilistic ideal from the intensification of a toxic reality. This is the fundamental trajectory of Right Accelerationism.

36. Land, 'CyberGothic', p. 354.

37. Land, 'Machinic Desire', p. 353.

38. *Ibid.*, p. 353.

39. *Ibid.*, p. 341.

40. Robin Mackay and Armen Avanessian, *#Accelerate: The Accelerationist Reader* (Falmouth: Urbanomic, 2014), p. 4.

41. Writing in the UK at the time of Thatcherism's neoliberal rebranding of the political right as future-oriented rather than conservative, Land sticks the knife into the traditional left through an open wound. By the early 1990s, it had been over ten years since the Saatchi brothers had helped Thatcher into power with the slogan 'Labour Isn't Working', Eurocommunism was at its height, Martin Jacques and Stuart Hall were campaigning for a new leftwing

politics for *New Times*, and Tony Blair was already waiting in the wings to 'modernise' the Labour Party. Land's technophilic philosophy draws on Bataille, Deleuze and Lyotard, but his easy dismissal of the 'geriatric socialism' is of its time as this was embodied by Thatcher, Jacques and Saatchi. Alan Sears summarises the disorienting effects of the political conjuncture: 'We tend to associate the political left with change and the right with preserving the status quo, but the decision to break the postwar accord cast the political right (the conservatives) in the position of disrupting the status quo in order to strengthen dominant power relations. As the right went on the offensive, it put the left in the defensive role of fighting to preserve the limited conditions and rights that had already been won'. Sears, *The Next New Left*, p. 87.

42. Benjamin Noys, *Malign Velocities: Accelerationism and Capitalism* (London: Zero Books, 2014), p. 60.

43. David Harvey, *Seventeen Contradictions and the End of Capitalism* (Oxford: Oxford University Press, 2014), p. 82.

44. Thomas Carlyle, 'Signs of the Times', *Selected Writings*, edited by Alan Shelston (London: Penguin, 1986), p. 67.

45. His technophilic polemic is also a denunciation of labour as flesh, labour as humanity, and labour as the expendable element of a system headed for full automation. Not only has the labour movement been backing the wrong side in the opposition between labour and capital but, more importantly for him, it has backed the wrong side in the opposition between humanity and machine. Labour, in a sense, is an obsolete form of work when machines do all the work for us – or rather, for themselves.

46. The genius is not universally associated with the hostility to commerce and capitalism but has been associated with the historical emergence of copyright and authorship. For the classic version of this argument see Martha Woodmansee, *The Author, Art, and the Market*. Katie Scott points out, however, 'Since copyright was squarely recognized as an instrument of trade, synonymity was not presumed to exist between the holder of the copyright and the personality of the author. Anyone, whether involved in the production process (as patron, publisher, printmaker, printer or 'genius') or not, could legitimately obtain a copyright' (Katie Scott, 'Authorship, the Académie, and the Market in Early Modern France', *Oxford Art Journal*, Vol. 21, No. 1, 1998, p. 30). In my reading of the eighteenth-century literature on genius, the genius is formed as a type in parallel with copyright not as its reflection but as a contradictory composite of possessive individualism, ecstatic anti-rationalism and absolute freedom.

47. Charles Batteux, *The Fine Arts Reduced to a Single Principle*, translated by James O. Young (Oxford: Oxford University Press, 2015 [1746]), p. 15.

48. Herbert Dieckmann, 'Diderot's Conception of Genius', *Journal of the History of Ideas*, Vol. 2, No. 2, 1941, p. 151.

49. For a critique of posthumanism, see Joan Anim-Addo, 'Towards A Post-Western Humanism Made to the Measure of Those Recently Recognized as Human', *Edward Said and Jacques Derrida: Reconstellating Humanism and the*

Global Hybrid, edited by Mina Karavanta and Nina Morgan (Cambridge: Cambridge Scholars Publishing, 2008), pp. 250–73.

50. Karl Marx, *Capital*, pp. 553–4.
51. *Ibid.*, p. 554.
52. *Ibid.*, p. 555. At the same time, it has to be acknowledged that the Luddites were precise in their choice of machines to smash in the early nineteenth century. Kevin Binfield describes how the Luddites specifically targeted 'the use of machines whose purpose was to reduce production costs, whether the cost reductions were achieved by decreasing wages or the number of hours worked' (Kevin Binfield, *Writings of the Luddites* (Baltimore: Johns Hopkins University Press, 2004), p. 3).
53. Marx, *Capital*, pp. 568–9.
54. 'The roboticisation of services is now gathering pace … Under particular threat have been "routine" jobs – jobs that can be codified into a series of steps. These are tasks that computers are perfectly suited to accomplish … leading to a drastic reduction in the numbers of routine manual and cognitive jobs' (Srnicek and Williams, *Inventing the Future,* p. 110).
55. Jasper Bernes criticises Srnicek and Williams from a different perspective, arguing that their view is possible 'only if one thinks of technology as a series of discrete tools, rather than an ensemble of interconnected systems' (Bernes, 'The Belly of the Revolution', p. 333) and that 'the presence of communist potentials as unintended features —"affordances", as they are sometimes called – of contemporary technology needs to be argued for, not assumed as a matter of course' (Bernes, 'Logistics, Counterlogistics, and the Communist Prospect', *Short-Circuit: A Counterlogistics Reader*, http://desarquivo.org/sites/default/files/short_circuit_a_counterlogistics_reader.pdf, (accessed February 2019), 2016, p. 45.

Chapter 5

1. Maurizio Lazzarato, *Marcel Duchamp and the Refusal of Work*, translated by Joshua David Jordan (Los Angeles, Ca.: Semiotext(e), 2014), p. 7.
2. *Ibid.*, p. 41.
3. *Ibid.*, p. 6.
4. *Ibid.*, p. 9.
5. John Roberts, 'Art After Deskilling', *Historical Materialism*, 10, 2010, p. 83.
6. *Ibid.*, p. 85.
7. Thierry De Duve, *Kant After Duchamp* (Cambridge, Mass.: MIT, 1998), pp. 175–84.
8. Lazzarato, *Marcel Duchamp and the Refusal of Work*, p. 41.
9. *Ibid.*, p. 41.
10. Hudis, *Marx's Concept of the Alternative to Capitalism*, p. 18.
11. Lazzarato, *Marcel Duchamp and the Refusal of Work*, p. 19.
12. *Ibid.*, p. 35.
13. *Ibid.*, p. 28.

14. Felix Guattari, *Chaosmosis: An Ethico-Aesthetic Paradigm*, translated by Paul Bains and Julian Pefanis (Indianapolis: Indiana University Press, 1995), pp. 10–11.
15. Hudis, *Marx's Concept of the Alternative to Capitalism*, p. 133. Original emphasis.
16. Ruskin quoted in Michael Perelman, *The Invention of Capitalism* (Durham: Duke University Press), p. 57.
17. Lazzarato, *Marcel Duchamp and the Refusal of Work*, p. 20.
18. Nancy Fraser says 'the sexual division of labour assigns to women the work – and it is indeed work, though unpaid and usually unrecognized work – of purchasing and preparing goods for domestic consumption'. Nancy Fraser, *Fortunes of Feminism: From State-Managed Capitalism to Neoliberal Crisis* (London: Verso, 2013), p. 35. Also see Helen Molesworth, 'Rrose Selavy Goes Shopping', in *The Dada Seminars*, edited by Leah Dickerman and Matthew S. Witkowsky (Washington, DC: National Gallery of Art, 2005).
19. Lazzarato, *Marcel Duchamp and the Refusal of Work*, p. 27.
20. *Ibid.*, p. 5.
21. *Ibid.*, p. 41.
22. *Ibid.*, p. 39.
23. *Ibid.*, p. 6.
24. *Ibid.*, p. 6.
25. *Ibid.*, p. 8.
26. *Ibid.*, p. 8.
27. *Ibid.*, p. 8.
28. *Ibid.*, p. 9.
29. Steve Edwards, 'Factory and Fantasy in Andrew Ure', *Journal of Design History*, Vol. 14. No. 1, 2001, p. 17.
30. Ure quoted in Marx, *Capital*, Volume One, p. 544.
31. Oscar Wilde, *The Soul of Man and Prison Writings* (Oxford: Oxford University Press, 1990 [1895]), p. 15.
32. E. P. Thompson quoted in *E. P. Thompson and the Making of the New Left*, edited by Cal Winslow (London: Lawrence and Wishart, 2014), p. 248.
33. Terry Eagleton, 'Saint Oscar: A Foreword', *New Left Review*, 177, 1989, p. 127.
34. William Morris, *Useful Work Versus Useless Toil* (London: Penguin, 2008), p. 59.
35. *Ibid.*, p. 17.
36. Wilde, *The Soul of Man*, p. 15.
37. *Ibid.*, p. 15.
38. *Ibid.*, p. 15.
39. *Ibid.*, p. 15.
40. *Ibid.*, p. 15.
41. Michael Heinrich, *An Introduction to the Three Volumes of Karl Marx's Capital*, translated by Alexander Locascio (New York: Monthly Review Press, 2004), p. 19.
42. Wilde. *The Soul of Man*, p. 15.
43. *Ibid.*, p. 15.
44. *Ibid.*, p. 16.

45. *Ibid.*, p. 16.
46. John Barrell, *The Political Theory of Painting from Reynolds to Hazlitt: 'The Body of the Public'* (New Haven: Yale University Press, 1986), p. 15.
47. Antonio Palomino y Velasco, 'The Pictorial Museum and Optical Scale', *Art in Theory 1648–1815: An Anthology of Changing Ideas*, edited by Charles Harrison, Paul Wood and Jason Gaiger (Oxford: Blackwell Publishing, 2000 [1724]), p. 318.
48. *Ibid.*, p. 319.
49. Hudis, *Marx's Concept of the Alternative to Capitalism*, p. 16.
50. Wilde, *The Soul of Man*, p. 16.
51. Eagleton, 'Saint Oscar', p. 127.
52. Bertrand Russell, *In Praise of Idleness* (London: Routledge, 2004 [1935]), p. 3.
53. *Ibid.*, p. 15.
54. *Ibid.*, pp. 4–5.
55. *Ibid.*, p. 5.
56. Russell's concept of respectable idleness contrasts sharply with the discourses on idleness that have dogged the workers' movement. A comparison with the reference to idleness in E. P. Thompson's *The Making of the English Working Class* is illuminating. Here, the word idleness as quoted by the historian is always presented in conjunction with other vices: 'idleness, brawls, sedition and contagion' (E. P. Thompson, *The Making of the English Working Class* (London: Penguin, 1991 [1963]) p. 57), 'a beggarly, idle and intoxicated mob' (p. 69), 'idle and profligate' (p. 220), 'idleness and depravity' (p. 222), 'idleness and deceit' (p. 266), 'idleness, profligacy, Improvidence and thriftlessness of labour' (p. 357), 'swearing, gaming, drunkenness, idleness, sexual looseness' (p. 366), and 'idleness and drunkenness' (p. 782).
57. Marx, *Capital*, p. 526.
58. Granted, the history of socialist and communist militancy has always argued for elimination of the working class, but only as part of the revolutionary dismantling of the class system as a whole.
59. For Gyrogy Markus, Benjamin 'affirmed the critical, emancipatory potential of mass culture, particularly film' (Markus, 'Walter Benjamin or: The Commodity as Phantasmagoria', *New German Critique*, No. 83, 2001, p. 8). For my purpose, here, Markus – and Benjamin – overplay the argument by requiring technologically enhanced cultural production to be emancipatory in a directly political sense.
60. Although Benjamin's theory of the loss of the aura subverts the Romantic anti-industrialisation inaugurated by Carlyle, it remains attached to the Western Marxist belief that artworks are commodities and that the social character of the commodity can be felt. I do not dispute that a world experienced through commodities and the exchange of equivalents has subjective effects, but I contend that neither the presence nor the absence of the aura signifies the presence or absence of value production (I am thinking, here, of Marx's well-known remark that the commodity cannot reveal its social relations of production) and therefore it is not decisive in the question of what constitutes postcapitalist cultural production.

61. Walter Benjamin, 'The Work of Art in the Age of Its Reproducibility' translated by Edmund Jephcott and Howard Eiland, *Selected Writings, Volume 3, 1935–1938* (Cambridge, Mass.: Harvard University Press, 1936), p. 114.

62. See Christian Fuchs, *Digital Labour and Karl Marx* (London: Routledge, 2014).

Conclusion

1. Nick Srnicek and Alex Williams, *Inventing the Future*, p. 109.

2. Alberto Toscano, 'Chronicles of Insurrection: Tronti, Negri and the Subject of Antagonism', *The Italian Difference: Between Nihilism and Biopolitics*, edited by Lorenzo Chiesa and Alberto Toscano (Melbourne: Re.press), p. 114.

3. Weeks, *The Problem with Work*, p. 99.

4. Although, for Marxist value theory, it is impossible to produce value (or capital accumulation) without labour, this principle is not adhered to within contemporary postcapitalist theory and so automation appears to be simultaneously postcapitalist and capitalist because the automation of work is not adequately differentiated from the preservation of an automated production of value.

5. John Cunningham, 'Make Total Destroy', in Noys, *Communization and its Discontents*, p. 209.

6. Fredric Jameson describes 'utopian enclaves' as 'something like a foreign body within the social'. Jameson, *Archaeologies of the Future: The Desire Called Utopia and Other Science Fictions* (London: Verso, 2005), p. 16.

7. Benjamin Noys, 'The Fabric of Struggles', *Communization and its Discontents*, p. 10. This image brilliantly collapses the spatial practices of utopian colonies into the revolutionary space of contesting the existing society rather than removing oneself from it completely.

8. For a small survey, see Gregory Sholette, 'Swampwalls, Dark Matter & The Lumpen Army of Art', *Proximity*, No. 1, 2008, pp. 33–43; John Roberts, 'Art, "Enclave Theory" and the Communist Imaginary', *Third Text*, Vol. 23, No. 4, 2009, pp. 353–67; Marina Vishmidt, 'All Shall Be Unicorns: About Commons, Aesthetics and Time', *Open!* https://www.onlineopen.org/all-shall-be-unicorns (accessed February 2019) 2014 and Pelin Tan, 'Practices of Commoning in Recent Contemporary Art', *ASAP/Journal*, Vol. 3, No. 2, 2018, pp. 278–85.

9. Christian Fuchs, *Digital Labour and Karl Marx* (London: Routledge, 2014).

10. Jakob Rigi, 'Foundations of a Marxist Theory of the Political Economy of Information: Trade Secrets and Intellectual Property, and the Production of Relative Surplus Value and the Extraction of Rent-Tribute', *Triple-C*, Volume 12, No. 2, 2014, pp. 909–36.

11. Stallabrass does not argue that Web 2.0 users are unpaid workers exploited by tech giants who sell them as a commodity to advertisers but refers to the 'externalization of costs' that results when 'people offered their unpaid labour to populate the sites of vast corporations'. Julian Stallabrass, *Internet Art: The Online Clash of Culture and Commerce* (London: Tate Publishing, 2000).

12. Peter Meiksins, 'Work, New Technology, and Capitalism', *Capitalism and the Information Age: The Political Economy of the Global Communications Revolution*, edited by Robert McChesney, Ellen Meiksins Wood and John Bellamy Foster (New York: Monthly Review Press, 1998), p. 152.

13. Lucy Lippard, 'Postface', *Six Years: The Dematerialization of the Art Object* (Los Angeles, Ca.: University of California Press, 2001 [1973]), p. 263.

14. The artist Terry Atkinson at the time effectively pointed out that the claim to dematerialisation was ontologically misguided, since paper, air temperature, emissions of gas and both written and spoken language all are necessarily material.

15. Ian Burn retrospectively argued, 'Conceptual Art was a specific reaction against the entrenched art marketing system' but 'one does not need to have an object in order to have a commodity. Ideas can and do exist as commodities in societies like ours.' Ian Burn, 'The 'Sixties: Crisis and Aftermath (or The Memoirs of an Ex-Conceptual Artist)', *Conceptual Art: A Critical Anthology*, edited by Alexander Alberro and Blake Stimson (Cambridge, Mass.: MIT Press, 1999), p. 402.

16. Christian Fuchs, *Digital Labour and Karl Marx* (London: Routledge, 2014), p. 126.

17. For an example of this optimism, see Geert Lovink and Florian Schneider, 'Reverse Engineering Freedom', http://geertlovink.org/texts/reverse-engineering-freedom/ (accessed February 2019), 2003.

18. Fuchs, *Digital Labour and Karl Marx*, p. 99.

19. *Ibid.*, p. 104.

20. *Ibid.*, p. 127.

21. I have a certain amount of sympathy for Smythe's intellectual project insofar as he attempted to shift the Marxist debate on 'communications' away from questions of ideology towards an analysis of the 'economic function for capital [mass communications systems] serve'. Dallas Smythe, 'Communications: Blindspot of Western Marxism', *Canadian Journal of Political and Social Theory*, Vol. 1, No. 3, 1977, p. 1.

22. Sut Jhally quoted in Bill Livant, 'Working at Watching: A Reply to Sut Jhally', *Canadian Journal of Political and Social Theory*, Vol. 6, Nos 1–2, 1982, p. 211.

23. Michael A. Lebowitz, 'Too Many Blindspots on the Media', *Studies in Political Economy*, 21, 1986, p. 171. This point is updated by Balano and Viera who say: 'What is sold by Google, by the way, is not the users themselves, as Fuchs proposes in the above excerpt, because the advertiser does not buy any individual users or even their singular information. Advertisers buy only an amount of data about a target audience based on categories, as we have outlined.' César Balano and Eloy Viera, 'The Political Economy of the Internet: Social Networking Sites and a Reply to Fuchs', *Television and New Media*, Vol. 16, No. 1, 2015, p. 58.

24. Lebowitz, 'Too Many Blindspots', p. 169.

25. Fuchs, 'The Digital Labour Theory of Value and Karl Marx in the Age of Facebook, YouTube, Twitter, and Weibo', in *Reconsidering Value and Labour in*

the Digital Age, edited by Eran Fisher and Christian Fuchs (London: Palgrave, 2015), p. 29.

26. Fuchs perceives rent entirely through the lens of a particular type of rent, namely the income derived from things that have no value such as land. As important as this example of rent is, it is not the whole story. Rent is income derived from payments for the use of something with or without value (land, a house, a car, etc.), while the ownership of it is not transferred.

27. Since unproductive labour is wage labour paid for from revenue rather than capital, Fuchs is mistaken here because the audience is not waged and is therefore neither productive nor unproductive. 'The notion of unproductive labour', Fuchs says, 'has historically been used for signifying reproductive work, service work and feminized work as secondary and peripheral. It has thereby functioned as an ideological support mechanism for discrimination against women.' Fuchs, 'The Digital Labour Theory of Value', p. 36. This may be true, but it is a misreading all the same. Fuchs mistakenly assumes that it is impossible for an unproductive labourer to be exploited, and also forgets that all unproductive labour is waged labour (i.e. a cost to the employer rather than an investment of capital). He also ought to have said that unwaged labour is neither productive nor unproductive but insofar as it produces and maintains material wealth rather than value, is 'useful labour'. See Ian Gough, 'Marx's Theory of Productive and Unproductive Labour', *New Left Review*, 76, November/December 1972, pp. 47–72.

28. Fuchs, 'The Digital Labour Theory of Value', p. 27.

29. *Ibid.*, p. 33. Fuchs refers to the activity of users as proof that social media is not rent-seeking since its business model requires labour. Given that Marx develops a labour theory of value, it might seem sensible to conclude that he believes monopoly goods are not produced by labour, but this is not the case. Monopoly goods have no value because the actual labour time used up in their production is not subject to the social processes through which actual labour time is averaged.

30. *Ibid.*, p. 33.

31. *Ibid.*, p. 33.

32. *Ibid.*, p. 33.

33. Lebowitz, 'Too Many Blindspots', p. 169.

34. First, users are ideologically coerced to use commercial platforms in order to be able to engage in communication, sharing and the creation and maintenance of social relations, without which their lives would be less meaningful. Second, companies, not the users, own the platforms and the created profit. Third, users spend time on corporate internet platforms that are funded by targeted advertising capital accumulation models.

35. It is true that the slave's labour produces the means of her own life as well as the life of the slave-owner, and in this sense the slave's food, lodging, clothes and so on, which appear in the form of a gift from the slave-owner, are produced through necessary labour by the slave. In this sense, the slave, like the wage-labourer, works part of the day for herself and part of the day for the slave-owner – i.e. part paid and part unpaid. The working day of the slave,

like the working day of the wage-labourer, can be divided in two as necessary labour and surplus labour, but the slave, who produces material wealth but not value, does not produce surplus value.

36. The notion of 'surplus watching time' – in which audiences engage in work for advertisers by looking at or clicking on adverts on top of the time spent engaging directly in leisure – is an allegory of the production of surplus value through surplus labour, but it is not an example of it.

37. Gough, 'Marx's Theory of Productive and Unproductive Labour', p. 56.

38. Robert Prey and Jakob Rigi, 'Value, Rent, and the Political Economy of Social Media', *The Information Society*, 31:5, 2015, p. 398.

39. *Ibid.*, p. 398.

40. Similarly, a DJ purchases vinyl records and plays these without any extra charge being paid by nightclubbers. The records are dead labour, the value of which has been fully realised through sale, and the nightclubbers consume the music as part of the living labour performed by the DJ, who produces surplus value for the club owner.

41. Paul Romer, 'Endogenous Technological Change', *Journal of Political Economy*, Volume 98, No. 5, 1990, pp. 71–102.

42. Jeremy Rifkin, *The Zero Marginal Cost Society: The Internet of Things, The Collaborative Commons, and the Eclipse of Capitalism* (New York: St Martins Press, 2015).

43. Rob Lucas, 'The Free Machine', p. 134.

44. Paul Mason, *Postcapitalism: A Guide to Our Future* (London: Allen Lane, 2015), p. 143.

45. Karl Marx and Frederick Engels, 'The Communist Manifesto', *The Cambridge Companion to The Communist Manifesto*, edited by Terrell Carver and James Farr (Cambridge: Cambridge University Press, 2015), p. 241.

46. For an account of how mechanisation and automation create the 'cost disease' for the performing arts, the care industry and so on, see William Baumol, *The Cost Disease: Why Computers Get Cheaper and Health Care Doesn't* (New York: Yale University Press, 2012).

47. Bernes, 'The Belly of the Revolution: Agriculture, Energy, and the Future of Communism', p. 332.

48. Karl Marx and Frederick Engels, 'The Communist Manifesto', *The Cambridge Companion to The Communist Manifesto*, edited by Terrell Carver and James Farr (Cambridge: Cambridge University Press, 2015), p. 241.

49. Julian Stallabrass, in his analysis of the relationship between net art and capitalism acknowledges 'the suspicion felt by many online activists of the art world's archaic and elitist practices, which stand opposed to the apparently hyper-modern and democratic character of the Net'. Stallabrass, *Internet Art*, p. 8. Note, also, how the subtitle of Stallabrass' study frames his analysis of art and capitalism in terms of the Académie's statute against commerce.

50. The three types of fettering identified by Cohen are: first, development fettering – capitalist relations of production fetter the development of technologies (e.g. that are possible but unprofitable); second, use fettering – capitalist relations of production impede optimal use of the high technology;

and third, net fettering – capitalism can be said to fetter the forces of production if the net effect of shifting to socialism would be greater used productive power at any point in the future. G. A. Cohen, *History, Labour, and Freedom: Themes From Marx* (Oxford: Clarendon, 1988), pp. 109–23.

51. *Ibid.*, p. 119.
52. *Ibid.*, p. 119.
53. I take this term from Flint Schier's discussion of black and white (i.e. monochrome) images, which he says are 'non-committal about colour'. Schier, *Deeper Into Pictures: An Essay on Pictorial Representation* (Cambridge: Cambridge University Press, 1986), p. 165.
54. From a capitalist point of view – i.e. from the perspective of value production – the enclosures were, originally, an act of unfettering in the long revolution against feudal fetters on the capitalist mode of production. The enclosures become fetters again, for instance, when the legal protection of value production prevents new technologies from delivering the full capacity of their productive power.

Bibliography

Abbing, Hans, *Why Are Artists Poor? The Exceptional Economy of the Arts* (Amsterdam: Amsterdam University Press, 2002)

Anderson, Kevin B., *Marx at the Margins: on Nationalism, Ethnicity, and Non-White Societies* (Chicago: Chicago University Press, 2016)

Anim-Addo, Joan, 'Towards A Post-Western Humanism Made to the Measure of Those Recently Recognized as Human', in *Edward Said and Jacques Derrida: Reconstellating Humanism and the Global Hybrid*, edited by Mina Karavanta and Nina Morgan (Cambridge: Cambridge Scholars Publishing, 2008)

Argan, G. C., *The Renaissance*, translated by Robert Allen (London: Thames and Hudson, 1969)

Arthur, Chris, *Dialectics of Labour: Marx and his Relation to Hegel* (Oxford: Basil Blackwell, 1986)

Asimov, Isaac, *The Rest of the Robots* (London: Harper, 2018 [1967])

Ayres, James, *Art, Artisans and Apprentices* (Oxford: Oxbow Books, 2014)

Bahr, Herman, 'Expressionism'[1920] in *Art in Theory 1900–2000: An Anthology of Changing Ideas*, edited by Charles Harrison and Paul Wood (Oxford: Blackwell Publishing, 1992)

Balano, César and Eloy Viera, 'The Political Economy of the Internet: Social Networking Sites and a Reply to Fuchs', *Television and New Media*, Vol. 16, No. 1, 2015

Banaji, Jairus, *Theory as History: Essays on the Modes of Production and Exploitation* (Chicago: Haymarket Books, 2011)

Barrell, John, *The Political Theory of Painting from Reynolds to Hazlitt: 'The Body of the Public'* (New Haven: Yale University Press, 1986)

Batteux, Charles, *The Fine Arts Reduced to a Single Principle*, translated by James O. Young (Oxford: Oxford University Press, 2015 [1746])

Baudrillard, Jean, *The Mirror of Production*, translated by Mark Poster (St Louis: Telos Press, 1975)

Beech, Dave, *Art and Value: Art's Economic Exceptionalism in Classical, Neoclassical and Marxist Economics* (Leiden: Brill, 2015)

Benjamin, Walter, *Charles Baudelaire: A Lyric Poet in the Era of High Capitalism* (London: Verso, 1997)

Benjamin, Walter, *Selected Writings, Volume 3 1935–8*, translated by Edmund Jephcott and Howard Eiland (Cambridge, Mass.: Harvard University Press, 2002)

Berardi, Franco 'Bifo', *The Soul at Work: From Alienation to Autonomy*, translated by Francesca Cadel and Guiseppina Mecchia (Los Angeles, Ca.: Semiotext(e), 2009)

Bernes, Jasper, 'The Belly of the Revolution: Agriculture, Energy, and the Future of Communism', *Materialism and the Critique of Energy*, edited by Brent Ryan Bellamy and Jeff Diamanti (Chicago: MCM Publishing, 2018)

Bernes, Jasper, 'Logistics, Counterlogistics, and the Communist Prospect', *Short-Circuit: A Counterlogistics Reader*, http://desarquivo.org/sites/default/files/short_circuit_a_counterlogistics_reader.pdf, (accessed February 2019)

Bernes, Jasper, 'Art and Revolution', *The Sage Handbook of Frankfurt School Critical Theory*, Volume 3 (London: Sage, 2018)

Bidet, Jacques, *Critical Companion to Contemporary Marxism*, edited by Jacques Bidet and Stathis Kouvelakis (Leiden: Brill, 2001)

Billington, James, *Fire in the Minds of Men: The Origins of the Revolutionary Faith* (New York: Basic Books, 1980)

Binfield, Kevin, *Writings of the Luddites* (Baltimore, Md.: Johns Hopkins University Press, 2004)

Bloch, Ernst, *The Principle of Hope*, translated by Neville Plaice, Stephen Plaice and Paul Knight (Cambridge, Mass.: MIT Press, 1986 [1959])

Blunt, Anthony, *Artistic Theory in Italy 1450–1660* (Oxford: Oxford University Press, 1987 [1940])

Boltanski, Luc and Eve Chiapello, *The New Spirit of Capitalism* (London: Verso, 2005 [1999])

Brantlinger, Patrick, '*News from Nowhere*: Morris's Socialist Anti-Novel', *Victorian Studies*, Vol. 19, No.1, 1975

Bratton, Benjamin, *The Stack: On Software and Sovereignty* (Cambridge, Mass.: MIT, 2015)

Braunschweig, Max, 'The Philosophic Thought of the Young Marx', *Alienation: The Cultural Climate of Our Time*, edited by Gerald Sykes (New York: George Braziller, 1964)

Brouillette, Sarah, 'Academic Labor, the Aesthetics of Management, and the Promise of Autonomous Work', *nonsite.org*, 9, np

Bruegel, Irene, 'Wages for Housework', *International Socialism*, 89, 1976, https://www.marxists.org/history/etol/newspape/isj/1976/no089/bruegel.htm (accessed March 2019)

Brotton, Jerry, *The Renaissance: A Very Short Introduction* (Oxford: Oxford University Press, 2006)

Bryan-Wilson, Julia, *Art Workers: Radical Practice in the Vietnam War Era* (Berkeley, Ca.: University of California Press, 2009)

Burn, Ian, 'The 'Sixties: Crisis and Aftermath (or The Memoirs of an Ex-Conceptual Artist)', *Conceptual Art: A Critical Anthology*, edited by Alexander Alberro and Blake Stimson (Cambridge, Mass.: MIT Press, 1999), pp. 392-408

Camfield, William A., 'The Machinist Style of Francis Picabia', *The Art Bulletin*, Vol. 48, Nos 3–4, 1966

Carlyle, Thomas, 'Signs of the Times', *Selected Writings*, edited by Alan Shelston (London: Penguin, 1986)

Cleaver, Harry, *Rupturing the Dialectic: The Struggle Against Work, Money and Financialization* (Edinburgh: AK Press, 2017)

Cohen, G. A., *History, Labour, and Freedom: Themes From Marx* (Oxford: Clarendon, 1988)

Cole, Michael and Mary Pardo, *Inventions of the Studio, Renaissance to Romanticism* (Chapel Hill, NC: University of North Carolina Press, 2005)

Crary, Jonathan, 24/7 (London: Verso, 2014)

Cunningham, John, 'Make Total Destroy', Communization and its Discontents: Contestation, Critique, and Contemporary Struggles, edited by Benjamin Noys (New York: Autonomedia, 2012)

Dauvé, Gilles, 'Human, All Too Human', Endnotes, 1, 2008, pp. 90–102

Dauvé, Gilles and Karl Nesic, 'Love of Labour? Love of Labour Lost...' [2002], Endnotes, 1, 2008, pp. 104–63

De Duve, Thierry, Kant After Duchamp (Cambridge, Mass.: MIT, 1998)

Delat, Chto, 'A Declaration on Politics, Knowledge and Art', 2008, https://chtodelat.org/b5-announcements/a-6/a-declaration-on-politics-knowledge-and-art-4/ (accessed March 2019)

Dieckmann, Herbert, 'Diderot's Conception of Genius', Journal of the History of Ideas, Vol. 2, No. 2, 1941

Doanne, Mary Ann, 'Technophilia: Technology, Representation, and the Feminine', The Gendered Cyborg: A Reader, edited by Linda Janes, Kath Woodward and Fiona Hovenden (London: Routledge, 2000), pp. 110–21

Eagleton, Terry, 'Saint Oscar: A Foreword', New Left Review, 177, 1989

Edwards, Steve, 'Factory and Fantasy in Andrew Ure', Journal of Design History, Vol. 14, No. 1, 2001

Endnotes, 'Communisation and Value-Form Theory', Endnotes 2, 2010, pp. 60-105

Endnotes, 'Defeat', Endnotes 4, 2015, pp. 152-67

Epstein, S. R., 'Craft Guilds, Apprenticeship, and Technological Change in Pre-Industrial Europe', Journal of Economic History, 58, 1998

Farr, James, Artisans in Europe, 1300–1914 (Cambridge: Cambridge University Press, 2000)

Federici, Silvia, Caliban and the Witch (New York: Autonomedia, 2009)

Félibien, André, 'Preface to Conférence de l'Académie de Peinture et de Sculpture', Art and Its Histories, edited by Steve Edwards (New Haven: Yale University Press, 1999 [1669])

Fernbach, David, 'Introduction', in Karl Marx, The Revolutions of 1848: Political Writings, Vol. 1 (London: Verso, 2010)

Fisher, Mark, Capitalist Realism: Is There No Alternative? (London: Zero Books, 2009)

Fitzsimmons, Michael, From Artisan to Worker: Guilds, the French State, and the Organization of Labor 1776–1821 (Cambridge: Cambridge University Press, 2010)

Frase, Peter, Four Futures: Life After Capitalism (London: Verso, 2016)

Fraser, Andrea, 'How Has Art Changed?' Frieze, 94, October 2005

Fraser, Nancy, Fortunes of Feminism: From State-Managed Capitalism to Neoliberal Crisis (London: Verso, 2013)

Fraser, Pamela and Roger Rothman (eds), Beyond Critique: Contemporary Art in Theory, Practice, and Instruction (New York: Bloomsbury, 2017)

Fuchs, Christian, Digital Labour and Karl Marx (London: Routledge, 2014)

Gale, Matthew, Dada and Surrealism (London: Phaidon, 1997)

Gardner, Anthony, Politically Unbecoming: Postsocialist Art Against Democracy (Cambridge, Mass.: MIT Press, 2015)

Gates, Henry Louis, *Figures in Black: Words, Signs and the 'Racial' Self* (Oxford: Oxford University Press, 1987)

Gibson–Graham, J. K., *The End of Capitalism (As We Knew It)* (Minneapolis, Minn.: University of Minnesota Press, 2006 [1996])

Gielen, Pascal, *The Murmuring of the Artistic Multitude: Global Art, Memory and Post-Fordism*, translated by Clare McGregor (Amsterdam: Valiz, 2009)

Gilroy, Paul, *The Black Atlantic* (London: Verso, 1993)

Gorz, André, *Farewell to the Working Class: An Essay on Post-Industrial Society*, translated by Michael Sonenscher (London: Pluto Press, 1982 [1980])

Gorz, André, *Paths to Paradise: On the Liberation From Work* (London: Pluto Press, 1985)

Gough, Ian, 'Marx's Theory of Productive and Unproductive Labour', *New Left Review*, 76, November/December 1972

Gould, Carol, *Marx's Social Ontology: Individuality and Community in Marx's Theory of Social Reality* (Cambridge, Mass.: MIT Press, 1978)

Guattari, Felix, *Chaosmosis: An Ethico-Aesthetic Paradigm*, translated by Paul Bains and Julian Pefanis (Indianapolis: Indiana University Press, 1995)

Gulli, Bruno, *Labor of Fire: The Ontology of Labor Between Economy and Culture* (Philadelphia, PA: Temple University Press, 2005)

Hadjimichalis, Costis, *Uneven Development and Regionalism: State, Territory and Class in Southern Europe* (London: Croom Helm, 1987)

Hall, Stuart, 'When was the "Post-colonial"? Thinking at the Limit', in I. Chambers and L. Curtis (eds), *The Post-colonial Question* (London: Routledge, 1996)

Haraway, Donna 'A Manifesto for Cyborgs: Science, Technology, and Socialist Feminism in the 1980s', *The Gendered Cyborg: A Reader*, edited by Gill Kirkup, Linda Janes and Fiona Hovenden (London: Routledge, 2000)

Hardt, Michael and Antonio Negri, *Empire* (Cambridge, Mass.: Harvard University Press, 2000)

Harreld, Donald J., 'Craft Guilds in the Early Modern Low Countries', *The Sixteenth Century Journal*, Vol. 39, No. 1, 2008

Harrison, Charles and Paul Wood, *Art in Theory 1900–2000: An Anthology of Changing Ideas* (Oxford: Blackwell, 1992)

Harvey, David, *Spaces of Hope* (Edinburgh: Edinburgh University Press, 2002)

Harvey, David, *Seventeen Contradictions and the End of Capitalism* (Oxford: Oxford University Press, 2014)

Hatherley, Owen, *The Chaplin Machine: Slapstick, Fordism and the Communist Avant-Garde* (London: Pluto Press, 2016)

Heinrich, Michael, *An Introduction to the Three Volumes of Karl Marx's Capital*, translated by Alexander Locascio (New York: Monthly Review Press, 2004)

Hemingway, Andrew, *Landscape Between Ideology and the Aesthetic: Marxist Essays on British Art and Art Theory, 1750–1850* (Chicago: Haymarket, 2017)

Hess, Moses, *The Holy History of Mankind and Other Writings*, edited by Shlomo Avineri (Cambridge: Cambridge University Press, 2004)

Holloway, John, *In, Against and Beyond Capitalism: The San Francisco Lectures* (Los Angeles, Ca.: PM Press, 2016)

Holloway, John and Eloína Peláez, *Zapatista! Reinventing Revolution in Mexico* (London: Pluto Press, 1998)

Holmstrom, Nancy, quoted in Tithi Bhattacharya, *Social Reproduction Theory: Remapping Class, Representing Oppression* (London: Pluto Press, 2017)

Hudis, Peter, *Marx's Concept of the Alternative to Capitalism* (Chicago: Haymarket Books, 2013)

Huyssen, Andreas 'The Vamp and the Machine: Technology and Sexuality in Fritz Lang's *Metropolis*', *New German Critique*, Nos 24/25, 1981

Jameson, Fredric, *Archaeologies of the Future: The Desire Called Utopia and Other Science Fictions* (London: Verso, 2005)

Jameson, Fredric, 'The Politics of Utopia', *New Left Review*, 25, 2004

Jauss, Hans Robert and Peter Heath, 'The Idealist Embarrassment: Observations on Marxist Aesthetics', *New Literary History*, Vol. 7, No. 1, 1975

Jones, Caroline A., *Machine in the Studio: Constructing the Postwar American Artist* (Chicago: University of Chicago Press, 1996)

Kain, Philip, *Schiller, Hegel and Marx: State, Society, and the Aesthetic Ideal of Ancient Greece* (Kingston: McGill-Queen's University Press, 1982)

Kaluzynska, Eva, 'Wiping the Floor with Theory: A Survey of Writings on Housework', *Feminist Review*, No. 6, 1980

Kant, Immanuel, *Critique of Judgement*, translated by Werner S. Pluhar (Indianapolis, Ind.: Hackett, 1987 [1790])

Kautsky, Karl, *Thomas More and His Utopia* (London: Lawrence and Wishart, 1979 [1888])

King, Margaret L., *Women of the Renaissance* (Chicago: University of Chicago Press, 1991)

Kristeller, Paul O., 'The Modern System of the Arts: A Study in the History of Aesthetics Part I', *Journal of the History of Ideas*, Vol. 12, No. 4, 1951

Kunst, Bojana, *Artist at Work: Proximity of Art and Capitalism* (London: Zero Books, 2015)

Kurz, Robert, 'The Degradation of Culture', *Krisis: Contributions to the Critique of Commodity Society* (London: Chronos Publications, 2002)

Land, Nick, *Fanged Noumena: Collected Writings 1987–2007* (Falmouth: Urbanomic, 2014)

Lazzarato, Maurizio, *Marcel Duchamp and the Refusal of Work*, translated by Joshua David Jordan (Los Angeles, Ca.: Semiotext(e), 2014)

Léger, Marc James, *Brave New Avant Garde: Essays on Contemporary Art and Politics* (London: Zero Books, 2012)

Lippard, Geert and Florian Schneider, 'Reverse Engineering Freedom', http://geertlovink.org/texts/reverse-engineering-freedom/ (accessed February 2019), 2003

Lippard, Lucy, *Six Years: The Dematerialization of the Art Object* (Los Angeles, Ca.: University of California Press, 2001 [1973])

Livant, Bill, 'Working at Watching: A Reply to Sut Jhally', *Canadian Journal of Political and Social Theory*, Vol. 6, Nos 1–2, 1982

Longinus, *On Great Writing: On the Sublime*, translated by G. M. A. Grube (Indianapolis, Ind.: Hackett Publishing, 1991)

Lorenzano, Luis, 'Zapatismo: Recomposition of Labour, Radical Democracy and Revolutionary Project', *Zapatista!*, edited by John Holloway and Eloína Peláez (London: Pluto Press, 1998), pp. 126–58

Löwy, Michael, *The Theory of Revolution in the Young Marx* (Chicago: Haymarket Books, 2005)

Lucas, Rob, 'The Free Machine', *New Left Review*, 100, 2016

Lukàcs, Georg, *History and Class Consciousness: Studies in Marxist Dialectics*, translated by Rodney Livingstone(Cambridge, Mass.: MIT Press, 1971 [1923])

Lütticken, Sven, 'The Coming Exception: Art and the Crisis of Value', *New Left Review*, 99, 2016

Mackay, Robin and Armen Avanessian, *#Accelerate: The Accelerationist Reader* (Falmouth: Urbanomic, 2014)

Malevich, Kasimir, 'From Cubism and Futurism to Suprematism' in *Art in Theory 1900–2000: An Anthology of Changing Ideas*, edited by Charles Harrison and Paul Wood (Oxford: Blackwell Publishing, 1992 [1920])

Malik, Suhail and Andrea Phillips, 'Tainted Love: Art's Ethos and Capitalization', *Contemporary Art and Its Commercial Markets: a Report on Current Conditions and Future Scenarios*, edited by Maria Lind and Olav Velthius (Stockholm: Sternberg Press, 2012)

Marcuse, Herbert, *Eros and Civilization* (Boston, Mass.: Beacon Press, 1955)

Marcuse, Herbert, *The Aesthetic Dimension: Toward a Critique of Marxist Aesthetics* (Basingstoke: Macmillan, 1990 [1978])

Marcuse, Herbert, *Heideggerian Marxism*, edited by Richard Wolin and John Abromeit (Nebraska: Nebraska University Press, 2005 [1932])

Marin, Louis, *Utopics: Spatial Play*, translated by Robert Vollrath (New Jersey: Humanities Press, 1984)

Markus, Gyorgy, 'Walter Benjamin or: The Commodity as Phantasmagoria', *New German Critique*, 83, 2001

Marx, Karl, *Economic and Philosophical Manuscripts*, translated by Martin Milligan (London: Lawrence and Wishart, 1959 [1844])

Marx, Karl, *Capital: A Critique of Political Economy*, Volume 1, translated by Ben Fowkes (London: Penguin, 1959 [1867])

Marx, Karl, *Theories of Surplus Value, Part 1*, translated by Emile Burns (Moscow: Progress Publishers, 1978 [1862–75])

Marx, Karl, *A Contribution to the Critique of Political Economy*, translated by S.W. Ryazanskaya (London: Lawrence and Wishart, 1981 [1859])

Marx, Karl and Frederick Engels, 'The Communist Manifesto', *The Cambridge Companion to The Communist Manifesto*, edited by Terrell Carver and James Farr (Cambridge: Cambridge University Press, 2015)

Mason, Paul, *Postcapitalism: A Guide to Our Future* (London: Allen Lane, 2015)

Massey, Doreen, *For Space* (London: Sage, 2005)

Meiksins, Peter, 'Work, New Technology, and Capitalism', in *Capitalism and the Information Age: The Political Economy of the Global Communications Revolution*, edited by Robert McChesney, Ellen Meiksins Wood and John Bellamy Foster (New York: Monthly Review Press, 1998)

Merrifield, Andy, *The Amateur* (London: Verso, 2017)

Michel, Christian, *The Académie Royale de Peinture et de Sculpture – The Birth of the French School, 1648–1793*, translated by Chris Miller (Los Angeles, Ca.: The Getty Research Institute, 2018)

Midnight Notes, *Auroras of the Zapatistas: Local and Global Struggles of the Fourth World War* (New York: Autonomedia, 2001)

Mills, C. Wright, *White Collar* (Oxford: Oxford University Press, 1963 [1951])

Millán, Márgara, 'Zapatista Indigenous Women' in *Zapatista!: Reinventing Revolution in Mexico*, edited by John Holloway and Eloína Peláez (London: Pluto Press, 1998)

Molesworth, Helen, 'Rrose Selavy Goes Shopping', in *The Dada Seminars*, edited by Leah Dickerman and Matthew S. Witkowsky (Washington, DC: National Gallery of Art, 2005) pp. 173–90

Molesworth, Helen, 'House Work and Art Work', *October*, Vol. 92, Spring 2000

Molyneux, John, *The Future Socialist Society* (London: Socialist Workers Party, 1987 [1986])

Morris, William, *Useful Work Versus Useless Toil* (London: Penguin, 2008)

Morton, A. L., *The English Utopia* (London: Lawrence and Wishart, 1969 [1952])

Mouffe, Chantal, *Agonistics: Thinking the World Politically* (London: Verso, 2013)

Mouffe, Chantal, *For a Left Populism* (London: Verso, 2018)

Musto, Marcello, *Another Marx: Early Manuscripts to the International* (London: Bloomsbury, 2018)

Neil, Monty 'Rethinking Class Composition Analysis in the Light of the Zapatistas', *Auroras of the Zapatistas: Local and Global Struggles of the Fourth World War*, edited by Midnight Notes (New York: Autonomedia, 2001)

Nochlin, Linda, *Women, Art, and Power and Other Essays* (London: Thames and Hudson, 1989)

Noys, Benjamin, *Communization and its Discontents: Contestation, Critique, and Contemporary Struggles* (New York: Autonomedia, 2012)

Noys, Benjamin, *Malign Velocities: Accelerationism and Capitalism* (London: Zero Books, 2014)

Ogilvie, Sheilagh, 'Rehabilitating the Guilds: a Reply', *Economic History Review*, 61:1, 2008

Palomino y Velasco, Antonio, 'The Pictorial Museum and Optical Scale' in *Art in Theory 1648–1815: An Anthology of Changing Ideas*, edited by Charles Harrison, Paul Wood and Jason Gaiger (Oxford: Blackwell Publishing, 2000 [1724])

Paternak, Anne, 'Foreword', *Living as Form: Socially Engaged Art From 1991–2011*, edited by Nato Thompson (New York: Creative Time Books, 2012)

Perloff, Marjorie, *The Futurist Moment: Avant-Garde, Avant Guerre, and the Language of Rupture* (Chicago: University of Chicago Press, 1986)

Plant, Sadie, 'The Future Looms: Weaving Women and Cybernetics', *Body and Society*, Volume 1, Nos 3–4, 1995

Pollock, Griselda, *Old Mistresses: Women, Art and Ideology* (London: I. B. Taurus, 2013)

Postone, Moishe, *Time, Labour and Social Domination: A Reinterpretation of Marx's Critical Theory* (Cambridge: Cambridge University Press, 1993)

Precarious Workers Brigade, 'Training for Exploitation', *The Journal of Aesthetics and Protest*, 2012

Prey, Robert and Jakob Rigi, 'Value, Rent, and the Political Economy of Social Media', *The Information Society*, 31:5, 2015, pp. 392–406

Rancière, Jacques, *Dissensus: On Politics and Aesthetics*, translated by Steven Corcoran (London: Continuum, 2010)

Raunig, Gerald, *Art and Revolution: Transversal Activism in the Long Twentieth Century* (Los Angeles, Ca.: Semiotext(e), 2007)

Rifkin, Jeremy, *The Zero Marginal Cost Society: The Internet of Things, The Collaborative Commons, and the Eclipse of Capitalism* (New York: St Martins Press, 2015)

Rigi, Jakob, 'Foundations of a Marxist Theory of the Political Economy of Information: Trade Secrets and Intellectual Property, and the Production of Relative Surplus Value and the Extraction of Rent-Tribute', *Triple-C*, Volume 12, No. 2, 2014, pp. 909–36

Roberts, John, 'Art, "Enclave Theory" and the Communist Imaginary', *Third Text*, Vol. 23, No. 4, 2009

Roberts, John, 'Art After Deskilling', *Historical Materialism*, 10, 2010, pp. 77–96

Romer, Paul, 'Endogenous Technological Change', *Journal of Political Economy*, Volume 98, No. 5, 1990, pp. 71–102

Ross, Andrew, *No Collar: The Humane Workplace and its Hidden Costs* (Philadelphia, Pa.: Temple University Press, 2003)

Ruskin, John, *Unto This Last and Other Writings* (London: Penguin, 1985)

Russell, Bertrand, *In Praise of Idleness* (London: Routledge, 2004 [1935])

Said, Edward, *Culture and Imperialism* (London: Chatto and Windus, 1993)

Sandberg, Åke, *Enriching Production: Perspectives on Volvo's Uddevalla Plant as an Alternative to Lean Production* (Aldershot: Avebury, 2011 [1995])

Schapiro, Meyer, *Modern Art: 19th and 20th Centuries* (New York: George Braziller, 1979)

Schier, Flint, *Deeper Into Pictures: An Essay on Pictorial Representation* (Cambridge: Cambridge University Press, 1986)

Schiller, Friedrich, *Aesthetical and Philosophical Essays*, edited by Nathan Haskell Dole (Boston, Mass.: Francis A. Niccolls, 1954)

Scott, Katie, 'Authorship, the Académie, and the Market in Early Modern France', *Oxford Art Journal*, Vol. 21, No. 1, 1998

Sears, Alan, *The Next New Left: A History of the Future* (Nova Scotia: Fernwood Publishing, 2014)

Sennett, Richard, *The Craftsman* (London: Penguin, 2008)

Sewell, William, *Work and Revolution in France: The Language of Labor from the Old Regime to 1848* (Cambridge: Cambridge University Press, 1980)

Shaviro, Steven, 'Accelerationist Aesthetics: Necessary Inefficiency in Times of Real Subsumption', *e-flux* #46 (June 2013) https://www.e-flux.com/journal/46/60070/accelerationist-aesthetics-necessary-inefficiency-in-times-of-real-subsumption/ (accessed 27 November 2018)

Sholette, Gregory, 'Swampwalls, Dark Matter & The Lumpen Army of Art', *Proximity*, No. 1, 2008, pp. 33–43

Smith, Dorothy, *The Everyday World as Problematic: A Feminist Sociology* (Boston, Mass.: Northeastern University Press, 1987)

Smythe, Dallas, 'Communications: Blindspot of Western Marxism', *Canadian Journal of Political and Social Theory*, Vol. 1, No. 3, 1977

Solomon, Maynard, *Marxism and Art: Essays Classic and Contemporary* (Detroit, MI: Wayne State University Press, 1974)

Srnicek, Nick and Alex Williams, *Inventing the Future: Postcapitalism and a World Without Work* (London: Verso, 2015)

Stallabrass, Julian, *Internet Art: The Online Clash of Culture and Commerce* (London: Tate Publishing, 2000)

Stracey, Frances, 'Pinot-Gallizio's "Industrial Painting": Towards a Surplus of Life', *Oxford Art Journal*, Vol. 28, No. 3, 2005

Tan, Pelin, 'Practices of Commoning in Recent Contemporary Art', *ASAP/Journal*, Vol. 3, No. 2, 2018

Taylor, Keith, *The Political Ideas of the Utopian Socialists* (London: Frank Cass, 1982)

Théorie Communiste, 'Much Ado About Nothing?', *Endnotes*, 1, 2008

Thompson, E. P., *William Morris: Romantic to Revolutionary* (Los Angeles, Ca.: PM Press, 2011 [1976])

Thompson, E. P. quoted in *E. P. Thompson and the Making of the New Left*, edited by Cal Winslow (London: Lawrence and Wishart, 2014)

Thompson, Nato, *Seeing Power: Art and Activism in the 21st Century* (Brooklyn, NY: Melville House, 2015)

Thompson, Nato and Greg Sholette, *The Interventionists: Users' Manual for the Creative Disruption of Everyday Life* (North Adams, Mass.: MoCA Publications, 2004)

Tokumitsu, Miya, *Do What You Love: And Other Lies about Success & Happiness* (New York: Regan Arts, 2018)

Toscano, Alberto, 'Chronicles of Insurrection: Tronti, Negri and the Subject of Antagonism', in *The Italian Difference: Between Nihilism and Biopolitics*, edited by Lorenzo Chiesa and Alberto Toscano (Melbourne: Re.press, 2009)

Vásquez, Adolfo Sánchez, *Art and Society: Essays in Marxist Aesthetics*, translated by Maro Riofrancos (London: Merlin Press, 1973 [1965])

Vidokle, Anton, 'Art Without Work?', *e-flux*, #29, November 2011 https://www.e-flux.com/journal/29/68096/art-without-work/ (accessed 27 November 2018)

Virilio, Paul, *Speed and Politics: An Essay of Dromology*, translated by Mark Polizzotti (New York: Semiotext(e), 1986 [1977])

Virno, Paolo, 'Virtuosity and Revolution: The Political Theory of Exodus', translated by Ed Emery, in *Radical Thought in Italy: A Potential Politics*, edited by Paolo Virno and Michael Hardt (Minneapolis: University of Minnesota Press, 1996)

Vishmidt, Marina, 'All Shall Be Unicorns: About Commons, Aesthetics and Time', *Open!*, 2014 https://www.onlineopen.org/all-shall-be-unicorns (accessed February 2019)

Vishmidt, Marina, *Speculation as a Mode of Production: Forms of Value Subjectivity in Art and Capital* (Leiden: Brill, 2018)

Wackernagel, Martin, *The World of the Florentine Renaissance Artist: Projects and Patrons, Workshop and Art Market*, translated by Alison Luchs (New Jersey: Princeton University Press, 1981 [1938])

W.A.G.E., 'Wagency', https://wageforwork.com/wagency (accessed March 2019), 2018, np

Weeks, Kathi, *The Problem with Work: Feminism, Marxism, Antiwork Politics, and Postwork Imaginaries* (Durham: Duke University Press, 2011)

Wilde, Oscar, *The Soul of Man and Prison Writings* (Oxford: Oxford University Press, 1990 [1895])

Wittkower, Rudolf, 'Individualism in Art and Artists: A Renaissance Problem', *Journal of the History of Ideas*, Vol. 22, No. 3, 1961

Wood, Neal, *John Locke & Agrarian Capitalism* (Berkeley, Ca.: University of California Press, 1984)

Woodmansee, Martha, *The Author, Art, and the Market: Rereading the History of Aesthetics* (New York: Columbia University Press, 1994)

WReC, *Combined and Uneven Development: Towards a New Theory of World-Literature* (Liverpool: Liverpool University Press, 2015)

Index

uneven and combined development
10–12
unproductive labour see labour
Ure, Andrew 83–4, 127n
useful labour see labour
Utopian Socialism 7, 9, 13, 14–18,
21–2, 35, 42, 53, 108n, 129n

value theory 1–2, 6–7, 57–8, 95, 129n
material wealth 1, 9, 28–30, 32, 50,
55–6, 58, 60, 79–80, 83, 89,
96, 102, 109n, 131n, 132n; value
extraction 55, 57, 85, 61, 76,
90. 100; value production 7–8,
28–31, 59, 91, 95–6, 98, 133n
Vasari, Giorgio 39, 48, 118n
Vásquez, Adolfo Sánchez 42–3, 56–7,
116n, 120n
Vidokle, Anton 46, 117n
Vinci, Leonardo da 48
Virilio, Paul 67, 122n
Virno, Paolo 8, 106n, 119n
Vishmidt, Marina 120n

Wackernagel, Martin 39, 114n
W.A.G.E 46, 55, 105n, 117n

wages for artists 45–8, 61–2
wages for housework 47, 60–1
Warhol, Andy 82
Warwick Research Collective 10–12,
107n
Web 2.0 13, 94–8
Weeks, Kathi 2, 8, 23, 53, 93, 106n,
110n, 120n, 129n
Wilde, Oscar 84–8, 101, 127n
Williams, Alex see Srnicek, Nick
Williams, Hank 99
Wittkower, Rudolf and Margot 37, 113n
Wollen, Peter 122n
Wood, Neal 108n
Woodmansee, Martha 117n
work 9
abolition of work 6, 8–9, 78, 82–4,
91, 93; feminist politics of
work 46–7, 54, 81, 93–4, 117n;
micropolitics of work 45; politics
of work 6; worker, 7, 117n; work
ethic 8, 15, 81
workshop 39–40
workers movement 2, 13, 117n

Zapatista 19–22